Rembrandt to Gainsborough

Masterpieces from Dulwich Picture Gallery

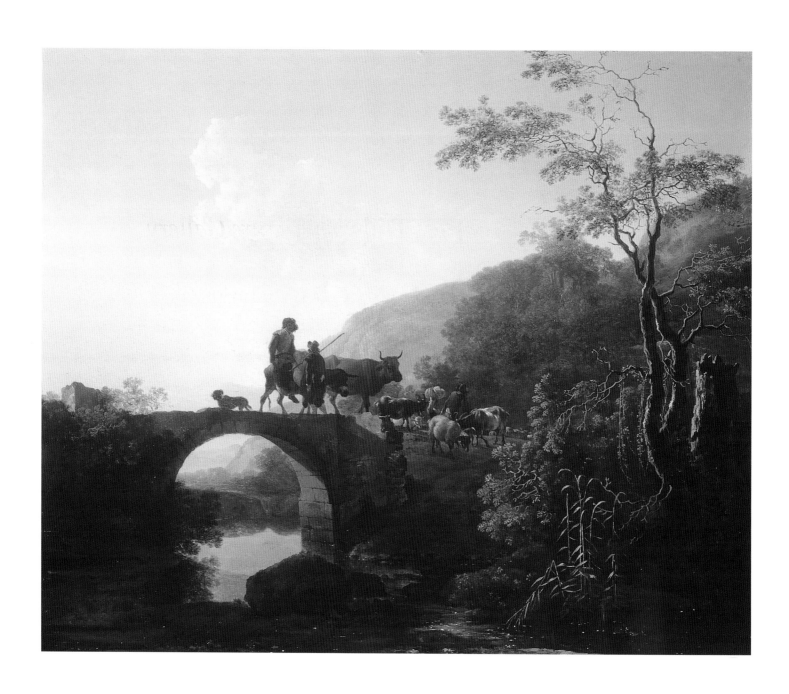

REMBRANDT TO GAINSBOROUGH

Masterpieces from Dulwich Picture Gallery

Ian A.C. Dejardin, Desmond Shawe-Taylor,
and Giles Waterfield

MERRELL HOLBERTON
PUBLISHERS LONDON

—

THE AMERICAN FEDERATION OF ARTS

This catalogue has been published in conjunction with *Rembrandt to Gainsborough: Masterpieces from England's Dulwich Picture Gallery*.

Made possible by Ford Motor Company.

The exhibition is organized by The American Federation of Arts and Dulwich Picture Gallery. The catalogue is supported in part by the Samuel H. Kress Foundation. Additional assistance is provided by the Benefactors Circle of the AFA.

The American Federation of Arts is a nonprofit art museum service organization that provides traveling art exhibitions and educational, professional, and technical support programs developed in collaboration with the museum community. Through these programs, the AFA seeks to strengthen the ability of museums to enrich the public's experience and understanding of art.

EXHIBITION ITINERARY

The Museum of Fine Arts, Houston, Texas
October 24, 1999–January 9, 2000

The Speed Art Museum. Louisville, Kentucky
January 25–April 9, 2000

Publication Coordinator, AFA: Michaelyn Mitchell
Produced by Merrell Holberton Publishers Ltd
Designed and typeset in Albertina by Dalrymple
Printed in Italy

ISBN 1 85894 080 X *hardback*
ISBN 1 885444 10 9 *paperback*

First published in 1999 by Merrell Holberton Publishers Ltd, 42 Southwark Street, London SE1 1UN, and The American Federation of Arts, 41 East 65th Street, New York, New York 10021

Distributed in the USA and Canada by Rizzoli International Publications, Inc. through St Martin's Press, 175 Fifth Avenue, New York, NY 10010

The introduction by Giles Waterfield is adapted from *Collection for a King: Old Master Paintings from the Dulwich Picture Gallery*, London (Trustees of Dulwich Picture Gallery), 1985.

Photographs are supplied by the owner of the works and are reproduced by their permission.

Front cover: Gerrit Dou,
A Woman Playing a Clavichord (detail; cat. 51)

Frontispiece: Adam Pynacker,
Bridge in an Italian Landscape (cat. 63)

LIBRARY OF CONGRESS CATALOGING-IN-PUBLICATION DATA

Dejardin, Ian.
 Rembrandt to Gainsborough : masterpieces from Dulwich Picture Gallery /
Ian A.C. Dejardin, Desmond Shawe-Taylor, and Giles Waterfield
 p. cm.
 Exhibition itinerary, the Museum of Fine Arts, Houston, Texas, Oct. 24, 1999 –
Jan. 9, 2000, and the Speed Art Museum. Louisville, Kentucky Jan. 25 – Apr. 9, 2000.
 Includes bibliographical references and index.

 ISBN 1 85894 080 X (hb)
 ISBN 1 885444 10 9 (soft)

 1. Painting, European Exhibitions. 2. Painting, Modern — 17th–18th centuries
 — Europe Exhibitions. 3. Painting, Baroque — Europe Exhibitions. 4. Painting
 — England — London Exhibitions. 5. Dulwich Picture Gallery Exhibitions.
 I. Shawe-Taylor, Desmond. II Waterfield, Giles. III Dulwich Picture Gallery.
 IV. Museum of Fine Arts, Houston. V. Speed Art Museum. VI. Title

 ND456 .D44 1999
 759.94'074'74'42164 – dc21

 99–32469
 CIP

BRITISH LIBRARY CATALOGUING-IN-PUBLICATION DATA

Dejardin, Ian
 Rembrandt to Gainsborough : masterpieces from Dulwich
 Picture Gallery
 1. Dulwich College. Picture Gallery – History 2. Dulwich
 College. Picture Gallery – Catalogs
 I. Title II. Shawe-Taylor, Desmond, 1955– III. Waterfield,
 Giles IV. American Federation of Arts
 708.2'164

 ISBN 185894080X

Contents

Sponsor's Statement

All of us at Ford Motor Company salute Dulwich Picture Gallery and the American Federation of Arts for organizing this outstanding exhibition. This is the first time that many of these masterpieces, from the oldest art museum in England, will be seen by American audiences.

Ford Motor Company values its close association with Great Britain and generations of British customers. In addition to Ford vehicles, we continue to produce two of the world's finest luxury automobiles in Great Britain with Jaguar and Aston Martin.

The paintings from Dulwich Picture Gallery originated in many countries over two centuries, but their impact transcends national boundaries. The excellence of these pictures reflects Ford's commitment to excellence in design and performance. As a global company, we believe that art speaks a universal language, and we hope that you will enjoy this unique international collection.

WILLIAM CLAY FORD, JR.
Chairman, Ford Motor Company

Acknowledgments

Undeniably one of the finest collections of European Baroque painting, Dulwich Picture Gallery is one of Britain's artistic treasures. Rich in pictures by such towering figures as Rembrandt, Rubens, Poussin, and Van Dyck, the gallery itself is a masterpiece by the noted architect Sir John Soane. *Rembrandt to Gainsborough* represents a fortuitous opportunity: during a time in which Soane's innovative structure will be completely renovated, we are able to make the gallery's finest paintings available to an American audience. It is all the more gratifying that this exhibition will travel during the ninetieth anniversary year of the American Federation of Arts.

This exhibition would not have been possible without the generous cooperation of the entire staff of Dulwich Picture Gallery. First and foremost, I want to thank the gallery's director, Desmond Shawe-Taylor, for his interesting concept for the exhibition and for his tireless support. Ian A.C. Dejardin, curator of the gallery, was instrumental at every stage and also contributed significantly to this publication. I want to acknowledge Lucy Till, exhibitions officer at the gallery, for carefully overseeing the logistics of this project, and Gillian Wolfe, head of education, for her valuable contribution to the development of interpretive materials. Finally, thanks go to Giles Waterfield, former director of the gallery, for allowing us to reprint his informative text on the formation of Dulwich Picture Gallery.

At the AFA, numerous staff members have lent their talents to the realization of this project. First among them are Thomas Padon, director of exhibitions, and Suzanne Ramljak, curator of exhibitions, who diligently guided the organization of this exhibition from its inception. Michaelyn Mitchell, head of publications, brought her creative talents to the publication of this handsome book. Lisbeth Mark, director of communications, oversaw the promotion and publicity efforts for the project. Betsy Grenier, director of development, worked closely with the exhibition sponsor. Katey Brown, head of education, and Brian Boucher, assistant curator of education, developed the educational materials accompanying the exhibition. Mary Grace Knorr, registrar, handled the challenges of traveling the exhibition. I also wish to recognize the contributions of Beth Huseman, publications assistant, and Christina Ferando, exhibitions assistant.

This exhibition marks the AFA's first collaboration with Merrell Holberton Publishers Ltd. Our gratitude goes to Hugh Merrell and Paul Holberton for their graciousness and expertise in producing this fine publication.

Lastly, our sincere thanks go to our generous sponsor, Ford Motor Company, without whom this exhibition would not be possible, as well as to the Samuel H. Kress Foundation for its support of the catalogue, and the Benefactors Circle of the AFA.

SERENA RATTAZZI
Director, The American Federation of Arts

Preface

Dulwich Picture Gallery has been described as "London's most perfect Gallery." Its appeal derives from a number of complementary factors. It is England's first public art gallery. The fascinating story of its foundation in 1811 brings together the utopian visions of the Romantic period in Europe with the operations of pure chance. To a greater extent than in any other comparable museum, the visitor to Dulwich is aware of the founders, Noel Desenfans, his wife Margaret, and their friend Sir Francis Bourgeois. This is partly because they are buried on site, in the gallery's mausoleum, but also because their collection, their building, and, more intangibly, their vision can be experienced in a remarkably unchanged fashion. The building is another of the gallery's peculiar attractions. The pet project of the greatest architect of the period, Sir John Soane, it is possibly the most influential example of gallery design in the world. The setting is unique: within a garden next to the original Jacobean quadrangle of Dulwich College, in the heart of Dulwich Village, a famous oasis of parks, playing fields, and Georgian houses within a few miles of the center of London. All these things act as a splendid frame for the paintings themselves: one of the most important collections of seventeenth- and eighteenth-century European art on public display.

Rembrandt to Gainsborough takes many of the delights of Dulwich on tour. Architecture and ambience clearly do not travel. We are fortunate, therefore, in being able to evoke them through the next best means: by reprinting the definitive history of the gallery and its architecture, written by Giles Waterfield, director of the gallery from 1979 to 1996. The remainder of the catalogue is devoted to the various national schools of painting represented in the collection. It is hoped that this arrangement reflects the founders' intention that their paintings should act as a "national gallery," offering a complete view of old master painting. As the canon has expanded, this view has now come to seem partial: covering "only" European painting of the seventeenth and eighteenth centuries. Within this important episode in European painting, however, the Dulwich collection has a scope, a breadth of taste, and a coherence that one associates with the great royal collections and national galleries of the world. It is difficult to imagine a more appealing and informative introduction to the age of Baroque.

This is the largest and most important group of paintings ever to go on tour from Dulwich Picture Gallery. The exhibition has depended from its inception through to its realization upon the initiative, commitment, and professionalism of the American Federation of Arts. We at the gallery are most sincerely grateful to the AFA director, Serena Rattazzi, and to her colleagues for their tireless

dedication to this project; in particular I should like to single out Thomas Padon and Suzanne Ramljak, who first proposed this happy collaboration, and Michaelyn Mitchell, who has worked with such patience on the catalogue. We are also greatly indebted to the publishers for their handsome production of the catalogue, and in particular to Hugh Merrell and Paul Holberton. I am most grateful to the staff of Dulwich Picture Gallery who have worked with such dedication on this project, in particular the curator, Ian Dejardin; the exhibitions officer, Lucy Till; the collections manager, Alan Campbell; technicians Steve Atherton and Marco Garcia; painting conservators Sophie Plender and Nicole Ryder; and frame conservator Tom Proctor. Invaluable help was given by Colleen Egan and Paul Matthews in the curatorial office.

This exhibition has been most generously sponsored by Ford Motor Company; we are most grateful for this support for Dulwich Picture Gallery and its work and for the opportunity it provides of allowing a new audience to become acquainted with the collection.

Dulwich Picture Gallery is presently (1999) closed for restoration and new building work, which will bring the facilities of the gallery up to the very best modern standards. The refurbished gallery will re-open in May 2000 and we hope that many visitors to this exhibition will be tempted to make the journey to Dulwich to savor the full experience of the gallery and its unique collection. In the meantime it is a great pleasure to all of us associated with the gallery that the greatest works from the collection should still be enjoyed during closure by the people of the United States.

DESMOND SHAWE-TAYLOR
Director, Dulwich Picture Gallery

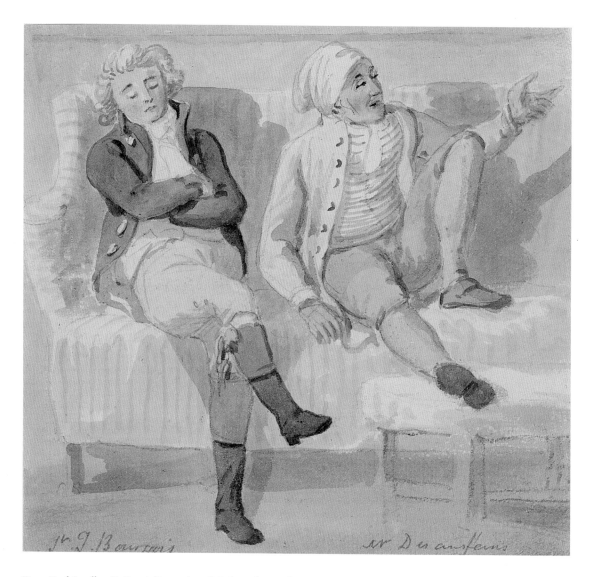

Fig. 1 Paul Sandby, *Sir Francis Bourgeois and Noel Joseph Desenfans, ca.* 1805,
watercolor on card, 5⅝ × 6 in. (14.3 × 15.3 cm)
Dulwich Picture Gallery Archive

Sandby's watercolor captures the easy informality of the two
"gentleman-dealers" entertaining at their home in Charlotte Street.

A History of Dulwich Picture Gallery

Giles Waterfield

The two principal founders of the Dulwich collection (fig. 1), Noel Desenfans (1744–1807) and Francis Bourgeois (1756–1811), were well known in their day in the artistic world of London; indeed, they were notorious, and the numerous references to them in contemporary newspapers, pamphlets, and diaries are by no means universally flattering. Neither was English by origin; both came from relatively obscure backgrounds, and both, whether as collector or practitioner, used art as a means of social advancement. Desenfans remarked in the preface to a sale catalogue of 1802 that it was only through the fine arts that the untitled could hope to achieve distinction in society, and such distinction was something both of them craved. In life they sought fame through exhibitions and intrigues at the Royal Academy, through auctions, collecting, and manipulation of the press; in death they pursued the same aim by a bequest, and finally achieved what they desired.

NOEL DESENFANS

The most substantial source for the early life of Desenfans (fig. 2) is the *Memoir* written in 1810 by "JT," presumably his friend John Taylor, a journalist and author. It is not a particularly reliable source, being a panegyric and tending to exaggerate and even falsify. Desenfans was born in 1744 in Douai, to parents of whom nothing is known; the rumor that he was a foundling appears unjustified, since in later life he made a regular allowance to a relation in Paris, continued by his wife in her will. Douai, a town about twenty-five miles south of Lille in northeast France, was best known in the eighteenth century for its ancient university, where Desenfans received his education. By the 1750s the university was somewhat in decline, but it introduced him to such lasting friends as John Philip Kemble, later a great tragic actor on the English stage, and to Charles-Auguste de Calonne, who was to become first minister of France in the 1780s and a major collector of paintings. According to the *Memoir*, Desenfans won every important prize at Douai, and achieved equal success at the University of Paris, which he attended from the age of eighteen. In Paris he embarked on a literary career with *L'Élève de la nature*, a work which, we are told, won him the approval of Jean-Jacques Rousseau.

Douai had an old association with England through its Catholic English College, and it may have been this connection that encouraged the young man in 1769 to seek his fortune in London. He worked as a teacher of languages before establishing himself by marriage. On June 10, 1776, at the age of thirty-one,

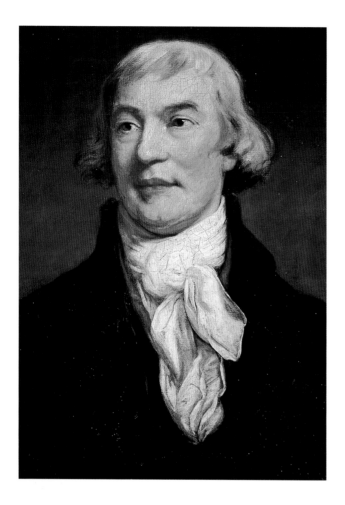

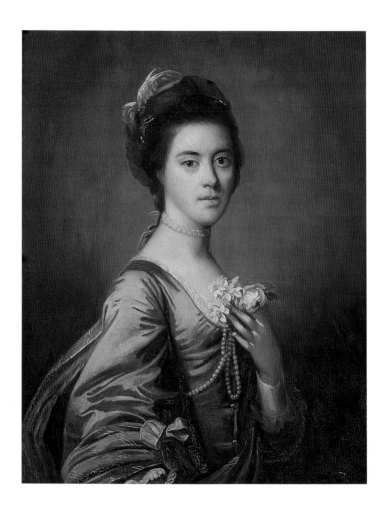

Fig. 2 (left) James Northcote, *Noel Joseph Desenfans*, 1796, oil on canvas, 28⅞ × 24 in. (oval, 73.3 × 60.9 cm; detail)
Dulwich Picture Gallery

Fig. 3 (right) Moussa Ayoub after Joshua Reynolds, *Miss Margaret Morris, later Mrs. Desenfans*, 1938, oil on canvas, 29⅞ × 25 in. (75.9 × 63.5 cm)
Dulwich Picture Gallery

This is a copy of a lost portrait by Reynolds painted in 1757 when Margaret Morris (1737–1814) was in her twenties.

Desenfans was married at Saint Marylebone Parish Church to the aunt of two of his pupils – a woman aged forty-five by the name of Margaret Morris (fig. 3). It appears to have been a hasty marriage and is unlikely to have met with the approval of the Morrises, from Swansea in South Wales, who had recently become prosperous through the rope trade and had been granted a baronetcy. Margaret Morris had the advantage of a respectable private income (though not the capital sum of £5000 traditionally attributed to her). She evidently settled without complaint into the role of unobtrusive wife: almost no descriptions remain of her beyond Taylor's comment, after her husband's death, "It is enough to say that her mind and heart fully entitled her to such a husband, and [she] too well proves her sense of his worth, by inconsolable regret."

Desenfans set himself up during the 1770s as a picture dealer and made, at least until the 1790s, a fair amount of money. His knowledge of art was limited: several anecdotes are told of tricks being played on him (in one case by Joshua Reynolds) in which he was induced to enthuse over or buy modern forgeries of old masters. His judgment was especially exposed by a spectacular and absurd legal case in 1787, when he sued a rival dealer and personal enemy, Benjamin Vandergucht, for selling him a false Poussin. Desenfans won the case, in which most of the leading artists in London appeared as witnesses, but his reputation cannot have been enhanced. In a London where picture collecting was becoming increasingly popular, but where most collectors were more interested in famous names than in quality, Desenfans was assisted by a number of factors, especially his close

business relationship with Jean-Baptiste-Pierre Lebrun (1748–1813), his friendships with such important Frenchmen as Calonne, and the active assistance of Francis Bourgeois.

Married, though unhappily, to the portraitist Elisabeth Vigée Lebrun, Lebrun was one of the most remarkable connoisseurs and dealers of his time, and in many ways Desenfans modeled himself upon this compatriot. The two friends collaborated for a long period; Lebrun wrote after Desenfans's death, "Never again could I find such a partner as my friend Desenfans with whom I conducted business for thirty years to our mutual satisfaction." Lebrun lived in considerable style in a house in the rue de Cléry in Paris. There he built a gallery, which housed his personal collection, from which several pictures were sent to London for sale by Desenfans in 1789. Lebrun was given to writing extended catalogues for his sales and presenting himself as a connoisseur who only incidentally dealt in paintings. In all these respects Desenfans imitated him. Desenfans, too, kept a large house with a major collection, which, for much of the time, he claimed to regard as his personal one; he, too, wrote a long catalogue to accompany his sale of 1802, and he, too, liked to be seen as a gentleman rather than a dealer. In the 1780s a newspaper scathingly remarked of him, "A certain foreign gentleman who is said to be a great encourager of the arts has found that secret of dealing pictures without passing as a *dealer*, of exhibiting them without *being an exhibitor*, and of heaping money without passing for a monied man."

Lebrun also regularly furnished his London colleague with important pictures, including Murillo's *Flower Girl* (cat. 18), Poussin's *Triumph of David* (cat. 26), and *Les Plaisirs du bal* (cat. 33) by Watteau. Lebrun's paintings were sold by Desenfans by private arrangement or at auction and the proceeds were divided equally between the two. Desenfans had other suppliers, such as Gavin Hamilton, the well known Scottish artist-collector in Rome, but Lebrun was by far his most fruitful connection.

FRANCIS BOURGEOIS, R.A.

The other major influence on Desenfans was his friend and collaborator Francis Bourgeois (fig. 4). Bourgeois was the son of Issac (*sic*) Bourgeois, a Swiss, and of Elizabeth Gardin, an Englishwoman. Issac, probably the child of that name baptized in the Huguenot Church in London in 1707–08, was a descendent of a Swiss family, originally from Yverdon in the Vaud, but living in London. He appears to have practiced as a watchmaker in Saint Martin's Lane. According to Benjamin West (reported by Farington), Bourgeois senior, on the death of his wife, "quitted England and left the two children [there was a sister] here unprovided for. Desenfans by some means became with others interested in the fate of these children to whom he was in no way related." The daughter was sent to Switzerland and young Francis became the charge of Desenfans. Farington recorded a conversation with Bourgeois in 1805 in which he recalled having been with Desenfans from the age of ten. This precarious early life is at variance with the "official" biography presented in *Public Characters of 1799–1800*, in which Bourgeois is depicted as "destined by his father to the profession of arms in consequence of the friendship entertained for the family by the late Lord

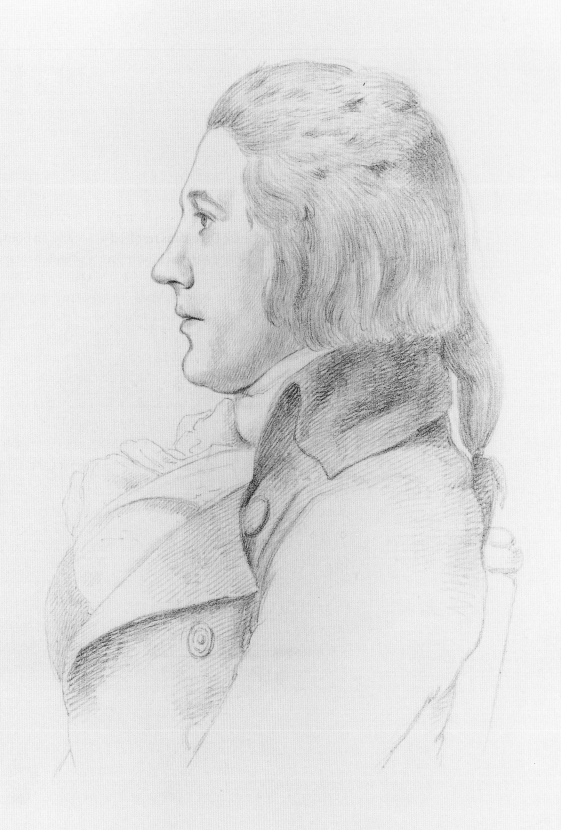

Sir Francis Bourgeois

Heathfield," who had supposedly promised the boy a commission. Such a discrepancy is typical of the hyperbolic early accounts of the lives of these two men.

Desenfans, fascinated by the power of art, decided that his protégé Francis Bourgeois should become a painter. He was sent as a pupil to De Loutherbourg, the gifted French artist who had lived in London since 1771. His style shaped that of Bourgeois, though he also, by his own account, learnt from nature. In 1776 he was sent by Desenfans on a grand tour of France, Italy, and Switzerland. On his return he moved back into the Desenfans household, and stayed with his benefactors for the rest of his life.

BOURGEOIS AND THE ROYAL ACADEMY

Desenfans was determined that his friend should make a reputation as an artist. Positions at court and membership of the Royal Academy constituted official recognition, and these Desenfans resolved to achieve on Bourgeois's behalf. He worked hard on publicity, frequently inserting complimentary paragraphs in newspapers, notably *The London Chronicle, The Morning Herald*, and *The World*. A comment from *The World* of May 7, 1791, is characteristic: "From the crowds which daily encircle the celebrated picture of *The Convicts*, by Sir F. Bourgeois at the Exhibition at the Royal Academy, you continually hear the observation 'And is it possible that this Painter can have been excluded from the Royal Academy?'"

Bourgeois was not excluded for long. His first attempt at election as associate of the Royal Academy at the age of twenty-five was not a success (he received no votes), but in 1787 he did become an associate, and in 1793 the academicians, fortified, it was rumored, by Desenfans's hospitality, elected him (after four ballots) to full membership. His position was further assured by appointments as painter to the King of Poland in 1791, and in 1794 as landscape painter to King George III of England.

Dulwich Picture Gallery possesses twenty-one paintings by Bourgeois (see fig. 5). Late in the nineteenth century several of them hung in the gallery mausoleum; now (with one exception) they do not hang at all. His talent, except for a dashing

Fig. 4 George Dance, *Sir Francis Bourgeois*, 1798–1800, graphite and red chalk on paper, 9¹⁄₁₆ × 7¹⁄₁₆ in. (23 × 18 cm) Dulwich Picture Gallery Archive

George Dance's profile portrait (part of a series of heads of distinguished men) conveys something of Bourgeois's "pleasing countenance," as one contemporary described it.

Fig. 5 Francis Bourgeois, *William Tell, ca.* 1795, oil on canvas, 30¼ × 43¼ in. (76.8 × 110.2 cm) Dulwich Picture Gallery

In a rare reference to his Swiss ancestry, Bourgeois shows the champion of Swiss liberty about to shoot an apple off his son's head.

virtuosity in some of his sketches (he tended to imitate the freely executed "hot" manner of De Loutherbourg), was inconsiderable. Many of the reviews of his works shown at the Royal Academy reflect contemporary skepticism, his coloring being found particularly offensive. In May 1794 *The Morning Post* declared his *Sans Culottes* the worst picture in the Academy exhibition, adding: "Sir Francis Bourgeois last year exhibited a penny ride in the Royal Academy. We wish that this year he would treat himself to a pennyworth and gallop out of the exhibition." Nonetheless, he established a fair reputation. His works were bought by the Royal Family, Joshua Reynolds, John Soane, and such major collectors as Lord Methuen for Corsham and Lord Egremont for Petworth House; and he received commissions from the King of Poland and the Empress of Russia.

Fig. 6 John Britton, *Charlotte Street House Inventory: The Skylight Room*, 1813, ink on paper
Dulwich College Archive

This illustrated inventory shows how the Bourgeois-Desenfans collection of 360 paintings was hung in its cramped Charlotte Street home. The Skylight Room anticipates Soane's top-lit galleries and was used to hang the very largest paintings (the Veronese and two Murillos (cat. 1, 19 and 20) are visible on this page).

THE HOUSE IN CHARLOTTE STREET

After a number of moves, the Desenfans family and Bourgeois settled in 1786 in a fashionable new house combining nos. 38 and 39, Charlotte Street, Portland Place (now Hallam Street). The house (now demolished) was at the end of the street, beside open country. Two inventories of its contents, made in about 1802 and in 1813, reveal the spaciousness of the interior, with a saloon, a parlor and ante-room, a drawing room, a dining room, a "Berchem Room" and a "Cuyp Room," a little parlor with an adjoining closet, and a "Skylight Room" at the top for the largest pictures (fig. 6). At its peak, this domestic display of old masters must have been spectacular: 360 paintings crowded within the house, fourteen Poussins in the dining room, twelve Cuyps in the library, and, in the Skylight Room, Reynolds's *Mrs. Siddons*, a nine-footer, which was hung above a picture seven feet in height. Bourgeois and Desenfans were enthusiastic hosts, giving many dinner parties, from which, even when the company was mixed, Mrs. Desenfans was absent.

Their circle of friends was important to the two men, and they were at pains to expand it. It included representatives of the theater, especially John Philip Kemble; of painting and architecture, such as Sir William Beechey, Joseph Farington, Benjamin West, and Sir John Soane; and of literature, including the writers John Taylor and James Boaden. What it lacked was representatives of high society. Desenfans was on friendly terms with such figures as the king's brother, the Duke of Gloucester, for whom he acted as agent, and in 1786 his collection was visited by the Royal Family, but he could not claim the aristocratic intimates whose attention he craved. His habit of leaving tickets for his box at the opera or the circus with members of the nobility was not received with enthusiasm. Though both Desenfans and Bourgeois were well known, they seem to have been viewed with skepticism and some hostility in society. Leigh Hunt's account of meeting Bourgeois may be regarded as typical: "He was in buckskins and boots, the dandy dress of that time; and appeared to us a lively, good-natured man, with a pleasing countenance. Ever afterwards we had an inclination to like his pictures, which we believe were not very good; and unfortunately, with whatever gravity he might paint, his oath and buckskin would never allow me to consider him a serious person" (*The Companion*, June 25, 1828).

DESENFANS AND BOURGEOIS AS DEALERS

During the 1780s Desenfans and Bourgeois worked closely together. Their co-operation was such that it is misleading to regard them as possessing separate collections, particularly as the money was Desenfans's. They held a number of sales at Christie's, most notably one on April 8, 1786, which included Holbein's *Henry VIII Delivering the Charter to the Surgeon Barbers' Company of London* (Royal College of Surgeons, London) and works from the Palazzo Barberini in Rome, especially Claude's *Saint Ursula* (now in the National Gallery, London). The catalogue to this "Truly Superb, and well-known collection" was characteristically flowery. By 1790 Desenfans was a familiar name in the London art world, and it was not surprising that when, in that year, Prince Michael Poniatowski, brother of the King of Poland (fig. 7), spent a few months in London, he should have made

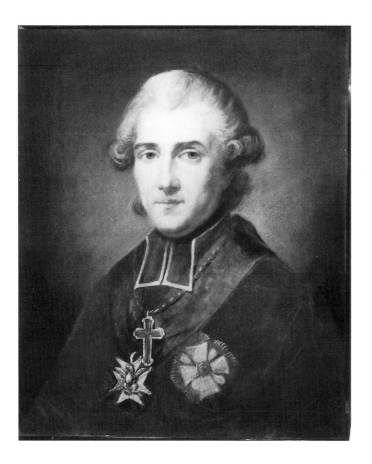

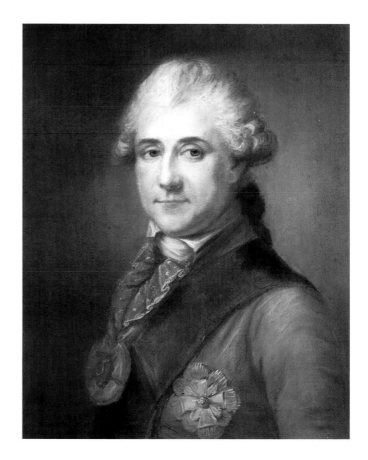

Fig. 7 (left) After Marcello Bacciarelli, *Michael Poniatowski, Prince of Poland*, pastel on paper, mounted on canvas, 24 × 19¹⁵⁄₁₆ in. (60.9 × 50.6 cm)
Dulwich Picture Gallery

Michael Poniatowski (1736–1794) met Noel Desenfans in London in 1790 and recommended him to his brother, the King of Poland, as the man best placed to form a Polish royal collection.

Fig. 8 (right) After Marcello Bacciarelli, *Stanislaus Augustus, King of Poland*, pastel on paper, mounted on canvas, 24 × 20 in. (60.9 × 50.8 cm)
Dulwich Picture Gallery

Stanislaus Augustus Poniatowski (1732–1798) was King of Poland from his election in 1764 until his abdication upon the partition of Poland in 1795. Had his kingdom survived, the Dulwich Collection might now be hanging in Warsaw.

the acquaintance of this well-known dealer; or that he should have asked Desenfans to abandon commerce and devote himself to assembling old masters for the Polish king in order, according to the *Memoir*, to "promote the progress of the fine arts in Poland." Desenfans, realizing the possible advantages, agreed, and from 1790 to 1795 dedicated himself to that task.

STANISLAUS AUGUSTUS, KING OF POLAND

In the late eighteenth century Poland was in a particularly difficult position: economically seriously underdeveloped, dominated by Russia, and ruled by a king whose powers were severely limited, with a parliament in which proposed legislation on matters of state could be rejected by a single negative vote. It appeared in 1792 to an English visitor, Archdeacon Coxe, "of all countries the most distressed." In the early part of the century Poland had been governed by the Electors of Saxony, acquiring a superficial Western European flavor. From 1764 to 1795 the king was a Pole, Stanislaus Augustus Poniatowski (1732–1798; fig. 8), who wished to introduce Western ideas more conclusively. Stanislaus was a man of the Enlightenment: in his youth he had spent six years traveling in the West, and he retained strong links with France and England. He had also presumably been enlightened by a youthful spell as one of Catherine the Great's lovers. Frustrated to a large extent in his administrative ambitions, he worked to create a "new Poland" (a favorite expression for the king and his circle) through the arts.

Stanislaus was helped by the easy charm of his manners and by the interest already apparent among some of the Polish nobility in French, Italian, and English civilization. He was the most active patron of his time in Poland, in both

architecture and painting, and aimed to establish a native school of painting, aware of the most advanced Western tastes. A "school" of architecture has been named after him, a Neoclassical style first proposed by the French architect Victor Louis, who visited Warsaw in 1765, and developed by the Italians Domenico Martini and Jacopo Fontana.

Though the king was generally short of money, he erected such country retreats as the Lazienki Palace (fig. 9), from 1775 to 1795, and remodeled the State Rooms in the Royal Castle in Warsaw (destroyed in World War II and now restored). He invited foreign artists to his court, where a number spent extended periods and others visited for short lengths of time *en route* for Saint Petersburg, where royal patronage of Western artists was also strong. They included Jean-Baptiste Pillement, Bernardo Bellotto, and, in particular, Marcello Bacciarelli, who became the king's favorite portraitist and supervisor of artistic activity at court.

A NATIONAL GALLERY FOR POLAND

Stanislaus's collecting was assisted by the agents who acted for him in all the major cities of Europe, including Paris, Rome, Naples, Genoa, Venice, and Florence. In many cases these agents were his diplomatic representatives, such as the Marchese Antici, Polish *chargé d'affaires* in Rome; they tended to be rewarded not with money but with titles and portraits of their patron. Eager to establish a school of Polish art, Stanislaus sent young practitioners on allowances to France and Italy, and provided free instruction in art in the Royal Castle. His personal collection was extensive, being numbered in 1795 at 2289 paintings and 30,000 prints, though many of the pictures were copies, bought as such for didactic purposes. The collection was especially rich in the works of Rembrandt, Rubens, and Van Dyck.

Like Antici, Desenfans was to combine the roles of diplomat and dealer. He, too, was rewarded with a title – consul-general of Poland and colonel of the Royal Guard – while Bourgeois received a knighthood, which King George III of England recognized. Portraits of Stanislaus and of Prince Michael were sent to Desenfans, probably in 1795. In terms of social standing the new position was ideal for Desenfans: as he explained in his Memorandum of 1801 to the Tsar of

Fig. 9 Lazienki Palace, Warsaw
Stanislaus's suburban retreat, set in an English garden, was built in 1784 by one of his favorite architects, Dominik Merlini.

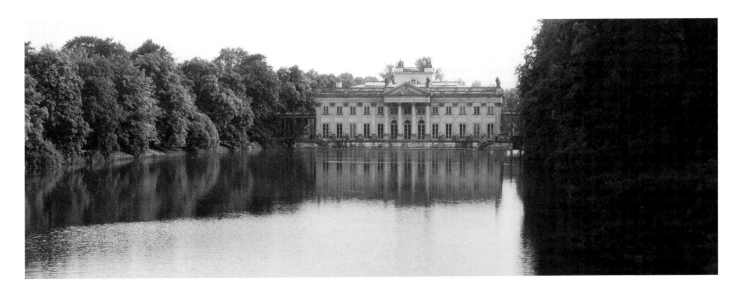

Russia, he gave up "commerce" for the dignified task of collecting for a king, and his new post was recorded in all his subsequent publications and announcements. Financially the new arrangement was less satisfactory. In 1793 Desenfans found himself obliged to pay the debts of Chevalier Bukaty, the Polish ambassador, and only £1300 of the loan of £1800 was repaid by Stanislaus. He later felt it his duty to give financial assistance to a number of Poles in exile.

The 1790s were an especially suitable time for the formation of a major art collection in London. Important paintings were entering Britain in larger numbers than ever before, partly because of the activities of agents working on behalf of British dealers, purchasing works of art from the nobility and religious communities in Italy for sale in England, and partly on account of the collections sent over from France for sale in London as a result of the French Revolution. Desenfans profited from both sources. Veronese's *Saint Jerome and a Donor* (cat. 1), for example, was a large altarpiece bought from a family chapel in North Italy by an unknown agent in the 1790s, then cut into several fragments to appeal to buyers. The most notable French aristocratic collections to be sold in London in the 1790s were those of the duc d'Orléans, from which ultimately came Wouwermans's *Halt of a Hunting Party* (cat. 70) and Le Brun's *Massacre of the Innocents* (cat. 29), and of Charles-Antoine de Calonne. Calonne employed Desenfans to

Fig. 10 Claude-Joseph Vernet, *Italian Landscape*, 1738, oil on canvas, 48⅝ × 68⅜ in. (123.8 × 174 cm)
Dulwich Picture Gallery

This is one of the many paintings Desenfans acquired from French aristocrats fleeing the Revolution.

handle the 1795 sale of his collection, arranged on behalf of needy French émigrés. At this sale Desenfans bought a number of extremely important works, notably Poussin's *Triumph of David* (cat. 26), Murillo's *Flower Girl* (cat. 18), Rembrandt's *Portrait of a Young Man* (cat. 50), and Vernet's *Italian Landscape* (fig. 10). By 1795 Desenfans had assembled a remarkable group of pictures, including examples of all the major artists of the past admired at the time, though contemporary art was less well represented. The Polish king's tastes, for Van Dyck and Rubens, Charles Le Brun, Gaspard Dughet, and Rembrandt, were naturally taken into account and Desenfans's purchases were closely supervised from Poland.

The pictures never reached Poland. In 1795 the country was partitioned for the third and final time, among Russia, Prussia, and Austria. Stanislaus was forced to abdicate, and Desenfans was left with over 180 pictures on his hands.

DESENFANS'S EFFORTS TO DISPOSE OF THE POLISH COLLECTION

Desenfans claimed to have spent £9000 on pictures for Poland between 1790 and 1795, and to have given up other business worth £2000–3000 per annum. For some time he hoped that the abdicated king, who he expected would settle in Italy, would purchase the paintings, but the death of Stanislaus in 1798 put paid to that hope. Through the half-hearted mediation of the British ambassador in Saint Petersburg, Desenfans wrote in 1798 to the tsar, Paul I, who had undertaken to pay Stanislaus's debts, asking for repayment of the remaining sum owed him by the former Polish ambassador. He wrote again in 1799, suggesting that the Russian government might like to buy the entire collection, strengthened by some Italian pictures, for the amount it had cost him. In 1801 yet another memorandum was sent, to the new tsar, Alexander I, detailing his expenses and losses resulting from the Polish connection and again suggesting that the tsar should acquire the pictures. This was a less unlikely scheme than it might seem, since in 1779 Catherine the Great had acquired the collection of Sir Robert Walpole from Houghton Hall. This time the tsar did not even reply to the letter.

In 1802 Desenfans held an auction of the paintings acquired for Poland at the premises of Skinner & Dyke in Berners Street. It was preceded by an exhibition lasting ten days, for which tickets were sold, and was announced in impressive terms in Desenfans's catalogue, a two-volume work with long explanatory texts. It is a quaint publication, revealing the writer's excitable naïveté and his strong personal animosities. He used his sale catalogue as a platform from which to comment on the excellence of French connoisseurs, and on the jealous character and general mediocrity of English "experts." This exercise was foolishly self-indulgent. The auction was not a success and relatively few of the pictures were sold – hardly surprising in view of Desenfans's vitriol and the unpredictable nature of the British market. (The letters of a leading dealer of the period, William Buchanan, reveal the relative scarcity of English buyers at the time, made cautious by the wars against France, and their fondness only for "pleasing" subject matter). It seems likely that many of the pictures were bought in.

A letter from Desenfans to Bejamin West of around 1803 reveals the events that first led to the bequest to Dulwich. Desenfans writes that he has been "full of troubles & anxieties" and is "at the eve of parting with Sr Francis … I am forc'd to

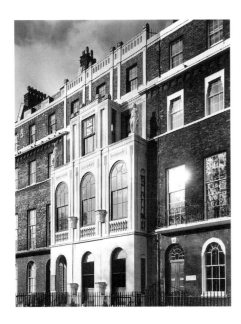

Fig. 11 Sir John Soane, *No. 13, Lincoln's Inn Fields* (*Sir John Soane's Museum*)

Soane bequeathed his house and collection as a museum. Sir Francis Bourgeois tried to do the same with his Charlotte Street house but was prevented by his landlord, the Duke of Portland.

take these steps I am now about, if I will not Be reduced to Beggary Such is his passion for pictures, that it will render him miserable, and makes it now impossible for me, to continue with him." He describes how Bourgeois had persuaded him to keep the pictures intended for Poland, and many more, including "a few costly pictures" from the Calonne collection. Sir Francis had promised to buy no more, but "he has been since, at every sale & every picture Room, where, like a child who wishes for everything in a toy shop, he has been buying whatever he saw; to put where? in my garret. One day, 'tis one Hundred guineas for a Guercino, the next three Hundred for a Venderwerff ..." Since "last December" Bourgeois had spent over £2000 on his "whimsical purchases." Desenfans and Bourgeois never did part company, but the letter shows the very strong involvement of Bourgeois in their purchases (Desenfans was, in his last years, kept mostly at home by a nervous ailment) and his determination not only to keep the collection intact but to embellish it. It seems likely that the idea of leaving the pictures as a permanent collection originated not with Desenfans but with his friend.

Desenfans died in 1807, having in 1803 made a will that left his property jointly to his wife and Sir Francis, apart from the pictures, which were bequeathed exclusively to Bourgeois. The artist felt himself obliged by Desenfans's parting wishes, as he stated in a letter of January 1810 to the Duke of Portland, to find a way of making the collection "conducive to the advancement of a Science to which his anxious views and unremitting labours had been invariably directed."

Bourgeois's first idea was to maintain the collection in the Charlotte Street house, but his request in 1810 to the landlord, the Duke of Portland, to be allowed to purchase the property so that the house "may be gratuitously open ... to artists as well as to the Publick," was abruptly refused. According to Farington, who visited Bourgeois on December 13, 1810, he had rejected his first idea of leaving the paintings to the British Museum because of the arbitrary "aristocracy" governing that institution, which might not keep the collection intact, and had decided instead to bequeath his pictures to the venerable institution of Dulwich College. By his will, dated December 20, 1810, he left his pictures to Mrs. Desenfans, on condition that after her death they should go to the college. Bourgeois, at the time he made the will, had been injured by a fall from his horse, and the decision may well have been made in haste. He died two weeks later.

MUSEUMS IN REGENCY ENGLAND

An interest in the creation of museums, and especially of a national gallery, is a recurrent theme in England in the late eighteenth and early nineteenth centuries. The opening in Paris of the Louvre in 1793 had a powerful effect in London. Such prominent artists as two presidents of the Royal Academy, Joshua Reynolds and Benjamin West, canvased for a national gallery; so did politicians such as Richard Brinsley Sheridan and Charles James Fox, and dealers including William Buchanan and Desenfans himself. In 1799 Desenfans had published *A Plan for Establishing a National Gallery*, an ingenious proposal for adding picture galleries to Montague House (the then British Museum), in which both contemporary works and old masters would be on view. He canvased on behalf of his plan at the Royal

Academy, but the government was not enthusiastic. Numerous collectors, artists, and architects reacted against such official indifference by creating their own galleries in their London houses, to which the respectable public was admitted – among them, Thomas Hope, John Nash, and Sir John Soane (whose house in Lincoln's Inn Fields remains open to the public; fig. 11). The house in Charlotte Street had very much the character of a private museum of this type. Bourgeois was generous with invitations, especially to young artists, such as David Wilkie, who visited in 1805.

DULWICH COLLEGE

In the early nineteenth century Dulwich College was a prosperous and indolent institution, better known for its hospitality than for educational zeal. The college had been founded in 1619 by the actor-manager Edward Alleyn (1566–1626; fig. 12), lord of the Manor of Dulwich, an urbane individual with connections at court. His institution was intended to shelter the old (there was accommodation for six "Poor Sisters" and six "Poor Brothers") and to educate the young (twelve "Poor Scholars"), but by the early nineteenth century the officers appointed to this task – master, warden, and four fellows – were content to exercise minimal supervision. In 1814 an account commented that "for many years past" no boy had been educated for university. By the early nineteenth century the college was not only notorious for its inactivity but was also partially in collapse physically.

From Bourgeois's point of view, the college (figs. 13–15) seemed an appropriate beneficiary. As a visiting surveyor described Dulwich in 1808, "The estate for its entirety, the beauty and variety of its views … is scarcely to be equalled … It is embosomed in a rich and fertile vale, whose surface is varied by detached eminences and is thus secluded … from the bustle and activity of trade and commerce, from the noisome air of manufactures and the 'busy hum of men.'" One of the reasons why Bourgeois settled on Dulwich was indeed the freshness of the air, which he felt would benefit the pictures. The governing body was known for its "urbanity" and "liberality of mind" – especially Lancelot Baugh Allen, who was master (from 1811); J.T. Smith, senior fellow, described by Horace Walpole in 1791 as "a smart divine … *très bien poudré*"; and the gentlemanly third fellow, the Reverend Robert Corry. Corry was on friendly terms with Bourgeois, probably through their mutual friend the actor J.P. Kemble.

The choice of Dulwich may also have been prompted by the fact that the college already possessed a picture gallery, with a large collection of old master paintings described by Horace Walpole as "a hundred mouldy portraits among apostles, sibyls and kings of England." These came from the collection of the founder Edward Alleyn and of actor and bookseller William Cartwright (1606– 1686; fig. 16). Although only a third of Cartwright's collection reached Dulwich, these eighty or so paintings constitute an important record of the taste of a man of moderate wealth in the seventeenth century.

THE CHARACTER OF THE COLLECTION

The pictures bequeathed to Dulwich College constitute a collection in the grand taste of the early nineteenth century. Most of the great Regency collections made

Fig. 12 British School, *Edward Alleyn*, 1626, oil on canvas, 80¹⁄₁₆ × 44¾ in. (203.8 × 114 cm) Dulwich Picture Gallery

Edward Alleyn (1566–1626) was the playwright Christopher Marlowe's leading man, creating, among others, the role of Doctor Faustus. With the fortune he made as a theatrical entrepreneur he purchased the Manor of Dulwich in 1605 and in 1619 founded the College of God's Gift, later known as Dulwich College.

Fig. 13 Dulwich College in 1790, from the north: "The Old College"

This is the college Soane knew and which he planned to extend to the south. The gallery as built runs south beyond the southwest corner of the block, approximately in line with the right hand (west) range visible here (see fig. 15). The giant Doric piers of the college south range probably dictated the similar articulation of Soane's gallery building.

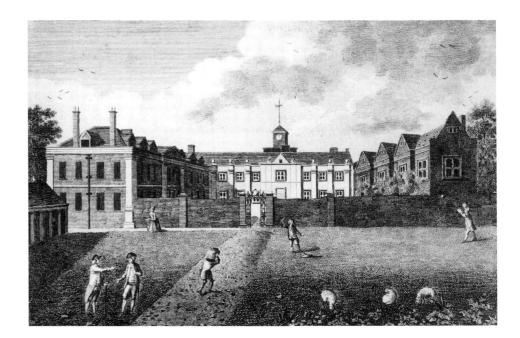

Fig. 14 Dulwich College in 1846, from the north: "The Old College"

Comparison with the previous illustration shows how the college became thoroughly gothicized in the early nineteenth century. The east range was remodeled in 1831 by Sir Charles Barry, who later designed the Houses of Parliament.

Fig. 15 Dulwich College, *ca.* 1840, from the south: "The Old College"

This engraving shows the rear façade of the south range of the college when the main quadrangle appeared as in fig. 14 (the top of the tower is just visible). On the extreme left is visible the corner of Soane's gallery.

Fig. 16 John Greenhill, *William Cartwright,*
oil on canvas, 40½ × 33⅜ in. (102.8 × 84.9 cm)
Dulwich Picture Gallery

In 1686 William Cartwright (1606–1686), an
actor and bookseller, bequeathed the major part
of his estate, including a collection of pictures, to
Dulwich College. Eighty of these are still
identifiable in the collection.

Fig. 17 Piero di Cosimo, *A Young Man, ca.* 1500,
oil (?) on poplar panel, 16¼ × 16⅛ in.
(41.2 × 41 cm)
Dulwich Picture Gallery

A much older picture than the rest of the
Bourgeois-Desenfans collection, this panel was
bought as a Leonardo da Vinci, presumably in
order to add this talismanic name to the list.

in England have been dispersed; where they survive they are generally submerged
within much larger holdings, for example the Angerstein or Beaumont pictures
in the National Gallery, London, or the Prince Regent's collection. The Dulwich
paintings, housed as they are in a contemporary gallery built to contain them,
represent, as a group, a highly important document of taste from 1790 to 1810.

What the present-day visitor sees is not only the Bourgeois collection, nor is it
precisely the group of paintings bought for the King of Poland, since only fifty-six
of the pictures in the 1802 sale can be identified as Dulwich pictures. Bourgeois
continued to buy and sell with the same objectives as lay behind his Polish
venture, namely to assemble an exemplary gallery for the inspection of the
public. The collection as left in 1811 contained some 350 pictures, of which over
one hundred are nowadays not on view. From the study of old inventories (rather
than of modern catalogues) it is clear that Bourgeois was intent on putting
together a representative collection of the artists most admired at the time.

In many ways the selection was traditional, looking back to eighteenth-century
taste as established in England by the Grand Tourists. Italian art, which, as
Desenfans recognized in his 1802 catalogue, presented particular difficulties for
English collectors, has turned out to be the weakest school at Dulwich, in quality
though not in numbers. The sixteenth-century Venetian school was represented,
theoretically, by Titian and Veronese. There were thirteen works by the Carracci
(most of them no longer accepted) and seven by Guido Reni (only two now

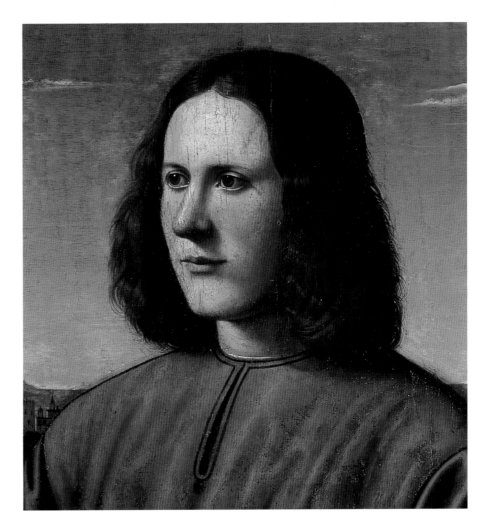

25

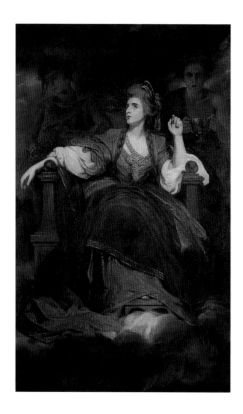

Fig. 18 Joshua Reynolds, *Mrs. Siddons as the Tragic Muse*, 1798, oil on canvas, 94⁵⁄₁₆ × 58⅛ in. (239.7 × 147.6 cm)
Dulwich Picture Gallery

An autograph copy painted for Noel Desenfans in 1789, this is one of the very few modern English paintings in the original Bourgeois bequest.

accepted). The list boasts three works by Leonardo da Vinci (one now attributed to Piero di Cosimo [fig. 17], the others unattributed). Correggio, Caravaggio, Andrea del Sarto, and Raphael were all included in theory, though Bourgeois did not lay claim to a Michelangelo.

The strength of the collection lies in the Dutch, Flemish, and French schools, also bought on generally traditional principles. Van Dyck (thirteen in the collection), Rubens (twenty), and Teniers (twenty-two) were the most popular Flemish artists. Although vernacular Dutch landscape painters such as Ruisdael and Hobbema contributed a few works, the taste of the eighteenth century is reflected in the very strong assembly of decorative Italianate landscapes: numerous paintings, mostly of high quality, by Cuyp (eighteen), Philip Wouwermans, Berchem, Both, and Dujardin. Low-life cabinet pictures, much esteemed at the time, are less fully represented in a collection of which the creators were conscious, perhaps, of the need to maintain dignity. As for the French school, pride of place went to an artist who was very popular and expensive at the time: Nicolas Poussin. Though of the seventeen pictures originally attributed to him only seven are now accepted, they still comprise one of the most important existing groups of work by this artist. Claude Lorrain, the other favorite French artist among English noble collectors, was represented by eight paintings, of which only two are still thought to be his.

Not all the paintings were by artists of the past, and the selection made by Bourgeois and Desenfans of contemporary works is very revealing. Desenfans was known for his attacks on living British artists, whom, like many others, he regarded as inferior to painters of earlier centuries. Of the forty works by Desenfans's contemporaries, twenty-one are by Bourgeois, reflecting the two collectors' determination to raise him to the status of a major artist. A number of pictures are portraits of Desenfans or Bourgeois (though they did not trouble to have Mrs. Desenfans commemorated) and of their close friends: De Loutherbourg, J.P. Kemble, the painter John Opie, and Pybus C.S. (Pybus) MP, a banker and business partner of Desenfans. Gainsborough features merely as the portraitist of De Loutherbourg (cat. 89). The only British painters included by Bourgeois for works other than portraiture were, apart from himself, Richard Wilson and Reynolds. Wilson, an artist whose reputation had risen sharply in the 1790s, is represented by one landscape (cat. 85), while Reynolds emerges as the only painter considered by Bourgeois and Desenfans as on a par with the old masters. The works by Reynolds in the gallery are, on the whole, not portraits but essays in historical painting: *The Death of Cardinal Beaufort* and *Mother with Sick Child*. The most striking is the large *Mrs. Siddons as the Tragic Muse* (fig. 18), more history painting than portrait. The original (now in the H. Huntington Art Gallery) was regarded by many contemporaries as the artist's greatest work, and was so much desired by Desenfans that, unable to buy it, he commissioned a second version in 1789 from the artist for the large sum of £735.

SIR JOHN SOANE

With his paintings, Bourgeois left Dulwich College an endowment of £10,000 and the sum of £2000 for erecting a new gallery, on the death of Mrs. Desenfans.

She was eager for work to begin at once, as she made clear to the master of the college: "The only consolation [she could] receive in this life [would] be to see the wishes and intentions of her dear Friend Sir Francis Bourgeois carried into effect in the most compleat and expeditious manner." Since she was willing to surrender possession of the pictures as soon as a gallery had been built to receive them, preparations began at once.

In his last illness, Bourgeois had expressed a wish to the master of Dulwich College that the architect of the new gallery should be Sir John Soane (1753–1837; fig. 19). Soane was one of the best-known architects of the period in Britain, holding several official positions, including the surveyorship of the Bank of England. The rebuilding of the bank, from 1788 to 1833, was the major achievement of his career (although, as is the case with many of his works, little of the original structure survives). He also designed numerous public buildings and private houses, including his own House and Museum in Lincoln's Inn Fields,

Fig. 19 Thomas Lawrence,
Sir John Soane RA, *Aged Seventy-six*, 1830, oil on canvas, 153½ × 43½ in. (390 × 110.5 cm)
Sir John Soane's Museum

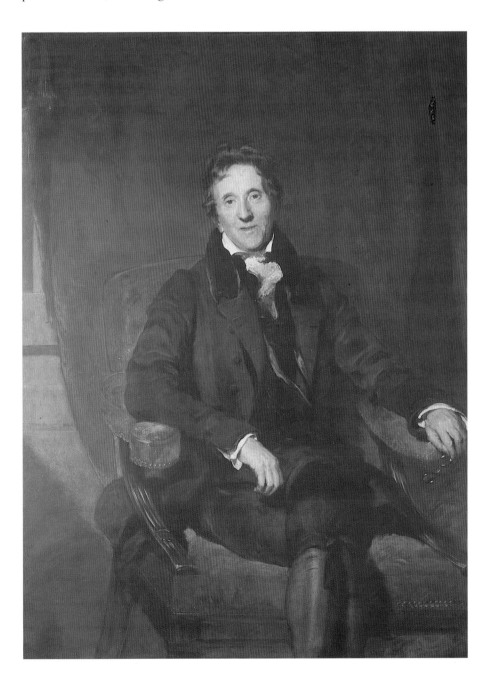

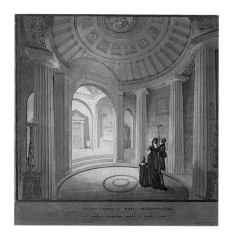

Fig. 20 Sir John Soane, *Desenfans Mausoleum, 38 Charlotte Street*, 1807, pencil, pen and ink, and watercolor, 25⁹⁄₁₆ × 25³⁄₈ in. (65 × 64.5 cm) Dulwich College Archive

The view is taken from the entrance to the mausoleum, which is off-center in order to accommodate a cramped and irregular site. The dramatic contrast between a low, dark rotonda and a tall, brightly lit burial chamber was repeated at Dulwich.

Fig. 21 J.M. Gandy, *A View of the Dome Area in Sir John Soane's Museum*, pen and watercolor, 15³⁄₈ × 8³⁄₄ in. (39 × 22.2 cm) Sir John Soane's Museum

The arrangement of sepulchral treasures (an Egyptian sarcophagus, Roman funerary urns, sarcophagi, and sundry antiquities) surrounding a bust of Sir John Soane himself makes this space a curious mixture of museum and mausoleum.

London (see fig. 11, p. 22). The individuality of Soane's style and his desire to create a new architecture based on classical principles but appropriate to the modern age made many of his contemporaries distrust his work.

Soane and Bourgeois had been close friends. They had fought on the same side in the Royal Academy battles of 1804; Soane kept Bourgeois's portrait and two of his paintings in his museum; and Mrs. Soane visited Bourgeois on his deathbed. The architect particularly relished the Dulwich commission, described in 1812 by a friend as his "favourite subject." He was moved by friendship, but also by the unusual terms of the commission: he was required to design not only a gallery but also a mausoleum for the bodies of the founders – both being types of structures in which he was particularly interested. On the death of Desenfans in 1807 Soane had erected a mausoleum for his body at the back of the Charlotte Street house (fig. 20). Bourgeois wanted a similar edifice to be raised at Dulwich, to house the bodies of Mr. and Mrs. Desenfans and his own. The expense was to be met by his executors. The erection of a private mausoleum was not unknown at this time – C.H. Tatham had designed such a structure for the Marquess of Stafford at Trentham in 1807 – but it was unusual, particularly for private citizens. Soane had never had an opportunity to design such a building, and it was a type that he found of extreme interest. His fascination with death and its symbolic commemoration is apparent from the succession of designs of mausolea exhibited by him at the Royal Academy from 1777 onwards, from his incorporation of numerous references to death in his first home at Pitshanger Manor in West London, and from his house at Lincoln's Inn Fields. In the last, the central portion of the museum has Roman funerary urns arranged around an Egyptian sarcophagus, with his own bust set in their midst (fig. 21). For Soane, as for Bourgeois, a personal museum was the most fitting memorial for a man who had dedicated his life to the arts. Bourgeois could not have chosen an architect better fitted to design his gallery and tomb.

EARLY DESIGNS FOR THE GALLERY

Bourgeois's will proposed that the pictures should be accommodated in the existing west wing of the college (see fig. 13, p. 24), after "repairing, improving and beautifying of the old building" (*Minutes of Private Sittings of the Master, Warden and Fellows of Dulwich College*, 1805–29). Soane made his first site visit on January 8, 1811, the day after the patron's death. He recommended that in view of the ruinous condition of the wing, it would be preferable to build anew behind the existing college, "in the Back Yard at right Angles to our present Kitchen" (*ibid.*), and the proposal was agreed to by the governing body (see fig. 15, p. 24).

Soane at first suggested the demolition of the two decayed wings of the old college and their replacement with a quadrangle to the south of the existing buildings. Several schemes were produced, of which one example (Sir John Soane's Museum, Design No. 5, May 1811; fig. 22) conveys the architect's thinking at this stage. The chapel wing of the old college was to be retained at the north side of the quadrangle (on the right in the drawing). The block with skylights was to house the pictures and anticipates the plan of the building as erected. Opposite the gallery a further exhibition room was planned as a library: it was at one time

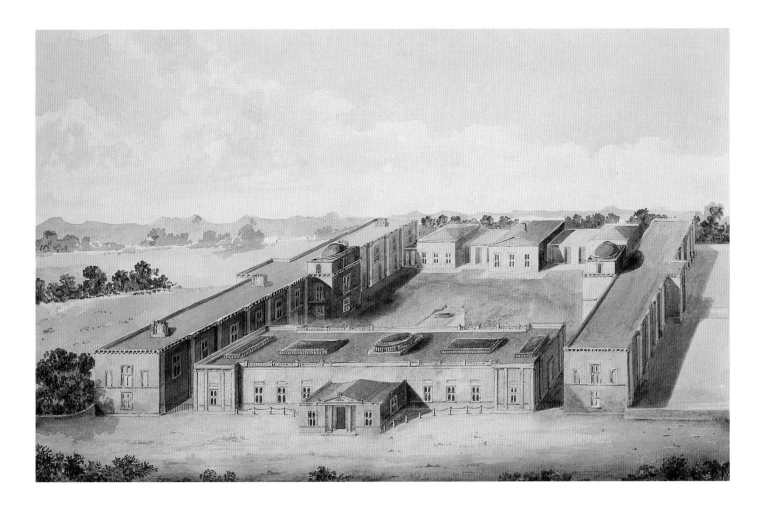

Fig. 22 John Soane, *An Early Proposal for Rebuilding Dulwich College, Seen from the East,* May 1811, pen and wash
Sir John Soane's Museum

Soane proposed to demolish the east and west ranges of the Old College (see fig. 13), smarten up the south range, and build a replica of it further to the south. The other two sides of this new quadrangle were closed by a library at the back (west), linked to the rest of the college by a loggia, and a freestanding, top-lit gallery building to the front (east), with a lobby jutting out into College Road.

Soane's intention, if neither of his sons became architects, to leave his own library and antiquities to Dulwich. The remaining wing would house almshouses and further accommodation for the college.

The style of these early elevations is a strange one. The authorities supposedly wanted a building in sympathy with the Jacobean buildings of the old college, the most prominent features of which were the mullioned and transomed windows and the giant pilasters. Soane, whose attitude to non-classical architecture was ambiguous, produced a compromise. The south block is a repetition of the old building. The gallery retains the Jacobean windows, but the pilasters round the entrance and on the end bays are typically Soanean in their thinness with recessed centers, as are the minimal decorative motifs over the doors. In other early designs Soane experimented with both an H-shaped and a cruciform arrangement. Though the new quadrangle was rejected by the authorities, it remained in the architect's mind. When studying the gallery today it is important to recall that the building was referred to during construction as the "new West Wing of the College" (*Minutes of the Private Sittings* ..., 1805–29), and that the proximity of the old buildings influenced its character.

In July, Soane and the college agreed on a design for a freestanding block, to be carried "into execution immediately" (*ibid.*), but difficulties arose over money. Soane submitted an estimate in July of £11,270, including £1000 for the mausoleum. The master and fellows could contribute only £5800, which, with the £2000 from Bourgeois and an additional £1000 for the mausoleum, still left a

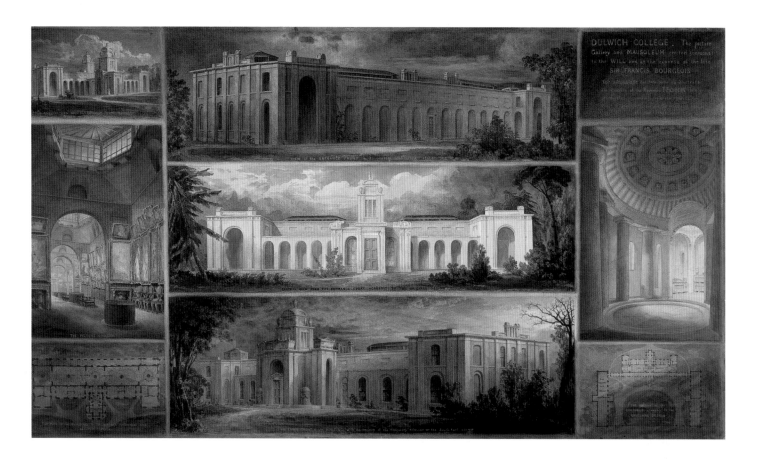

Fig. 23 J.M. Gandy, *"Mausoleum and Picture Gallery
with God's Gift College, Dulwich,"* ca. 1823,
watercolor
Sir John Soane's Museum

This composite image shows some real views
and some might-have-beens. Our best idea of
Soane's completed building is given by four
accurate panels – the two interiors, the east
façade (top center), and the west façade (bottom
center). The plan to the bottom right recalls
Soane's original quadrangular ideas (see fig. 22).
Three panels (top left, bottom right, and
absolute center) show Soane's unexecuted
"twin-tower" idea, whereby the form of the
mausoleum is replicated in an entrance lobby to
the east. These three views, and the plan to the
lower left, show the abandoned freestanding
loggia along the east façade (compare top
center). Otherwise the plan to the bottom left is
reliable.

deficit. Though pressed to do so, Soane was unable to reduce his estimate and
even proposed making up the sum himself. The problem was resolved by Mrs.
Desenfans, who, in September, offered a further £4000. The offer was accepted,
and on October 11 the governing body agreed that the building should be erected
according to Soane's plan.

During the summer and autumn of 1811 Soane produced a variety of designs
for the new building and continued to do so after the plan had been accepted. He
was particularly influenced by the governors' wish to accommodate the "Poor
Sisters" in the new building, and in November 1811 to move the mausoleum from
the east to the west side of the gallery. His proposals for the mausoleum were still
developing in the spring of 1812. After November 1811 work proceeded rapidly and
was largely completed by 1813. The pictures were brought to Dulwich in the
summer of 1814 and in March 1815 the mausoleum received its new inhabitants.
Work continued on the almshouses, and on the erection of a temporary porch to
the gallery (by another architect, George Tappen), until 1815. Only in 1817,
following difficulties over such questions as the heating system, were final details
including a brass railing and a "green floor cloth" completed and the collection
opened on a regular basis to the public (see fig. 23).

THE CHARACTER OF THE BUILDING

Dulwich Picture Gallery is a building that requires study; its quality is not easily
appreciated. One reason is its austerity, partly the result of financial constric-
tions. Soane wrote in August 1811 to the master of Dulwich College, "Every
attention in my power shall be paid to economize the expenditure as far as is

consistent with solidity and durability of construction," and, being scrupulously professional, he succeeded. He did not charge for his own services, and the building was erected for only £9788, less than his estimate, though a further £900 had to be spent on the almshouses. Such economy demanded sacrifices, in particular the proposed arcade on the garden front, which was never built. A drawing in the Soane Museum, probably intended to illustrate a lecture at the Royal Academy, shows the building as Soane originally envisaged it (fig. 24). Statues flank the mausoleum, the sides and summit of which are decorated with carving; the surrounds to the ground floor windows are in an elaborate version of Jacobean, and a balustrade links the chimney stacks on the skyline. The drawing is also interesting in suggesting the element of emotion in the architect's approach. The building is presented dramatically, beset by stormy weather, and the figures, much smaller in relation to the building than they would be in reality, demonstrate Soane's manipulation of scale to evoke the sublime.

Soane had for many years been interested in primitivism in architecture, in returning to the essentials of design as practiced in the early days of civilization. It was a theme he had previously explored principally in such buildings as stables and dairies. The gallery, with its rustic setting, its aesthetically uncritical authorities, and its stringent budget, gave him an opportunity to abandon established architectural modes for a new manner. For a museum, Soane's contemporaries would have expected a structure in stone, or at least stucco, using a classical order. These expectations were not met at Dulwich. The building, consisting of mausoleum, gallery (rooms I–V), and almshouses (rooms

Fig. 24 John Soane, *Design for the West Front of the Picture Gallery, ca.* 1815, pen and wash
Sir John Soane's Museum

This is another mix of fact and fantasy, including elaborate Jacobean-style windows and sculptural reliefs which were never executed. The exaggeration of the building's scale and the dramatic lighting effects convey that spirit of sublimity which Soane wished his visitors to experience.

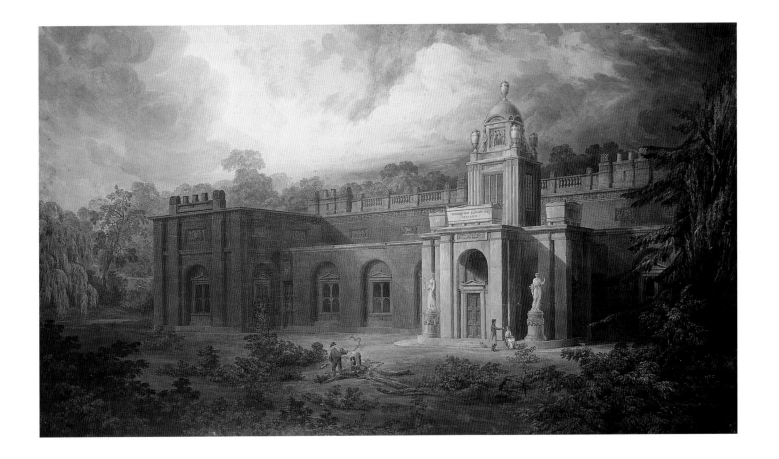

VI–IX), was erected in brownish-yellow London stock brick, the cheapest material available at the time and, in dignified buildings, normally concealed if used at all. Soane found brick, with its variety of shades, a sympathetic medium, and carefully supervised the quality of the brickwork. The only expensive substance employed was the Portland stone applied to the lantern and the frieze.

Even more startling to contemporaries was the abandonment of a classical order. Soane's concession to the classical canon was his application to the wings of a series of vertical brick projections, which can be seen as pilasters but are not differentiated in material from the rest of the building as a pilaster would normally be (fig. 25). These projections are supported by a strip of stone at ground level, suggesting a base, and conclude in a band of Portland stone that serves as an entablature. There is no other concession to the language of classical architecture.

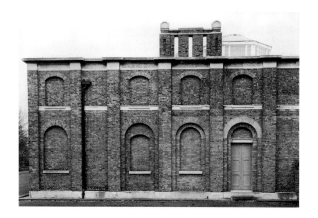 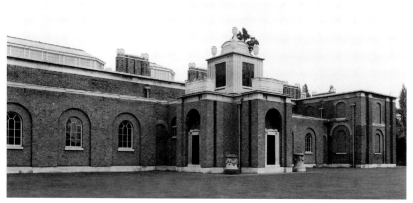

Fig. 25 (left) South Front of the Picture Gallery
Fig. 26 (right) West Front of the Picture Gallery

Soane's simplification of forms allowed him to concentrate on the qualities he regarded as important: the interplay of elements, the contrast of light and shade, the creation of a visually exciting skyline, the "art of surfaces." His interest in surface can be studied in the north and south elevations of the building. Just as, at the Soane Museum, he dissolves the boundaries of rooms by means of arches and mirrors, making space indefinable, so in these elevations he manipulates surface, creating five or six layers within the brick. It is not clear which of these layers represents the basic wall that the viewer expects immediately to identify in a building.

The individuality of the gallery is most apparent in the mausoleum (fig. 26). Its function is expressed externally by such symbols as the urns, the sarcophagi (above the doors), the sacrificial altars at the corners, and the doors, never to be opened and shaped to recall a classical funeral monument. The three tiers of the structure, their proportions carefully related to one another, culminate in the topmost urn. Characteristically, the decoration is sparse, confined to the "order" on the lower level and to the funereal accessories and incised lines above. Soane's concern with the contrast of solid and void is apparent in the arches containing the doors: the space above each portal, and the narrow openings in the brick at the side of each projection, create a sculptural and indeed painterly effect which reflects his belief that "the Poetry of Architecture" could embrace the other visual arts.

Soane's manipulation of scale can be seen in the doors themselves. Though only five feet high, they are made to seem larger by their position above two shallow steps, and by their tapering sides. As Sir John Summerson has pointed out, the gallery achieves an extraordinary nervous strength from the isolation, what he calls the "quasi-independence," of all the elements in the design from one another, whether they are individual motifs or sections of the building. Everything is distinct; nothing superfluous.

The interior of the gallery consisted originally of a sequence of five rooms (I–V; fig. 27). The arrangement derives from the traditional long gallery in a country

Fig. 27 J.M. Gandy, *Interior of the Picture Gallery, ca.* 1823 (detail of fig. 23)

The detail shows the Soane enfilade, with top lighting and heating cylinders down the center of the gallery.

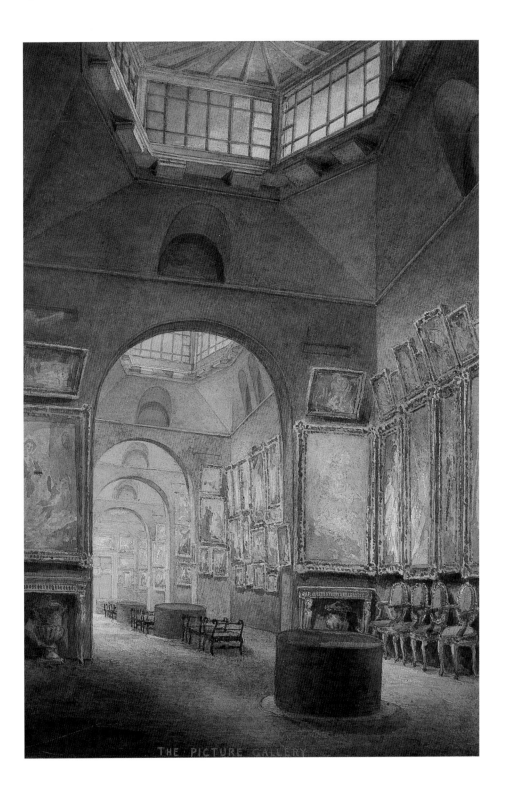

house, a form of room that was being revived in early nineteenth-century Britain to accommodate expanding private collections. The gallery of 1800–01 at Castle Howard, by C.H. Tatham, a design quite close to Dulwich, is a good example. The plan at Dulwich is straightforward, an alternation of cube and double cube, reflecting English Palladian faith in the virtue of perfect proportion. The rooms are linked by a succession of arches, as in earlier galleries such as George Dance's Shakespeare Gallery of 1789. There are no more classical references inside than there are out; only an allusion to pendentives in the unusual coved ceiling. The lighting system, which consisted originally of the vertical glasses alone, was intended by Soane to shed the clearest possible light on the picture while avoiding a glare, and is close to the design in the picture room of his own museum. Top lighting, a regular feature of contemporary galleries, was particularly desirable when, as at Dulwich, as much space as possible was needed for hanging paintings.

In the mausoleum (fig. 28), Soane passed from the practical to the theatrical. He had already created a similar space in the Charlotte Street mausoleum of 1807, and

Fig. 28 Interior of the Mausoleum at Dulwich Picture Gallery

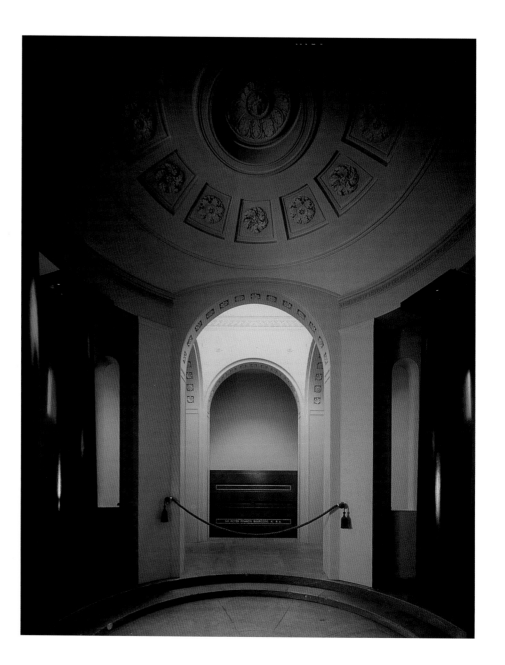

the Dulwich interior is close to this prototype. The visitor enters a circular vestibule with an artificial ceiling supported by a Greek Doric peristyle. This area was intended as a chapel, though never used as such. The chamber is minimally lit by two narrow windows at the side. All the materials are sham, the porphyry columns being merely painted wood, but the effect is not. By ingenious means – the creation of a circle within a square, the lowering of the center of the floor by two steps, the concave ceiling – Soane creates an impression of monumentality in miniature.

From the vestibule an arch leads to the burial chamber itself. The contrast in light is striking, since this burial chamber is lit by four openings in the lantern, filled with yellow glass. The effect of "mysterious light" (Soane's phrase) pouring into the mausoleum from above is highly Baroque, and is typical of the drama and the color that Soane sought in his interiors. The decoration, by contrast, is simplified, using only the Greek key pattern, serpents (a symbol of eternity) in relief above the arches, and classical figures, also in relief, on the ceiling. The sarcophagi, rectilinear and with stylized handles, constitute a strikingly advanced piece of design.

The atmosphere Soane wished to evoke is conveyed by a passage from his *Memoirs of the Professional Life of an Architect*: "We have only to fancy the Gallery brilliantly lighted for the exhibition of this unrivalled assemblage of pictorial art, – whilst a dull, religious light shews the Mausoleum in the full pride of funereal grandeur … calling back so powerfully the recollections of past times." The emotional power he wanted to express is evident.

The gallery was not favorably regarded by all Soane's contemporaries. A number of criticisms survive, notably one by the Reverend T.F. Dibdin, which the victim bitterly quoted, years later, in his *Memoirs*. Dibdin objected to what he considered the oddity of the building, and its lack of a classical order: "What a thing – What a creature it is! A Maeso-Gothic … Semi-Arabic, Moro-Spanish, Anglico-Norman – a what-you-will production! It has all the merit and emphatic distinction of being unique."

Critics throughout the nineteenth century regarded the building with caution, and the attitude towards it of past administrators is apparent from a photograph taken around 1910, showing it veiled in ivy. Only relatively recently has the force of the design been fully recognized.

Fortunately, the architects responsible for enlarging the gallery have always been sympathetic to its character. The first major addition to the exhibition space was made in 1884, when the almshouses were converted into galleries (rooms VI–IX; fig. 29). Further rooms were added around 1910 on the east side of the building by the college's architect, E.S. Hall, who removed the loggia at each end of the façade and created a succession of galleries that both internally and externally show a sensitive understanding of Soane's architecture (figs. 30–31). In 1936 the final room in this suite was added. During the post-war reconstruction the lobby added in 1866 at the south end of the building by Charles Barry Jr. was removed and a new entrance erected in the center of the building on the east side, as originally intended by Soane.

Fig. 29 E. Stanley Hall, *The East Front and Plan of the Picture Gallery "as now existing,"* 1909
Dulwich College Archive

The building appears as Soane left it except for the two interventions of Charles Barry Jr.: the lobby to the south added in 1866 and the conversion in 1884 of the almshouses into offices and display space, making the present galleries VI and IX.

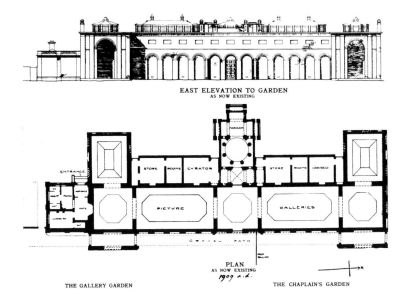

Fig. 30 E. Stanley Hall, *The East Front and Plan of the Picture Gallery "showing the proposed addition,"* 1909
Dulwich College Archive

Stanley Hall executed these proposals – the conversion of offices into display space to make the present gallery VIII and the addition of a "New Gallery" (the present Entrance Hall). He also conceived a complete range of galleries across the east façade. He built galleries X, XI, and XII; gallery XIII had to wait until 1937, by which time H.S. Goodhart-Rendel was the architect in charge.

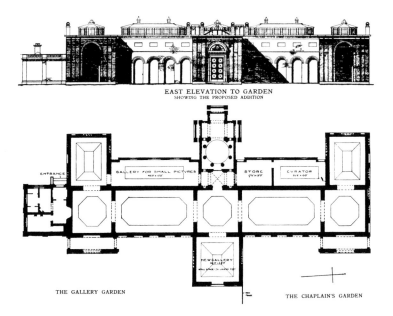

Fig. 31 Plan of the Picture Gallery when it re-opened in 1953

This plan shows the Stanley Hall and Goodhart-Rendel suite of galleries across the east front (X to XIII). Comparison with the previous figure shows the elimination of Barry's south lobby, moving the main entrance to the east by adding a porch to what is now called the Entrance Hall. The last vestige of the almshouses was lost in the creation of gallery VII, but a workshop and picture store now occupy gallery XIII.

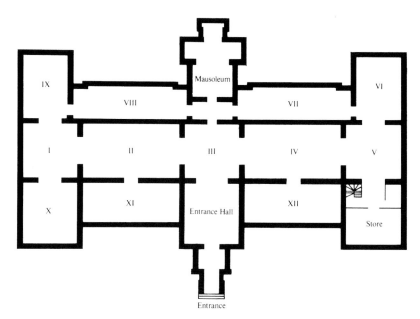

Until the reform of the college in 1857, the master and fellow tended to regard the gallery as a private perquisite. Though it was open to the public from 1817, admission tickets could not be taken at the door but had to be obtained in advance from one of several shops in central London, presumably to ensure that only respectable persons visited. After a disturbing incident, school parties were not admitted, nor children under fourteen. For lack of space elsewhere, the gallery was used for prize-givings until the mid-century. And in the 1820s one of the fellows, Mr. Lindsay, was regularly given permission to borrow a Poussin or a Van Dyck for his own rooms.

This amateurish organization of the gallery was reflected in the comments of visitors, especially the German art historians M. Passavant and Gustav Waagen. Waagen, in his *Treasures of Art in Great Britain* of 1854, wrote: "In none of the galleries which I have hitherto seen in England do the pictures agree so little with the names given to them, nor is so much that is excellent mixed with much that is indifferent and quite worthless." The first scholarly catalogue, by J.P. Richter, appeared as late as 1880.

The proprietorial attitude of the fellows towards the gallery did result in one important bequest, the set of portraits of the Linley family (see cat. 87 and 88). This family of distinguished musicians, including Elizabeth, later Mrs. Richard Brinsley Sheridan (her portrait hangs in the National Gallery of Art, Washington, D.C.), lived in Bath and London during the nineteenth century and formed part of the theatrical circle with which Desenfans was connected. One of the Linley brothers, Ozias (1766–1831; fig. 32), a highly eccentric clergyman, became junior fellow and organist of Dulwich College in 1816. Ozias's brother, William (cat. 90) bequeathed the family portraits, including works by Gainsborough and Lawrence, to the gallery.

Throughout the nineteenth century the governing body employed a keeper, or curator, whose duties as specified in 1821 were to supervise repairs and loans, to check "impropriety or irregularity" in visitors, and "to have a general care of the pictures," especially "to clean and varnish them at his own expense." The most memorable keeper was Stephen Poyntz Denning (*ca.* 1787–1864), who held the position from 1821 until his death. As had been the custom in private galleries since at least the time of Teniers, this curator was also a practicing artist. Denning specialized in small-scale portraits: his *Princess Victoria, Aged Four* (fig. 33) is one of the gallery's most popular works.

Under a new constitution set up in 1857 the collection was supervised by a committee, and standards became more professional. One of the more notable chairmen of this committee, from 1908 to 1919, was Henry Yates Thompson, an important collector and benefactor, who, during his tenure, practically became curator as well. He gave the gallery pictures, furniture, and books, paid for the addition of four exhibition rooms, and encouraged a major gift of paintings in the 1910s.

The donor was Charles Fairfax Murray (1849–1919; fig. 34). Murray was an artist and picture dealer, who, as a young man, had worked as assistant to Sir Edward Burne-Jones and was intimate with the Pre-Raphaelite circle: they knew him, on

Fig. 32 Archer James Oliver, *Ozias Linley*, *ca.* 1805, oil on canvas, 30¼ × 25¼ in. (76.8 × 64.2 cm)
Dulwich Picture Gallery

Ozias Linley (1766–1831) is the link between the Linley family and Dulwich: he became organist of Dulwich College in 1816, which presumably persuaded his brother William to bequeath the family portraits to the gallery in 1835.

Fig. 33 Stephen Poyntz Denning, *Queen Victoria, Aged Four*, 1823, 11 × 8¹⁵⁄₁₆ in. (27.9 × 22.7 cm) Dulwich Picture Gallery

This charming portrait of the future queen (looking almost amused) was purchased by the college in 1891 as a tribute to the artist Stephen Denning, who was curator of the Dulwich Picture Gallery from 1821 until his death in 1864.

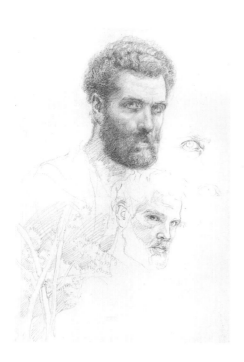

Fig. 34 Charles Fairfax Murray, *Self-portrait*, 1880–84, pencil
Fitzwillian Museum, Cambridge

Fairfax Murray (1849–1919), a minor Pre-Raphaelite painter but magnificent collector, was persuaded by his friend Henry Yates Thompson to give an important group of English portraits to the gallery.

account of his odd, squat physique, as "dear little Muffy." During his youth, Murray, in company with his friend and biographer W.S. Spanton, frequently visited the gallery, and he did not forget it. He spent much of his life in Italy, becoming an authority on Italian art, and, unobtrusively, one of the most important figures in the history of English collecting. By 1900 he was rich, and his generosity was outstanding: he made major gifts to the British Museum, the Fitzwilliam Museum, Cambridge, and the Birmingham City Art Gallery. Murray believed that British portraiture was inadequately represented in public collections, and his gift to Dulwich was intended to remedy this gap. The forty-one paintings he gave between 1911 and his death comprise, together with three old masters (including Bourdon; see cat. 32), portraits by all the leading portraitists working in England from the late seventeenth to the early nineteenth century (apart from Reynolds and Lawrence, who were already represented), and interesting examples of lesser-known artists such as Dahl and Vanderbank. The only painting in the collection by an American, West's *Mother and Child* (fig. 35), is part of this group.

For at least the first thirty years of its existence Dulwich College Picture Gallery (as it was known until 1979) was the most important accessible collection in London. The National Gallery, opened in 1824 in John Julius Angerstein's house in Pall Mall, contained a choice but much smaller selection of paintings. The visits to Dulwich of numerous literary, artistic, and political figures are well documented: William Hazlitt (who wrote about the gallery at length, in 1824), Charles Dickens, Thomas Carlyle, Alfred, Lord Tennyson, George Eliot; Antonio Canova, Samuel Palmer, David Cox, William Etty, William Powell Frith; among American artists, Chester Harding (who admired Van Dyck's *Emanuel Philibert* [DPG 173]) and Washington Allston. The young hero (new to London) of Charles Kingsley's *Alton Locke* describes the atmosphere around 1830: "The rich somber light of the rooms, the rich heavy warmth of the stove-heated air, the brilliant and varied colouring and gilded frames which embroidered the walls, the hushed earnestness of a few visitors, who were lounging from picture to picture, struck me at once with

Fig. 35 Benjamin West, *Mother and Child*, 1805, oil on canvas, 36 × 28 in. (91.4 × 71.1 cm) Dulwich Picture Gallery

Fig. 36 Interior of the Picture Gallery, *ca.* 1910

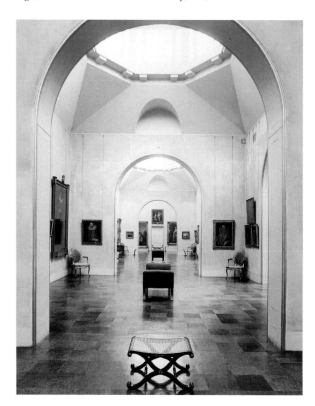

Fig. 37 Interior of the Picture Gallery, *ca.* 1960

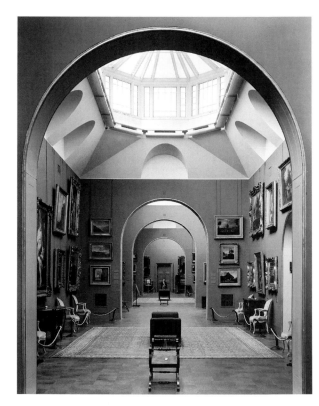

Fig. 38 Interior of the Picture Gallery, 1985

mysterious awe." When Henry James visited in 1869 the atmosphere was more chilly: "A pale English light from the rainy sky – a cold half-musty atmosphere & solitude complete save for a red-nosed spinster at the end of the vista copying a Gainsborough – the scene had quite a flavour of its own."

A number of important figures gained early impressions from the gallery. Robert Browning, who as a child lived nearby, wrote in 1846 of "that Gallery I so love and am so grateful to," and several of his poems are inspired by paintings in the collection. Holman Hunt copied there regularly as a student. And John Ruskin, who in his youth lived nearby at Herne Hill, used many of the gallery's pictures as fuel for his violent attack on the old masters in *Modern Painters*: he recorded in his diary for January 30, 1844, "Walked down to Dulwich Gallery, and thought the pictures worse than ever; came away encouragingly disgusted."

By the late nineteenth century the gallery's reputation for quietness had apparently made it an ideal meeting place for lovers. W.B. Yeats in the 1890s conducted a love affair at "Dulwich Picture Gallery and in railway trains," while in George Moore's *Evelyn Innes* (1898) two lovers regularly meet in these peaceful surroundings, though "they were ill at ease on a backless seat in front of a masterpiece." Fewer visits by literary personalities are recorded in this century. Evelyn Waugh, trying to visit in 1928, grew bored with waiting for a bus and instead went to buy a marriage license. D.H. Lawrence was more persevering, and described in 1909 "such a splendid little gallery – so little, so rich."

THE DECORATION AND ARRANGEMENT OF THE GALLERY

The gallery's appearance has been altered considerably over the years, reflecting changing attitudes to museums. A watercolor of about 1823, in the Soane Museum (figs. 23 and 27, pp. 30 and 33), shows the interior of the building soon after completion. The walls were painted in the color, "something like burnt Oker, but heavier" (Joseph Farington), recommended by Benjamin West as president of the Royal Academy; the floor was covered in green cloth, and the Desenfans' furniture was arranged against the walls. The circular protrusions in the center of the floor were stoves, part of the heating system that caused so much trouble. The pictures were hung two or three deep, with the top layer canted forward; even the piers were used as hanging space. The first catalogue (*ca.* 1816) shows that the paintings were not strictly arranged – it would hardly have been possible – by school; but the Dutch and Flemish paintings were placed in two rooms at the south end of the building, and those of the Italian, Spanish, and French Schools at the north end. The traditional fondness for hanging pictures as pendants dominated the arrangement as it had the original selection. The character of Dulwich at this time was that of a private collection, comparable to a gallery in a great country house.

By 1910, under the influence of Yates Thompson, the gallery had been tidied up (see fig. 36). A metal barrier had been erected round the walls, a dado introduced, the top row of pictures had been removed to the new rooms, and one of these served as a "Tribune" (like the famous octagonal room in the Uffizi, Florence) for a selection of what were regarded as the best pictures. Some of the walls had been covered in rich red damask, not, perhaps, the most suitable material. Many of the pictures had by this time been put under glass, and others consigned to the store room.

Such severity is even more apparent in the photograph of the gallery as rearranged after the restoration of 1952 (fig. 37). This was the era of the neutral setting and of the belief that the spectator's appreciation of a painting was enhanced by creating around it as colorless an environment as possible. Consequently, the walls were given a wash of grey paint, and the pictures, with the exception of the English portraits, which were double-piled in minor rooms, were arranged at eye-level in a single tier. The effect was cool and elegant, but not faithful to the original character of the building, and the pale walls made the paintings, with their dark grounds, appear darker.

Meanwhile there was increased interest in restoring the original character of older buildings as well as in the architecture of Soane, and the need for major redecoration provided an opportunity in 1980 to reconsider the appearance of the interior (fig. 38). It was decided to return the main galleries, as far as possible, to their original look. Only "as far as possible," because the rooms themselves had been altered, with large apertures opened in the walls for access to the side galleries, and because the range of exhibited pictures had changed considerably. Such elements as the skylights (with the top, diagonal sections glazed in 1910) and the introduction of artificial light had also changed the building's character. What was achieved had to be a compromise, though in one detail, the opening of the mausoleum to the public, it was possible to return to Soane's original intention. The brownish-red that was chosen recalls the color known to have existed in the nineteenth-century gallery, and was derived by the consultant, Ian Bristow, from a recipe of 1828 for "a color for picture galleries" that "harmonizes with paintings and gilt frame." The paintings were rehung, not as close together as they had been in the early nineteenth century, but in large-scale symmetrical arrangements such as were often found in major galleries in the Regency period.

THE GALLERY SINCE 1900

The additional galleries and the gift of pictures by Fairfax Murray represented a flowering in the gallery's fortunes around 1910. The governors felt that every necessary aim had been achieved. The proximity of the Crystal Palace at Sydenham, one of the most popular tourist attractions in London, benefited the gallery, which was quite heavily visited at this time. The governors had reckoned without the world wars. The gallery was little affected by World War I, though with the beginning of air raids a group of the most important paintings were taken for safety to the cellars of the Royal Academy. In 1939 eighty pictures were removed to Wales, to be followed the year after by the rest of the collection. It was a wise decision, for in 1944 one of the many bombs that struck Dulwich fell just outside the building, which was severely damaged. After some debate over whether the gallery should be re-erected in a modern idiom, it was decided to rebuild in replica. The work, conducted by the firm of Austin Vernon Associates under the consultancy of Arthur Davies, R.A., and Sir Edward Maufe, R.A., was completed in 1953, when the gallery reopened.

Since then the collection's history has not been smooth. The need to raise money prompted the governors in 1971 to send one of the paintings from the Bourgeois collection, Domenichino's *Adoration of the Shepherds*, for sale at Sotheby's; it raised £100,000 but the sale, a very unusual step for a museum in Britain, aroused much controversy.

In 1979 the governors of Dulwich College, who then had responsibility for the gallery, decided, in the absence of any professional staff, to appoint a director. In the following years the gallery embarked on a number of new activities, with appropriate staff gradually being recruited. An education program was introduced in 1986, predominantly but not exclusively aimed at children, with the intention of making the building and the collection accessible to as broad an audience as possible. An exhibitions program began in 1985, based at first on the permanent collection but gradually expanding to include contemporary art, architecture, and increasingly ambitious old master displays. The friends' organization, which gradually increased in size, provided invaluable support and help throughout this period.

None of this was enough to keep afloat a gallery that essentially was inadequately funded by a very modest annual subvention from Alleyn's College of God's Gift, the Dulwich College Foundation. As professional standards rose, so costs rose, too. By the early 1990s it was clear that a new solution had to be found. After extended negotiations, it was agreed in 1993 that the governors of Dulwich College would relinquish responsibility for the gallery to a new independent board of trustees approved by the Charity Commissioners. Lord Sainsbury of Preston Candover was appointed as the first chairman of the new board, supported by trustees with expertise in various areas. Assisted by a grant of £3 million from the National Heritage Memorial Fund and by numerous generous donations, the new board raised an endowment of £12 million to secure the gallery's future.

The gallery has long been short of space to offer the facilities needed by a modern museum, notably a café, a shop, an education room, a lecture theater, and proper storage. All of these are to be provided in an elegant new extension, opening in May 2000, funded in large part by the Heritage Lottery Fund, and designed by the architect Rick Mather. Every part of the old and new building will be linked by a glass cloister running along the south side of the old college chapel and forming three sides of a rectangle, thus, in part, and in a modern idiom, meeting Soane's intention of creating a gallery with a collegiate quadrangle. Even with so much change afoot, however, the gallery's most essential quality will be fiercely defended – that unique air of rural repose, a precious collection set in a garden among fields (fig. 39).

Fig. 39 Dulwich Picture Gallery today

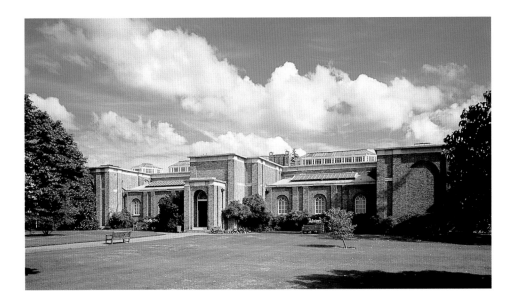

A Note on Sources

The principal sources for the history of Dulwich Picture Gallery
are as follows:

BOURGEOIS AND DESENFANS

'J.T.,' *Memoirs of the Late Noel Desenfans, Esq.*, 1810

Desenfans Archive (Dulwich College)

Desenfans, letter to Benjamin West (Historical Society of Pennsylvania)

N. Desenfans, *A Descriptive Catalogue … of some Pictures of the Different Schools purchased for His
 Majesty the Late King of Poland*, 2 vols., London, 1802

Desenfans's sale catalogues (Christie's Archives and Courtauld Institute of Art)

General Assembly Minutes (Royal Academy of Arts)

Whitley Papers (British Museum)

Joseph Farington, *Diaries*

Contemporary newspapers and memoirs

POLAND

Desenfans Archive (Dulwich College)

T. Mankowski, *Galerja Stanislawa Augusta*, Lwów, 1932

J. Fabre, *Stanislas-Auguste Poniatowski et l'Europe des lumières*, Paris, 1952

Treasures of a Polish King, exhib. cat., London, Dulwich Picture Gallery, 1992

A. Zamoyski, *The Last King of Poland*, London, 1992

DULWICH COLLEGE

Minutes of Private Sittings of the Master, Warden and Fellows of Dulwich College, 1805–29
 (Dulwich College)

G. Warner, *Catalogue of the Manuscripts and Muniments … at Dulwich*, London, 1881

W. Young, *History of Dulwich College*, London, 1889

S. Hodges, *God's Gift: A Living History of Dulwich College*, London, 1981

THE BUILDING

Drawings and notebooks in the Sir John Soane Museum, London

A.T. Bolton, *The Works of Sir John Soane* (Soane Museum Publications, no. 8), London [*ca.* 1920]

J. Summerson, "Soane the Man and His Style," and G.-T. Mellinghoff, "Soane's Dulwich
 Picture Gallery Revisited," in *John Soane*, London (Academy Editions/St Martin's Press), 1983

Minutes of the Governors of Dulwich College (Dulwich College)

Giles Waterfield, *Soane and After*, London (Trustees of Dulwich Picture Gallery), 1987

Giles Waterfield *et al.*, *Soane and Death*, London (Trustees of Dulwich Picture Gallery), 1996

LATER HISTORY

Bourgeois Book of Regulations (Dulwich College)

Minutes of the Governors of Dulwich College (Dulwich College)

W.S. Spanton, *An Art Student and His Teachers in the Sixties*, London, 1927

E. Cook, *Catalogue of the Pictures in the Gallery of Alleyn's College of God's Gift at Dulwich*,
 London, 1926

Peter Murray, *Dulwich Picture Gallery*, London, 1980

Richard Beresford, *Dulwich Picture Gallery: Complete Illustrated Catalogue*, London, 1998

CATALOGUE

I The Italian School

For the first hundred years of Dulwich Picture Gallery's existence, Guido Reni's *Saint Sebastian* (cat. 3) hung on the center of the wall at the north end of Soane's enfilade, as if it were the high altarpiece of the collection (see fig. 36, p. 40). Its position was a fitting symbol of the reverence for Italian art at the time of the gallery's founding. Even in the company of Rubens, Rembrandt, and Watteau, Reni takes precedence as if by birthright.

As Giles Waterfield has discussed, however, the Italian holdings of the original Bourgeois bequest were in many respects deficient for a "national gallery." Why, for example, are there no early Renaissance masters – no Botticelli and Piero della Francesca? Why are there so few examples of the great Venetians of the sixteenth century – Titian and Veronese? The significance of these gaps can be appreciated if we make comparisons with other collections. For example, the collection that the National Gallery in London had put together by the mid-nineteenth century (at about the time that it overtook in quality the static collection at Dulwich) was also lacking the great names of the fifteenth century – with almost no early Renaissance Italian or Flemish masters. The taste of the time held that true painting started with Leonardo, Michelangelo, and Raphael, and regarded Mantegna or Botticelli as forerunners, in rather the same way that, until recently, works by Handel and Bach were described as "early music." The National Gallery's Italian collection, however, started almost one hundred years earlier than that of Dulwich, around 1500 rather than 1600. It owned considerable holdings from the sixteenth century, including masterpieces by Raphael, Titian, and their contemporaries. The collection that Bourgeois and Desenfans put together represents the Italian High Renaissance with three meager offerings – two tiny predella panels by Raphael and a portrait by Piero di Cosimo (originally attributed to Leonardo). Otherwise the Italian sixteenth century was inadequately represented, with some poor copies of Titian (DPG 209 and 273), a decent studio Andrea del Sarto (DPG 251), and a fragment of an altarpiece by Veronese (cat. 1). This shortfall was almost certainly the result of lack of funds or of available paintings; to avoid Titian as a matter of taste was and always has been unthinkable.

In almost every other respect the Bourgeois-Desenfans collection reflects the prevailing view of the history of art (at least until the 1850s when "early painting" suddenly came into vogue) and anticipates that of the National Gallery. One aspect of this view was the idea that the Italians had the sixteenth century pretty much to themselves and that painting was "thrown open" to the rest of Europe in 1600. By neglecting the earlier period, the Bourgeois-Desenfans team built up a remarkably coherent collection chronologically – devoted, broadly speaking, to painting between 1600 and 1750 – in which all the major schools of painting as they were then understood (excluding the British) were given "fair" representation.

In such a universal collection devoted to one of the greatest ages of European painting the automatic precedence of the Italians has now been forgotten. Guido Reni, an artist revered in the early nineteenth century, became so out of fashion by the early twentieth century that his *Saint Sebastian* not only lost its prime position but also found its way to the storerooms, grimy, unloved, and denounced as a copy. The perceptive eye of Sir Denis Mahon and conservation work carried out in 1998 have brought the painting back into the display as an original Reni.

Reni was afforded such a seminal position in the early gallery not just because of the quality of a particular painting, but also by virtue of what Italian art stood for, something as universally acknowledged in 1600 as in 1800. Italian was the language of art. There are many reasons for this. The wealth of antique sculpture and architecture in Italy, and subsequently the masterpieces of the High Renaissance, made Italy a natural place of pilgrimage for artists throughout Europe. Most artists working elsewhere made a protracted Italian visit; many, such as Poussin and Claude, stayed all their life. Those who stayed away from Italy tended to be specialists in obviously local styles of painting or to feel, like Rembrandt, that they could see the best of Italian art at home.

Even those who stayed at home felt the hold of Italy. The perceived status of the art of painting, and therefore the artist's self-definition, the artistic theory of the period, and the ideal method of training were all things that had evolved in Italy during the sixteenth century and that were espoused almost without adaptation by every country in Europe. Reni's *Saint Sebastian* carried with it not only the tradition of Andrea del Sarto and Michelangelo but also the concept of what painting could aspire to be.

What did this universal artistic theory have to say? What did contemporary artists think they were doing? All would have agreed that the purpose of art was to imitate nature. This was true of every art, including architecture, but was especially true of painting. The best painting, however, was more than a mere copy of the visible world. Art should be imaginative, like poetry. This allowed the painter to become an honorary poet, working with his brain, like a gentleman, and not his hands, like a manual laborer. It is for this reason that drawing was sacrosanct in Italian art. Sketches were called *pensieri* or "thoughts"; drawing was regarded as the intellectual part of the art, painting the manual execution. In Reni's nudes (cat. 3 and 4), and indeed in most of the Italian paintings in this selection, the viewer can sense in the finished painting the drawing that has preceded it.

Clearly some forms of painting were more poetic than others; so the hierarchy of genres was born. At the top was "history painting" (as it was called, though "poetic painting" would have been a better title): this meant the imaginative depiction of stories from the Bible, ancient history, or mythology. Next in line came portraiture and genre painting, the depiction of particular people or scenes, requiring little or no imagination. Below this came landscape and still-life painting, the depiction of Nature without Man – in effect *Hamlet* without the prince.

Another factor determined how noble (or poetic) a painting was: the degree to which it improved upon the real world. A good portraitist could make some claim on this count, but it was especially the duty of history painters to show a world of ideal beings and noble deeds. At its simplest this meant exclusion: there is no place in history painting for vulgar, mundane, or ugly things, just as there is no place for toothache in a tragedy. The story of Saint Sebastian demands some arrows; that of Saint John the Baptist in the wilderness demands a reed staff and some wilderness. The inclusion of these elements in Reni's paintings is clearly a painful duty that he discharges in as summary and graceful a fashion as possible. On the positive side, improving on the real world meant creating figures of an unearthly beauty. The concept of ideal beauty exercised Italian theorists almost at the expense of everything else. Just as Plato taught that earthly forms poorly reflect their ideal equivalent in heaven, so it was the artist's task to see beyond the particular and imperfect to the universal and perfect. This applied particularly to the human form; God had created man in his own image, which meant that He Himself appeared in the likeness of a man. An ideal male nude could thus afford a glimpse of the living God.

But what did God look like? Who was to say which body was ideal and which was not? This type of problem was fiercely debated on a theoretical plane; in practise all artists and writers agreed that the sculpture of classical antiquity provided a working standard of beauty, which held good for depictions of Christ as well as Apollo. Classical sculpture

also provided a suitably ideal and generalized means of clothing figures, when the story demanded it.

There were few artists who could live up to all these ideals as completely as Reni. The two nudes in the Dulwich collection would have been pointed out, even while the artist was still alive, as paradigms.

These ideas affected the understanding of art throughout Europe until the nineteenth century. They did not, however, go unchallenged, even in Italy. They were modified during the seventeenth century by the influence of the Counter Reformation, a movement within the Catholic Church usually dated to between 1550 and 1650. To answer the Protestant challenge, the Catholic Church re-examined every aspect of its creed and reformed its institutions in order to live up to that creed and propagate it throughout the known world. In this huge enterprise art played an important part. The Protestants had denounced religious imagery as a whole as idolatrous (that is, in contravention of the Second Commandment). In many Protestant countries, including England, religious sculptures and paintings were destroyed in an orgy of "divinely ordained" vandalism. The Catholic Church defended the idea of religious imagery in theory but felt that painters should be more closely policed in order to ensure that in practise the objectives of faith were put before those of aesthetics. Religious paintings, it was felt, had become too detached and too obscure in their telling of the sacred stories, too lascivious in their treatment of the nude figure. Reni's *Saint Sebastian* gives some idea of the problem. According to the Church, art should become a Bible for the illiterate: it should tell stories of strict orthodoxy; it should tell them clearly and it should move the faithful spectator to love goodness and abhor evil. It is always difficult to assess the direct impact of such pronouncements, but much Catholic art of the seventeenth century is direct, populist, and emotionally manipulative, in a way that was impossible in previous centuries. Carlo Dolci's *Saint Catherine of Siena* (cat. 8), Bellucci's *Saint Sebastian* (cat. 9), Murillo's *Madonna of the Rosary* (a favorite Counter Reformation subject; cat. 21), and Poussin's *Return of the Holy Family from Egypt* (cat. 25) provide some contrasting examples of the phenomenon.

Another important influence on Italian painting of the seventeenth century was a single artist, whose revolutionary approach to painting owed a great deal to the Counter Reformation – Caravaggio (1573–1610). With Caravaggio the expressive imperative of the new Catholic art came into direct conflict with the aesthetic of ideal beauty. He considered that the unedited imitation of nature was the first and only objective of painting. Using a variety of techniques, he gave his paintings the shock of reality – a close, tactile, and violent quality. He set his figures in dark spaces and picked them out with a fierce and grazing light, accentuating every blemish of their skin. Biblical scenes are filled with mundane objects and wilful anachronisms. His compositions are crowded, as if the figures can scarcely be contained by the frame and threaten to spill out into the real world. It is not surprising that his work fell out of favor soon after his death and was neglected by most eighteenth-century collectors, including Bourgeois and Desenfans. His influence was considerable, however, as can be felt in the modern costumes and expressive claustrophobia of Guercino's *Woman Taken in Adultery* (cat. 5). Even Guido Reni, though following a fundamentally opposed artistic ideal, found himself fascinated by some of Caravaggio's effects. The way side light pours over his nudes (see cat. 3 and 4), exaggerating every dimple and crevice and giving the skin a vivid and sensual luminosity, is unthinkable without the example of Caravaggio.

DST

1 Paolo Veronese (Paolo Caliari)

VERONA 1528–1588 VENICE

Saint Jerome and a Donor, ca. 1563

Oil on canvas
88⅜ × 47¼ in. (224.5 × 120 cm)
DPG 270; Bourgeois bequest, 1811

REFERENCES: T. Pignatti, *Veronese*, Venice, 1976, no. 337; L. Bagatin, P. Pizzamano, and B. Rigobello, *Lendinara, notizie e immagini per una storia dei beni artistici e librari*, Treviso, 1992, pp. 212–13; R. Beresford in *Conserving Old Masters*, exhib. cat., London, Dulwich Picture Gallery, 1995, no. 1

Paolo Caliari is better known as Veronese, after his birthplace. He trained in Verona with Antonio Badile and Giovanni Caroto and was active as a painter there in the 1540s. In 1553 he moved to Venice, where, with Titian and Tintoretto, he became one of the three great Venetian painters of the High Renaissance, undertaking a formidable series of commissions for altarpieces and decorative cycles, and also painting portraits. In 1573 he was called before the Inquisition to account for his treatment of *The Last Supper* (Accademia, Venice), which was considered indecorous, but which he did not alter, solving the problem instead by re-titling the picture *The Feast in the House of Levi*.

This painting is a victim of the less scrupulous side of the eighteenth-century art market. Some time between 1769 and 1795 the huge altarpiece of the Petrobelli Chapel from San Francesco at Lendinara was cut down into three more saleable fragments, of which Dulwich's picture is one. The National Gallery of Scotland owns the other, left-hand, fragment, *Saint Anthony Abbot as Patron of a Kneeling Donor*, and the National Gallery of Canada owns the upper, arched portion, *The Dead Christ with Angels*. Cleaning in 1948 revealed overpainted details, not only of Saint Jerome's lion on the right, but of a missing central figure of Saint Michael with a devil underfoot. The lion had been systematically scraped off, and only a ghost of the original beast can now be seen.

The donor here is identifiable as Girolamo Petrobelli (died May 2, 1587), whose brother Antonio is shown in the Edinburgh fragment. The erection of a stone altar in 1563 was commemorated in an inscription identifying the two brothers as patrons. The altarpiece was presumably painted at the same time. It illustrates the principle of intercession, the two brothers being represented in the divine presence by their name saints, Anthony and Jerome (Girolamo being the Italian for that name). It is as if the brothers have been interrupted by their name saints while praying to Saint Michael (to whom the chapel was dedicated) for their souls, one of which is seen in Saint Michael's balance (visible in the Dulwich picture). Saint Jerome seems to remind Girolamo of the sure source of all mercy, gesturing to the image of the Dead Christ with the instruments of the Passion. Girolamo's surprise and awe are beautifully conveyed in his turned head. In its complete state the altarpiece must have been both beautiful and dramatic. Even in its fragmented state the interaction between donor and saint makes for a moving and imposing image.

IACD

2 Lodovico Carracci

BOLOGNA 1555–1619 BOLOGNA

Saint Francis in Meditation, early 1580s

Oil on copper
13¾ × 10⅛ in. (34.9 × 25.7 cm)
DPG 269; Bourgeois bequest, 1811

REFERENCES: H. Bodmer, *Ludovico Carracci*, Burg bei Magdeburg, 1939, p. 142

Lodovico Carracci served his apprenticeship with Prospero Fontana in Bologna. In 1582, with his cousins Annibale and Agostino Carracci, he founded the Accademia dei Desiderosi, of which he, as the eldest, was the legal head. Whereas his cousins moved to Rome, there to preside over the birth of a new form of Baroque classicism, Lodovico developed his own highly personal style based for the most part in Bologna. As a result, the Accademia can truly be said to have been at the fountainhead of two of the most important parallel developments of Baroque art, with Lodovico representing the dramatic, painterly strand. Both Guercino and Guido Reni learned from him in Bologna and were in turn influenced by Annibale when they visited Rome.

The color and emotional spirituality of this little *Saint Francis* are certainly reminiscent of Reni. Although Bodmer placed it among works attributed to the artist or from his workshop, recent cleaning has confirmed the attribution to Lodovico of this small devotional piece, a work from the early 1580s. It is not identifiable as any particular scene from the saint's life, the presence of the skull merely indicating a generalized scene of penitence. The painting was probably formerly owned by Sir Joshua Reynolds, appearing in his sale at Christie's, March 14, 1795 (lot 55), as "Annibale Carracci, *S. Francis at Devotion*, small, on copper."

IACD

3 Guido Reni

BOLOGNA 1575–1642 BOLOGNA

Saint Sebastian, 1630s

Oil on canvas
67 × 51⅝ in. (170.1 × 131.1 cm)
DPG 268; Bourgeois bequest, 1811

REFERENCES: D.S. Pepper, *Guido Reni*, Oxford, 1984, no. 54/5 (as copy); D.S. Pepper, *Guido Reni: L'opera completa*, Novara, 1988, no. 54/5 (as copy); D.S. Pepper in *Kolekcja dla Króla*, exhib. cat., Warsaw, Royal Castle, 1992, no. 21 (as Reni)

Guido Reni studied with Denys Calvaert before entering the academy set up by Lodovico, Annibale, and Agostino Carracci in 1594–95 (see cat. 2). In 1601 he went with Francesco Albani, a fellow pupil of both Calvaert and the Carracci, to Rome, where he received important commissions from Pope Paul V and his nephew Cardinal Scipione Borghese. In 1614 he returned to Bologna, where, apart from a trip to Naples and Rome in 1621 and visits to Rome in 1627 and 1632, he remained until his death. Reni was the leading painter of the Bolognese school and exerted a wide influence to the end of the century and beyond through his many pupils. In his own time, and right up to the middle of the nineteenth century, he was one of the most celebrated of all painters – like Raphael, dubbed "divine." In Victorian times, however, his reputation was violently attacked by such critics as John Ruskin, and has taken more than a century to recover.

The grandiloquence of the frame announces this picture's pre-eminence at Dulwich in the nineteenth century, when it was one of the paintings that hung in pride of place at the end of Sir John Soane's famous enfilade. Changing tastes and, in this case, a change of status – in 1880 it was catalogued (by J.P. Richter) as a studio work, in 1980 (by Peter Murray) as a copy – resulted in its removal to a less prominent position. Recent conservation, however, has fully reinstated its autograph status, as a prime version of a composition also to be found at the Prado and the Louvre. D.S. Pepper considers both the Dulwich and the Louvre paintings to be autograph replicas of the Prado original. Both the Dulwich and the Louvre paintings differ from the Prado version in the inclusion of Sebastian's left hand, in the more revealing loincloth, and in the figures added to the landscape. A pentimento in the Dulwich version clearly reveals that the loincloth has been reduced.

Although the painting has been damaged, particularly around the edges, its cleaning has revealed areas of exceptional virtuosity of paint handling, for instance, in the diagonal striations that model the saint's left thigh and in his loincloth. The handling of Reni's characteristic heavenward glance is also particularly fine, the subtly shaded head seeming less mannered than in the other versions. The sensitivity of the modeling of the torso in general, controlled but executed with speed and fluidity, suggests a date in the 1630s. The Prado version is dated 1617–18, and Pepper dates the Louvre version to the same time.

Sebastian was a Roman soldier condemned to death by the Emperor Diocletian for aiding the Christians. His fellow soldiers pierced him with arrows, and this image is the one most often shown by artists; for Sebastian, however, it represented only the beginning of the end. He did not die. Nursed back to life by Irene, a Roman widow (see cat. 9), he was eventually clubbed to death on reaffirming his faith to Diocletian.

IACD

4 Guido Reni

BOLOGNA 1575–1642 BOLOGNA

Saint John the Baptist in the Wilderness, 1636–37

Oil on canvas
88¾ × 63⅞ in. (225.4 × 162.2 cm)
DPG 262; Bourgeois bequest, 1811

REFERENCES: D.S. Pepper, *Guido Reni*, Oxford, 1984, no. 165; D.S. Pepper, *Guido Reni: L'opera completa*, Novara, 1988, no. 156

Guido Reni, like other Bolognese masters of this period, most famously Annibale Carracci and Guercino, developed a distinct "late manner." This picture, a superb example of Reni's late style, has the softness and fluidity Reni adopted in his last years; it is dated (by D.S. Pepper) to 1636–37, though Reni had treated the same subject on at least two occasions in the 1620s. His sureness of touch is most brilliantly demonstrated in the modeling of the figure, youthful and wiry but certainly not heroic, achieved with the utmost economy of painterly means. The coarseness of Saint John's drapery is effortlessly suggested.

The painting is also notable for its direct and dramatic interpretation of the Baptist's character, avoiding the theatrical emotionalism that makes much of Reni's religious work unpalatable to many. This teenage Saint John has a gaunt urgency of expression appropriate to his role and driven character. His diagonal posture and sideways glance imply a crowd of listeners off to the right, being summoned by the "voice crying in the wilderness" (Matthew 3:1–6; Mark 1:1–8; Luke 3:3–18; John 1:6–28).

The artist's biographer, Malvasia (1678), records the picture as being in the collection of G. Francesco Maria Balbi in Genoa. A Scottish dealer, Andrew Wilson, acquired the picture in January 1805, subsequently selling it for 1000 guineas, a fabulous price, to Noel Desenfans, from whom it passed to Francis Bourgeois.

IACD

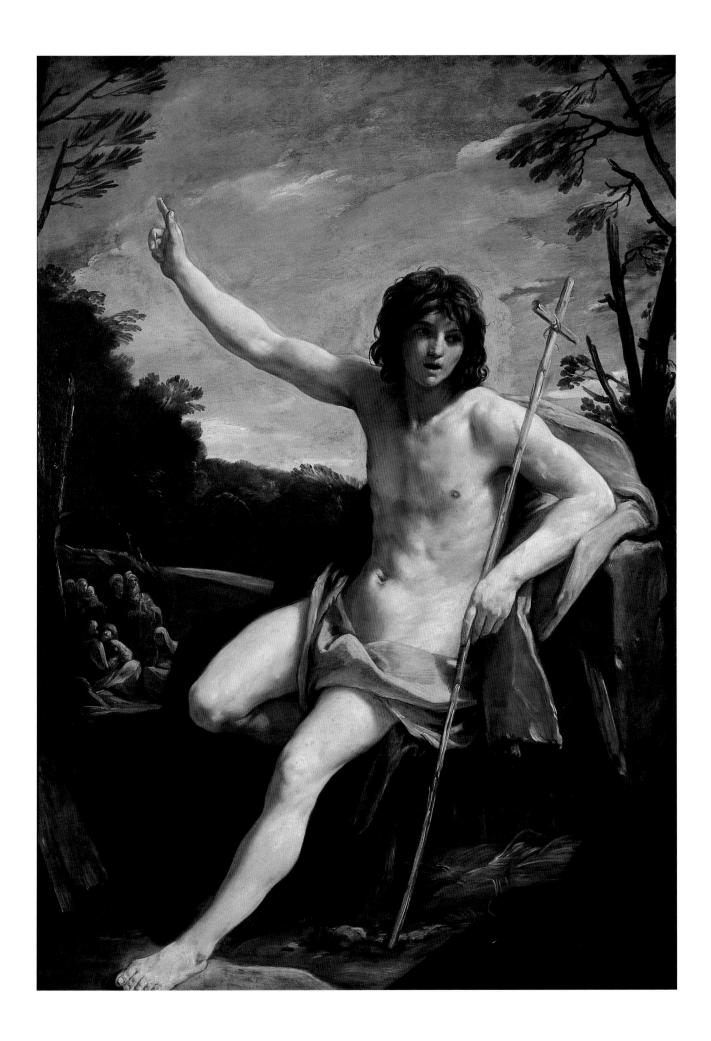

5 Guercino (Giovanni Francesco Barbieri)

CENTO 1591–1666 BOLOGNA

The Woman Taken in Adultery, ca. 1621

Oil on canvas
31⅝ × 48¼ in. (98.2 × 122.7 cm)
DPG 282; Bourgeois bequest, 1811

REFERENCES: D. Mahon in *Collection for a King*, exhib. cat., Washington, D.C., National Gallery of Art, and Los Angeles County Museum of Art, 1985–86, no. 12; L. Salerno, *I dipinti del Guercino*, Rome, 1988, no. 75

Giovanni Francesco Barbieri was nicknamed "il Guercino" in reference to a pronounced squint. He received some training in Bologna from the obscure Paolo Zagnoni before serving his apprenticeship in Cento from 1607 with Benedetto Gennari the elder, but he was essentially self-taught. Guercino was active as an independent master in Cento by 1613. His talent was recognized early: Lodovico Carracci wrote of a "young man from Cento who paints with a great joyfulness of invention. He is a great draftsman and a most felicitous colorist: his art is a display from nature and a wonder which amazes those who see his works." After a trip to Venice in 1618, Guercino was called to Rome to work for the Bolognese pope Gregory XV, remaining there until the pope's death in 1623. He then returned to Cento, where he stayed until 1642, when, following the death of Guido Reni, he moved his workshop to Bologna, effectively taking over Reni's mantle as leading master of the Bolognese school. The vigorous, dramatic style of Guercino's early years was abandoned after his visit to Rome in favor of a more restrained and classical manner.

With its dramatic lighting and bold handling of paint and subject matter, this painting is characteristic of Guercino's early manner. He uses light like a filmmaker: it intensifies the psychological impact of his scenes, flickering over the surface and picking out significant detail. In this case the eyes of Christ and the downcast expression of the adulteress attract the viewer's attention, while much of the power of the composition derives from the intricate patterns of gesturing hands. Denis Mahon dates the painting to 1621, either just before or just after Guercino's journey to Rome in May 1621.

Apart from this trip, Guercino resisted all offers from foreign courts, including that of Charles I of Great Britain. As a deeply religious man, he viewed England as virtually pagan. Moreover, he did not like to travel and had no need to. He had been perfectly happy to remain in Cento, and only the death of his rival, Guido Reni, led him to move to Bologna.

The scene illustrated is that described in John 8:2–11. In a situation engineered by the Pharisees to trick Christ into a denial of Mosaic Law, which demanded the stoning to death of an adulteress, this is the moment before Christ speaks. Guercino makes us feel the question hanging in the air, the fleeting moment of tension that will be defused only by Christ's answer: "He that is without sin among you, let him cast the first stone."

IACD

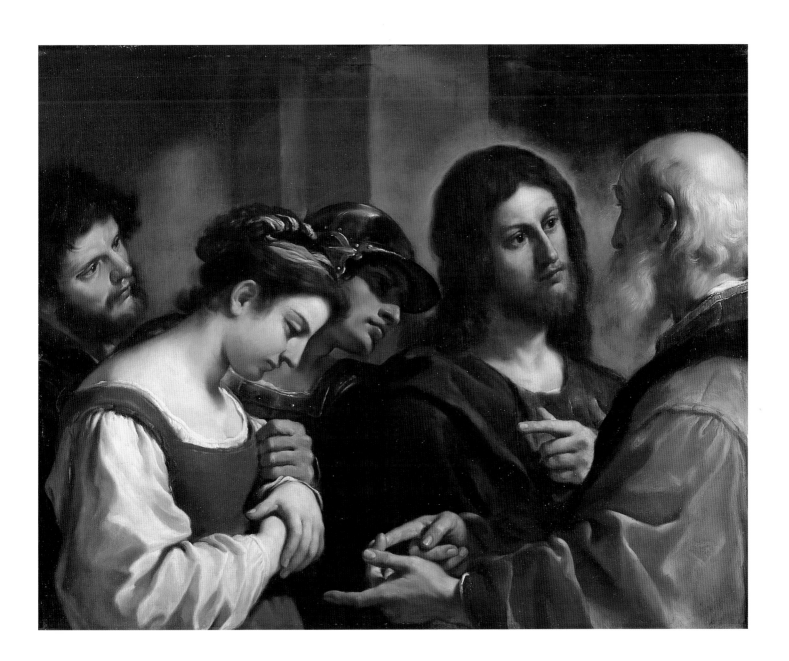

6 Guercino (Giovanni Francesco Barbieri)

CENTO 1591–1666 BOLOGNA

Saint Cecilia, ca. 1648–50

Oil on canvas
47⅞ × 39⅞ in. (121.9 × 101 cm)
DPG 237; Bourgeois bequest, 1811

REFERENCES: J.P. Richter and J.C.L. Sparkes, *Catalogue of the Pictures in the Dulwich College Gallery with Biographical Notices of the Painters*, London, 1880, no. 324; L. Salerno, *I dipinti del Guercino*, Rome, 1988, no. 266

Documented with certainty for the first time in 1804, in the collection of Noel Desenfans, this image is almost certainly the half-length picture painted for the Marchesa Virginia Turca Bevilacqua, from whom Guercino's scrupulous ledgers record an initial payment of 25 *scudi* on September 30, 1648, and the balance of 50 *scudi* on January 5, 1650.

The work therefore dates from the period when Guercino had taken over from Reni (see cat. 5) as principal painter in Bologna. His style, which had been gradually changing since his trip to Rome of 1621–23, had by this time acquired a distinctive classical character, very different from that of the *Woman Taken in Adultery* (cat. 5). While lighting remains important, and brings a peculiar intensity to the face of the saint as she concentrates on her music, the role of color – here, a rich, tawny Venetian palette – has come to the fore, and the composition is characterized by a calm breadth and solidity. In 1880 J.P. Richter arbitrarily reassigned the painting to Guercino's pupil Benedetto Gennari the younger, but this is clearly the work of the master and entirely typical of him.

Saint Cecilia, a rather obscure Roman virgin martyr, apparently heard heavenly music on the way to her unwanted marriage, and asked God to keep her body and soul without stain. From this association, she became the patron saint of music.

IACD

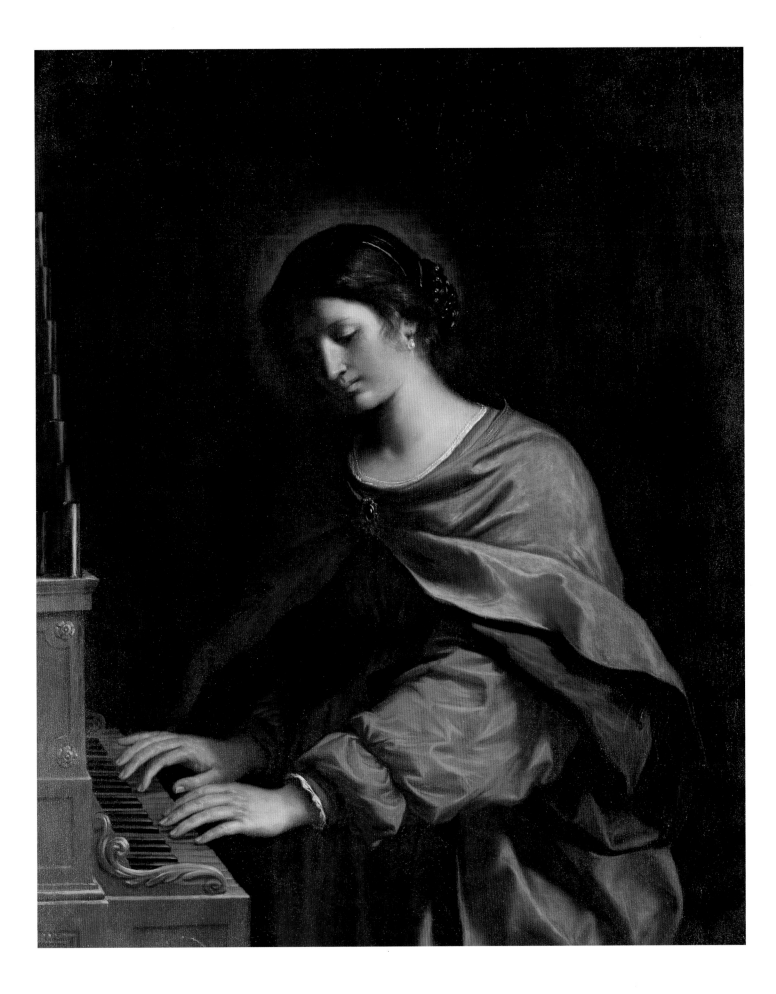

7 Salvator Rosa

ARENELLA 1615–1673 ROME

Soldiers Gambling, ca. 1656–58

Signed, lower right: *S Rosa*
(SR in monogram)
Oil on canvas
30⅜ × 24¼ in. (77 × 61.3 cm)
DPG 216; Bourgeois bequest, 1811

REFERENCES: L. Salerno, *L'opera completa di Salvator Rosa,* Milan, 1975, no. 136; R.W. Wallace, *The Etchings of Salvator Rosa,* Princeton, 1979, under no. 29 (as copy or imitation); M. Kitson in *Kolekcja dla Króla,* exhib. cat., Warsaw, Royal Castle, 1992, no. 23

Salvator Rosa was a pupil in Naples of his uncle Domenico Greco, and of Francesco Fracanzano and Aniello Falcone. Intensely ambitious and with a volatile temper, he soon acquired prominence and notoriety after moving to Rome in 1635. He was again in Naples, which he later claimed to loathe, in 1638 and was working in Viterbo in 1638–39. In 1640 he moved to Florence, where he produced satirical poetry and was involved with music and the theater, and became the center of a sophisticated literary circle. He returned to Rome in 1649.

As a painter he was chiefly famous for his landscapes, which eschewed classical regularity in favor of a wild romanticism, with riven trees, beetling crags, and picturesque *banditti* dwarfed by the majesty of nature. Beginning in the 1650s he also worked, though not entirely successfully, to establish a reputation for his history painting. Byronic two hundred years before Byron, Rosa's character lent itself to self-mythologizing and bio-graphical hyperbole. Stories abound of his arbitrary and high-handed treatment of despised patrons and his belief in his own talent. He was to become one of the archetypes of the tortured genius. British collectors in the eighteenth century particularly valued him, and virtually all of the major collections of the time contained examples of his work.

This painting is of particular interest in having its genesis in a series of etchings known as *Le figurine,* in which Rosa displayed his imaginative powers in characteristically picturesque figures, mostly soldiers. Rosa recognized the kinship, probably actual, between these soldiers and his favorite *banditti.* When soldiers were required, the bandits who infested the woods and mountains of Italy

were a natural source for recruitment. The figures in this painting (only one of which, the standing figure on the right, was worked up from the etchings) have a certain wild glamour about them, intensified by the lurid, hallucinatory colors and glowering sky. The painting probably dates from around the time of the first set of *Figurine, ca.* 1656–58.

IACD

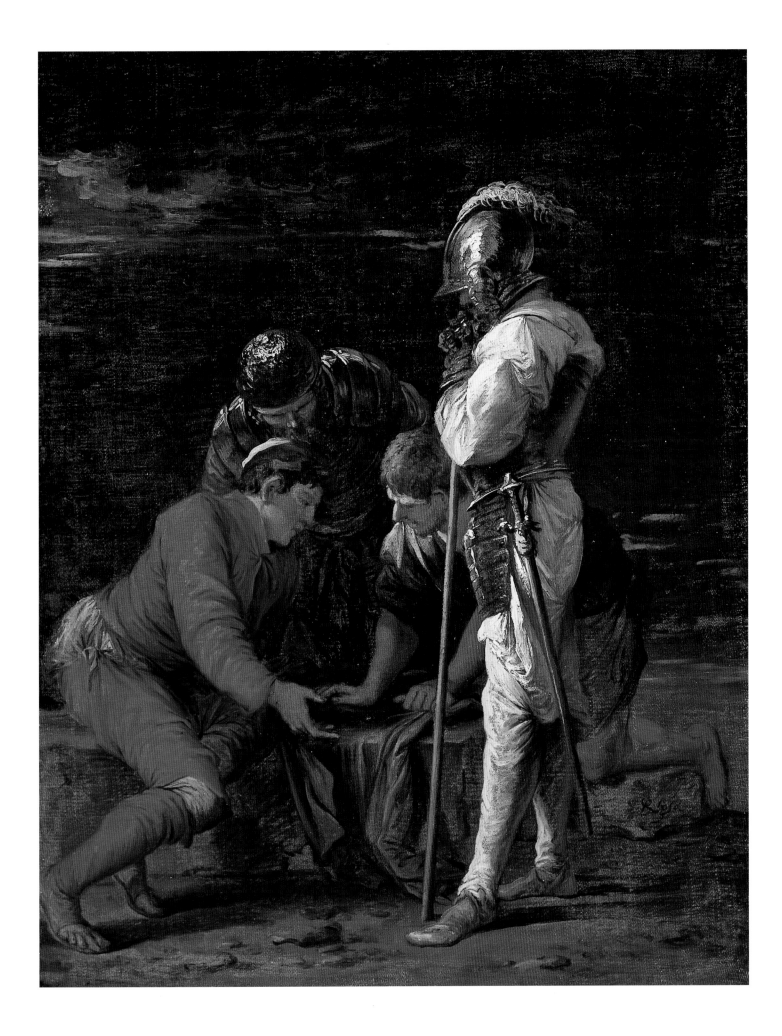

8 Carlo Dolci

FLORENCE 1616–1687 FLORENCE

Saint Catherine of Siena, ca. 1665–70

Oil on cedar panel
9⅝ × 7⅛ in. (24.4 × 18.1 cm)
DPG 242; Bourgeois bequest, 1811

REFERENCES: C. McCorquodale in
Kolekcja dla Króla, exhib. cat., Warsaw,
Royal Castle, 1992, no. 6; F. Baldassari,
Carlo Dolci, Turin, 1995, no. 122

Carlo Dolci studied under Jacopo Vignali. A child prodigy, Dolci was painting portraits by the age of fifteen and was soon receiving prestigious commissions. Apart from a trip to Innsbruck in 1675 to paint a portrait of Claudia Felice de' Medici, he remained in Florence, where he was a member of the Accademia del Disegno from 1648. Dolci painted a number of large altarpieces, as well as portraits and still lifes, but his reputation was made with the production of small-scale devotional pieces such as this. He was the foremost Florentine painter of the seventeenth century, celebrated throughout Europe.

Dolci's precision of technique eliminates the brushstroke almost entirely. Luminosity of color and a concentration on expression, allied to a slick chiaroscuro (owing much to Correggio and Leonardo) result in images of a curiously surreal intensity. Dolci was a deeply pious man, and his work was meant to elicit a similar response from those who looked at it. This form of manipulative religiosity, in which an artist focuses his viewer on reading an expression of suffering with particular accuracy, the better to identify with the object of devotion, was one of the characteristic legacies of the Counter Reformation, and in particular of the hugely influential *Spiritual Exercises* of Saint Ignatius Loyola.

Saint Catherine (*ca.* 1347–1380) took vows of virginity at seven, and at ten, in defiance of her family, entered the Third Order of Saint Dominic, the habit of which she wears here. Her work among cancer and leprosy patients ruined her health. She was alleged to have received the Stigmata, although the marks were not visible, and the Franciscans disputed this.

As a visionary saint she was a perfect subject for Dolci. Head raised up, eyes half-closed in hallucinatory concentration, her mouth is open as if in prayer or ecstasy. The crown of thorns in her vision, in which Christ offered her a choice between that or a crown of gold, has here taken physical form on her head. A single tear, rendered with a realism reminiscent of a Flemish fifteenth-century master's *Mater Dolorosa*, descends her cheek, providing a focal point for fervent meditation.

Dolci's reputation suffered in the nineteenth century. The English writer William Hazlitt, mistaking the subject of this painting, described it as follows, "No. 337, a *Mater Dolorosa*, by Carlo Dolce, is a very good specimen of this master; but the expression has too great a mixture of piety and pauperism in it. It is not altogether spiritual."

IACD

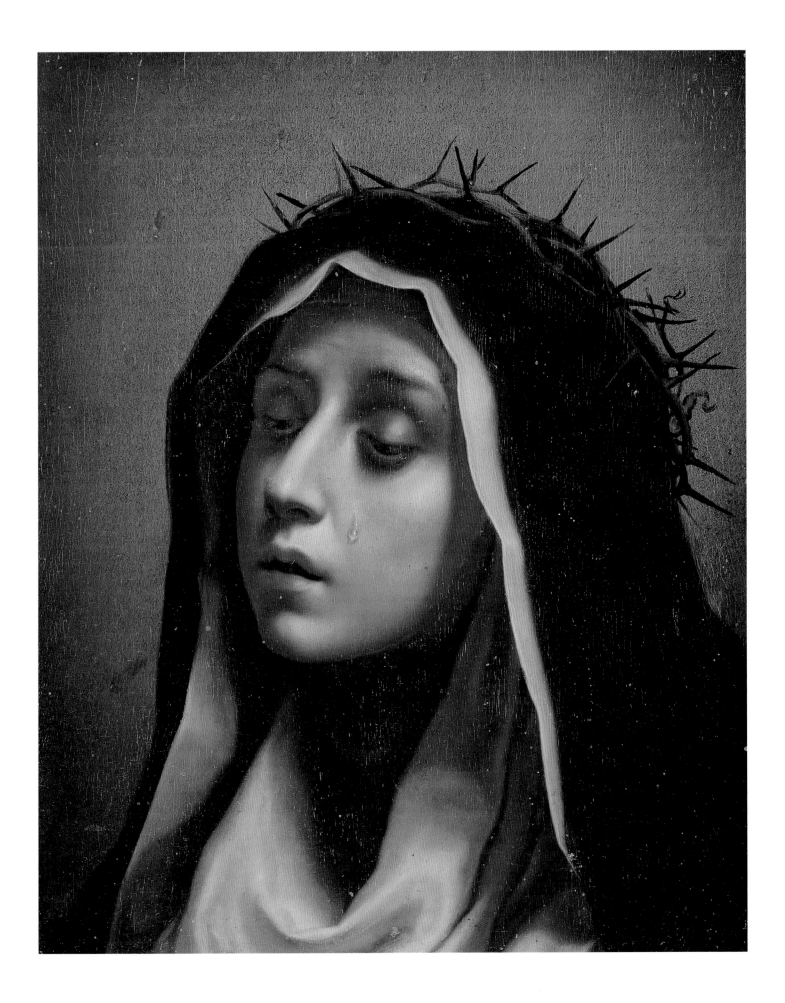

9 Antonio Bellucci

VENICE 1654–1726 PIEVE DI SOLIGO

Saint Sebastian Tended by Irene, ca. 1716–18

Oil on canvas
57 × 52⅞ in. (144.7 × 134.3 cm)
DPG 46; Gift of Rev. T.B. Murray, 1852

REFERENCES: F. Magani, *Antonio Bellucci, catalogo ragionato*, Rimini, 1995, no. 82

Antonio Bellucci is said to have studied drawing with the nobleman Domenico Difnico in Dalmatia, but his style was formed in Venice, where he was influenced by Pietro Liberi, Andrea Celesti, and Antonio Zanchi. In 1692 he undertook four altarpieces for Klosterneuburg in Austria, and for much of the next thirty years he worked abroad, in Vienna (1695–1700 and 1702) and Düsseldorf (1705–16). Bellucci was one of a series of Venetian artists, including his pupil Sebastiano Ricci, who visited England in the early years of the eighteenth century, in his case in 1716–22, enjoying great success with the court. He may have executed this painting during that period. His work for the Duke of Chandos at Canons Park included the decoration of a chapel that has since been moved to Great Witley Church, Worcestershire.

This scene represents the next phase in Saint Sebastian's story after the failed martyrdom by arrows shown in Guido Reni's work (cat. 3). Here Irene, the wife of Saint Castulus, having come to bury Sebastian, finds him alive, though pierced with arrows, and tends to him. With immense anxiety, she is trying to pull out an arrow; not surprisingly, he seems to be swooning, eyes raised to heaven for help. Sebastion is supported by an allegorical figure with a cross and chalice representing Faith, looking very much as if she has stepped out of a painting by Paolo Veronese, both in facial type and in handling. A heavenly light breaks behind the dominating cross, illuminating Faith and flooding across Sebastian's heroically beautiful body.

The story of Saint Sebastian was primarily used as a vehicle for painting the male nude, and Bellucci provides a piece of virtuoso work of an almost masochistic lushness, dwelling on showy details such as the way Faith's hand pinches the flesh and the rawness of the arrow wound, thereby intensifying our shared sense of the saint's agony. His tortured expression derives from the famous Hellenistic sculpture of Laocoön in the Vatican.

IACD

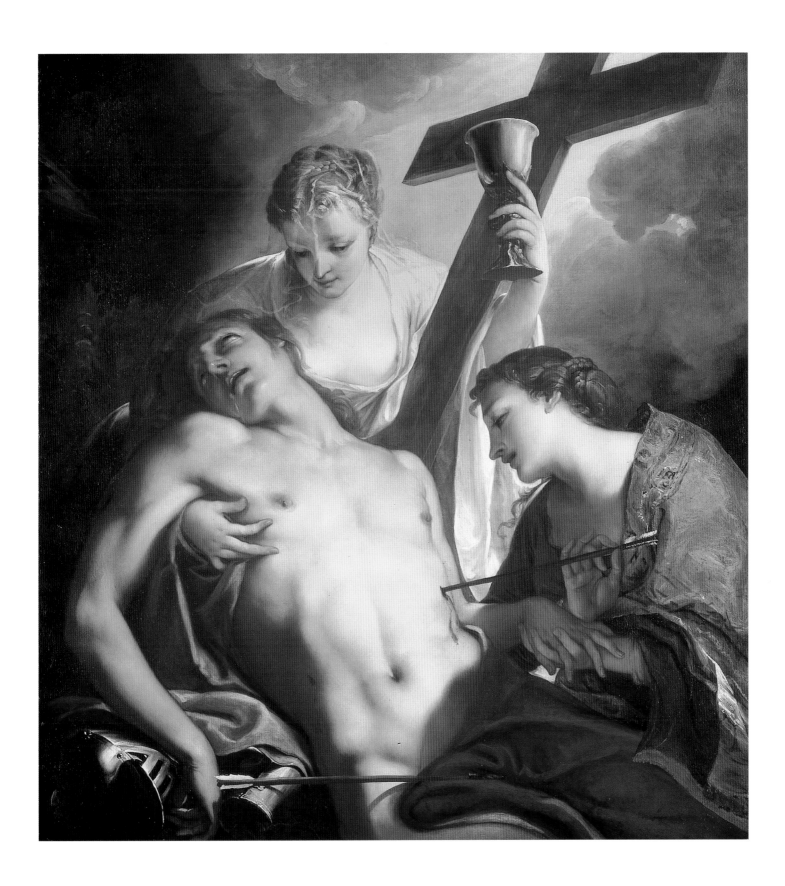

10 Sebastiano Ricci

BELLUNO 1659–1734 VENICE

The Fall of the Rebel Angels, ca. 1720

Oil on canvas
32¼ × 26¾ in. (82 × 67.8 cm), including
made-up strips of approximately ¾ in.
(2 cm) top and bottom and ⅜ in. (1 cm)
left and right
DPG 134; Bourgeois bequest, 1811

REFERENCES: J. Daniels, *Sebastiano Ricci*,
Hove, 1976, no. 176

Sebastiano Ricci trained in Venice with
Federico Cevelli and in Bologna with
Giovanni dal Sole. He was called to Parma by
Ranuccio II Farnese, who sent him to Rome to
complete his studies. Ricci's colorful career
included two spells in jail. He worked vari-
ously in Milan, Venice, Vienna, Bergamo, and
Florence before making a trip to England in
1711/12–16; he returned through France and
possibly Holland to Venice, where he finally
settled. He was elected to the French Academy
in 1716 and to the Accademia Clementina in
Bologna in 1723.

The subject of Saint Michael driving out the
Rebel Angels had been extremely popular with
artists ever since Raphael painted his seminal
version (Louvre, Paris) in 1518. Raphael's
poised angel has only one adversary; Ricci's
has to cope with five. To do this, he is provided
with a glowing shield (a prop perhaps more
reminiscent of the mythical Perseus), which
provides the principal light source for a
virtuoso display of figure painting. Similarly,
while Raphael (and Guido Reni, who also
painted a famous *Saint Michael*) posed his angel
upright, epitomizing grace and power in the
one heroic figure, Ricci makes far more of a
diagonal dash of the onslaught; this is an
exceptionally dynamic composition, carefully
balanced nonetheless in the form of a stable
triangle with Saint Michael's head at its apex. A
further modifying accent is implied by the line
of his gaze, which leads through the shield,
three carefully placed hands, and the head of
the central rebel.

The lively sense of movement, dynamic
handling of paint, and brilliant color are
characteristic of the Venetian Rococo, of
which Sebastiano Ricci was the virtual creator.
There are related drawings in the Royal Library
at Windsor Castle and in the Galleria
dell'Accademia, Venice.

IACD

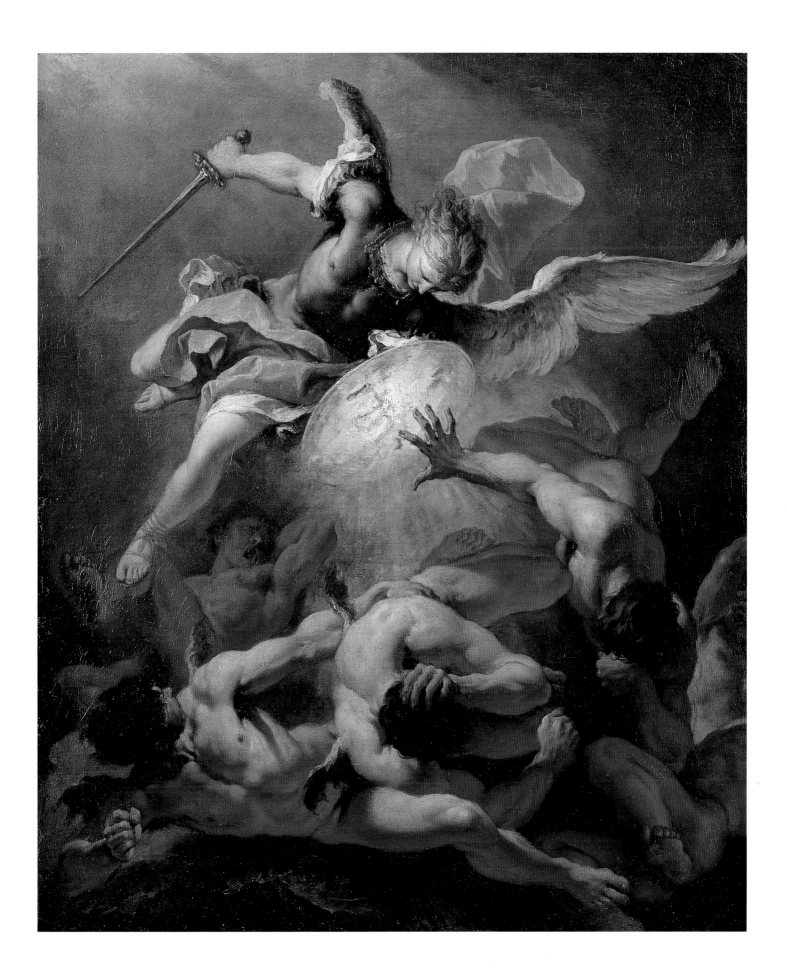

11 Sebastiano Ricci

BELLUNO 1659–1734 VENICE

The Resurrection, ca. 1715–16

Oil on canvas
34¾ × 46¾ in. (88.3 × 118.7 cm)
DPG 195; Bourgeois bequest, 1811

REFERENCES: J. Daniels, *Sebastiano Ricci*,
Hove, 1976, no. 177; J. Daniels in *Collection
for a King*, Washington, D.C., National
Gallery of Art, and Los Angeles County
Museum of Art, 1985–86, no. 28;
J. Daniels in *Kolekcja dla Króla*, exhib. cat.,
Warsaw, Royal Castle, 1992, no. 22;
Sebastiano Ricci, exhib. cat., Udine, Villa
Manin de Passariano, 1989, no. 38

Little survives of Sebastiano Ricci's
activity in England. Probably best known
is the cycle of paintings commissioned by
the Earl of Burlington for Burlington
House, Piccadilly, London, now the home
of the Royal Academy of Arts. This cycle
was divided up in 1729, though elements of
it are still visible at Burlington House and
at Chiswick House. The other significant
example of Ricci's work in England is *The
Resurrection of Christ*, which decorates the
apse of the Chapel of the Chelsea Hospital.
The Dulwich painting is one of two extant
sketches for that composition, and is in all
likelihood the original *modello*. The
commission may have been given to Ricci
by George I as something of a consolation
prize, after the commission to decorate
the newly completed dome of Saint Paul's
Cathedral, London – really the only
opportunity to paint religious themes on a
comparable scale to those in Italy to have
arisen in England – was given, for patriotic
reasons, to Sir James Thornhill.

This composition, which shows the
influence of both Annibale Carracci and
Veronese, epitomizes the qualities of the
Venetian Rococo in its movement and
bravura, and demonstrates Ricci's skills in
the handling of large-scale, dramatic
compositions.

IACD

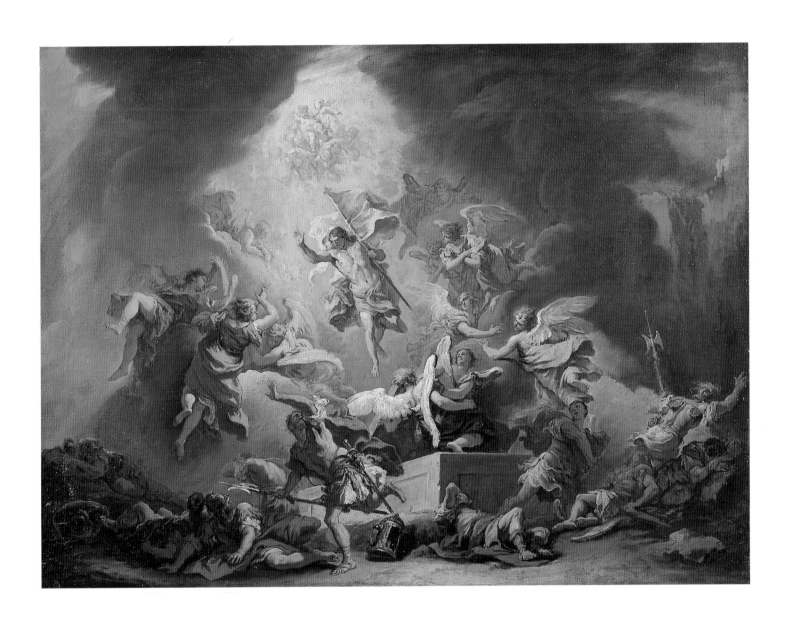

12 Canaletto (Giovanni Antonio Canal)

VENICE 1697–1768 VENICE

Old Walton Bridge over the Thames, 1754

Oil on canvas
19¼ × 30¼ in. (48.8 × 76.7 cm)
DPG 600; Gift of Miss E. Murray Smith, 1917

REFERENCES: W.G. Constable, *Canaletto*, Oxford, 1962; 2nd ed. rev. J.G. Links, Oxford, 1976 (reprinted with supplement, 1989), no. 441; J.G. Links in *Collection for a King*, Washington, D.C., National Gallery of Art, and Los Angeles County Museum of Art, 1985–86, no. 3

Canaletto was first trained by his father, a scene painter in the theater. He became a member of the Venetian painters' guild in 1720. He may have spent some time during this period in the workshop of the view-painter Luca Carlevaris. Canaletto's views of Venice sold particularly well to British visitors on the Grand Tour. The British consul Joseph Smith acted as his agent and was also his main patron. In the early 1740s the British market was affected by the War of the Austrian Succession and Canaletto turned to drawing and engraving and to painting *capricci* and landscapes. In 1746–55/56, apart from two return trips to Venice, he was based in England, where he painted topographical views of London and of his patrons' country houses. He returned to Venice in 1755–56 and became a member of the Venetian Academy in 1763.

This painting bears a label on the verso that reads: "Behind this picture on the original canvas is the following inscription by Canaletto: *Fatto nel anno 1754 in Londra per la prima ed ultima volta con ogni maggior attenzione ad instanza del Signior Cavaliere Hollis padrone mio stimatissimo/Antonio Canal detto il Canaletto* [Painted in 1754 in London, for the first and last time, with the greatest possible care, commissioned by Signor Hollis my most esteemed patron/Antonio Canal, called Canaletto]. It was necessary to reline the picture in 1850 so the inscription was hid. John Disney, 1850."

Thomas Hollis bought six paintings from Canaletto, of which *Old Walton Bridge* is by far the finest. Four of the works still have certificates of authentication such as the one recorded above, and no doubt this was something Hollis demanded for all six. The bridge, built in 1750, had a huge central arch, 130 feet wide. According to an old catalogue, Hollis himself can be seen in the foreground, with his friend Thomas Brand, his servant Francesco Giovannini, and his dog Malta. The artist toward the left is perhaps intended to be Canaletto himself.

The picture is unusual for its dramatic cloudscape. Other carefully observed details include a sailing barge with its mast and rigging lowered in preparation for going under the bridge. Canaletto's recorded assurance that this was the "first and last" version of this picture was in fact rather stretching a point. Less than a year later he revisited the composition and produced an extended version for Samuel Dicker MP, who lived in one of the houses visible on the other side of the river, and who had paid for the bridge to be built. Dicker's version (now in the Paul Mellon Collection, Yale) is seen from a slightly different angle and includes details of the stone-clad approaches and the surviving old bridge. The Dulwich picture is now accepted as one of the masterpieces of Canaletto's stay in England.

IACD

13 Giambattista Tiepolo

VENICE 1696–1770 MADRID

Joseph Receiving Pharaoh's Ring, ca. 1735

Oil on canvas
41¾ × 70¾ in. (106.1 × 179.7 cm)
DPG 158; Bourgeois bequest, 1811

REFERENCES: M. Levey in *Collection for a King*, exhib. cat., Washington, D.C., National Gallery of Art, and Los Angeles County Museum of Art, 1985–86, no. 30; M. Levey in *Kolekcja dla Króla*, exhib. cat., Warsaw, Royal Castle, 1992, no. 25; M. Gemin and F. Pedrocco, *Giambattista Tiepolo: I dipinti. Opera completa*, Venice, 1993, no. 206; A. Bayer in *Giambattista Tiepolo, 1696–1996*, exhib. cat., ed. K. Christiansen, Venice, Ca' Rezzonico, and New York, Metropolitan Museum of Art, 1996–67, no. 14

Giambattista Tiepolo studied with Gregorio Lazzarini in Venice, where he was active as an independent painter by 1715–16, becoming a member of the painters' confraternity in 1717. He soon established his reputation and received a succession of important commissions for altarpieces and ceiling decorations in and around Venice and in other North Italian cities. In 1750–53 he was working on decorations in the Residenz at Würzburg, assisted by his sons Domenico and Lorenzo. He was elected president of the Venetian Academy in 1756. On the summons of Charles III of Spain he traveled to Madrid in 1762 and remained there until his death. During his lifetime Tiepolo was the unrivalled master of ceiling decoration and large decorative schemes, continuing the tradition of Veronese.

This painting illustrates a scene in Genesis 41:42, when Pharaoh "said unto Joseph, See, I have set thee over all the land of Egypt. And Pharaoh took off his ring from his hand, and put it upon Joseph's hand, and arrayed him in vestures of fine linen, and put a gold chain about his neck." This is a rather uncommon subject and the picture is something of an oddity in the context of Tiepolo's work. The long, horizontal format is common enough in Bolognese seventeenth-century practice, as in Guercino's *Woman Taken in Adultery* (cat. 5), but is exceptional for Tiepolo. His color is bright, even sharp, with a tawny quality, and the figures are flattened out in relation to the picture's surface, as if in low relief. These characteristics make a date in the mid-1730s most likely, and one eye-catching detail – the standard-bearer's dragon helmet – is identical to another helmet, worn by the allegorical figure of Valor, in Tiepolo's frescos at the Villa Loschi al Biron, near Vicenza, of 1734. The

more distant of the two trumpeters has often been said to be a self-portrait. The artist's decorative brilliance is amply illustrated in such details as the figure with his back to us on the left, caught in silhouette against Pharaoh's dazzling sleeve, and in the architectural flourish of brackets that echoes that of the trumpeters directly below. All is held together by a strong compositional triangle, rooted by the solid fluted column that reinforces the focus of the composition on the delicately painted face of Joseph.

IACD

14, 15 Giambattista Tiepolo

VENICE 1696–1770 MADRID

Diana and a Nymph, ca. 1750

Apollo and Nymphs, ca. 1750

Each, oil on canvas
Each, 13⅛ × 13 in. (33.3 × 33 cm)
DPG 186, 189; Bourgeois bequest, 1811

REFERENCES: M. Gemin and F. Pedrocco, *Giambattista Tiepolo: I dipinti. Opera completa*, Venice, 1993, no. 399a

These two sketches were once a single *modello* for the ceiling decoration *The Triumph of Diana*, which survives in the first-floor *salone* of the Villa Cornaro at Merlengo in the Veneto. It had already been cut in two, for ease of viewing the figures, when Sir Francis Bourgeois bought them in May 1802. The date of the *modello* would be around 1750.

Diana is seen in triumph with the evidence of her hunting around her. Her brother Apollo, with his lyre, observes her from another cloud, while an unknown goddess, also equipped with hunting gear, gestures to a companion. The composition depends on a simple S-shaped line anchored at each end in clouds. The completed fresco replaces the *modello*'s two viewpoints with a single one.

IACD

16 Giambattista Tiepolo

VENICE 1696–1770 MADRID

Virtue and Nobility Putting Ignorance to Flight, early 1740s

Oil on canvas
25¼ × 14 in. (64.2 × 35.6 cm)
DPG 278; Bourgeois bequest, 1811

REFERENCES: M. Levey in *Collection for a King*, Washington, D.C., National Gallery of Art, and Los Angeles County Museum of Art, 1985–86, no. 31; B. Mazza in *I Tiepolo e il Settecento vicentino*, exhib. cat., Montecchio Maggiore and Bassano del Grappa, 1990, p. 312; M. Gemin and F. Pedrocco, *Giambattista Tiepolo: I dipinti. Opera completa*, Venice, 1993, no. 262a; B.L. Brown, *Giambattista Tiepolo: Master of the Oil Sketch*, exhib. cat., Fort Worth, Kimbell Art Museum, 1993, no. 24

This is a sketch for the ceiling of the *salone* of the Villa Cordellina at Montecchio Maggiore, near Vicenza, painted for a lawyer, Carlo Cordellina, in 1743. The scheme was completed with two lateral scenes of *The Continence of Scipio* and *The Family of Darius Before Alexander*, two examples in practice of the allegorical action enacted above them. The winged figure holds a laurel wreath, identifying her as Virtue; the companion to whom she clings holds a statuette, which could be an attribute of either Nobility or Glory. Nobility would seem to fit the theme better. Fame blows her own trumpet to the right, and Ignorance tumbles in defeat.

Tiepolo effortlessly defined the grand decorative style for the eighteenth century. As in this sketch, his schemes are sunlit and airy, and ravishingly colored.

IACD

17 Francesco Zuccarelli

PITIGLIANO (NEAR FLORENCE) 1702–1788 FLORENCE

Landscape with a Fountain, Figures, and Animals, ca. 1755–60

Oil on canvas
39¼ × 49⅛ in. (99.7 × 124.8 cm)
DPG 175; Bourgeois bequest, 1811

REFERENCES: E. Waterhouse, *Painting in Britain, 1530 to 1790* (Pelican History of Art), London, 1953; M. Levey, "Francesco Zuccarelli in England," *Italian Studies*, XIV, 1959, pp. 1–21; M. Levey, "Wilson and Zuccarelli at Venice," *Burlington Magazine*, CI, 1959, pp. 139–43

Although Francesco Zuccarelli's early career was based mainly in Florence (with some training in Rome from Paolo Anesi and Giovanni Maria Morandi), he is primarily associated with Venice and England. In about 1730, he moved to Venice, where he began to concentrate exclusively on landscapes and made some British friends, notably the Welsh landscapist Richard Wilson (see cat. 85). In the 1740s he received commissions from the British consul there, Joseph Smith, who played a similarly important role in the career of Canaletto (see cat. 12). Zuccarelli came to England in 1752 and stayed there, apart from a return trip to Venice in 1762–65, until 1771. His stay coincided with the establishment in 1768 of the Royal Academy of Arts, of which he was a founding member. Back in Venice in 1772, Zuccarelli was elected president of the Venetian Academy, spending the rest of his days largely in comfortable retirement.

A regular flow of Venetian artists to England, from Antoni Bellucci and Sebastiano Ricci to Canaletto, had familiarized patrons with the stylistic qualities of the Venetian Rococo, and through these and other artists such as Rosalba Carriera and Michele Marieschi the Venetians came to represent contemporary Italian art to the British more than any other school.

This painting, with its light and sunny scene and unspecific but picturesque Italianate subject matter, is typical of the kind of work that made Zuccarelli so popular. The artist brings a breath of Venetian Rococo to the kind of subject treated in the previous century by Dutch Italianate artists such as Nicolaes Berchem (see cat. 61, 62). Such work as this may also have contributed to the comparative lack of success of an artist like Richard Wilson, whose essentially Claudean vision found less favor with British patrons.

IACD

11 The Spanish School

In the early nineteenth century, when Dulwich Picture Gallery was founded, Spanish art was in the process of being rediscovered. Richard Cumberland's *Anecdotes of Eminent Painters in Spain* appeared in 1782 and was followed by a spate of Spanish travelogues, culminating in two celebrated and almost contemporary accounts of the country and its art, Richard Ford's *A Hand-Book for Travellers in Spain* of 1845, and William Stirling's *Annals of the Artists of Spain* of 1848. During these years Spanish pilgrimages were made by artists, such as Sir David Wilkie and Eugène Delacroix, and collectors, such as William John Bankes, whose Spanish Room can still be admired at Kingston Lacy in Dorset, and the agents of the French King Louis-Philippe, whose Spanish Gallery at the Louvre opened in 1838. Most significant of all, Spain was fought over by the French and British armies during the Peninsular War (1808–14) and its art looted and counter-looted. The Duke of Wellington's haul (graciously legitimized after the fact by the King of Spain) hangs in Apsley House, London.

The Dulwich Murillos (cat. 18–21) – for many years the best collection of Murillo on public display in England – made a significant contribution to the vogue for Spanish painting during the nineteenth century. It is unlikely, however, that Desenfans bought them (or his portrait by Velázquez; cat. 22) for their Spanishness or that he in any way participated in the discovery of Spain described above. A love of Spanish art as a whole would have been precocious for the 1790s and was felt more by visitors to Spain than collectors in London; neither Bourgeois nor Desenfans was especially adventurous in his taste or his traveling. The Spanish paintings in their collection reflect an older taste, which had prevailed for a century or more, and which favored only the works of Velázquez and Murillo, insofar as they seemed to fit into the European mainstream.

These two artists enjoyed international careers. The exchange of royal portraits was a routine of diplomacy which brought originals or good replicas of Velázquez's portraits to all the major courts of Europe. Several of Murillo's most enthusiastic patrons were foreign merchants living in Seville, including the Fleming Nicolas Omazur and the Dutchman Joshua van Belle, both of whom sent home fine collections. Individual examples of his work quickly spread still further: John Evelyn records "boyes of Morella" selling in London for 80 guineas (£84) in 1693, a price which seemed to him to be "deare enough." In fact, by the eighteenth century Murillo and Velázquez had joined the common currency of old master painting. Their influence was felt especially in England, where Murillo inspired Reynolds and Gainsborough (see below, "The English School," pp. 211–13) to develop their own evocative scenes of childhood (like cat. 18, 19, and 20), which, for want of a better title, they called "fancy pictures."

But the reputations even of Velázquez and Murillo fell short of their deserts (at least to our way of thinking). Neither artist received more than a cursory mention in the surveys of European painting of the period, such as the writings of Roger de Piles (see below) or the *Discourses* of Sir Joshua Reynolds. Their work also appears to have been only partially understood: Velázquez was known merely for his conventional portraiture, and neither artist was considered within their Spanish context, about which connoisseurs knew nothing. Even as late as the Peninsular War, the landscape painter George Wallis accurately observed, "Of the Spanish school we have no idea whatever in England." In the absence of this national context, both artists were in effect awarded the status of

honorary Italians. Alexander Jardine summed up the prevailing view in 1788 when he wrote, "It appears to me, as if Velázquez and Murillo should stand next to the very first of the Italian school, not only as faithful imitators of nature but sometimes soaring above her, toward the true sublime, and particularly the former; the one seems to dignify, the other to beautify nature" (references from Allan Braham's introduction to *El Greco to Goya; The Taste for Spanish Paintings in Britain and Ireland*, exhib. cat., London, National Gallery, 1981).

The case of Murillo and Velázquez is a fascinating example of the same thing being admired for different reasons. Jardine's words betray the prevailing Italianate view of artistic theory (see above, "The Italian School"), which recommended an artist first to observe and then to improve on Nature. According to these lights, Velázquez was admired for dignity, Murillo for beautification (achieved by his legendary softness of touch). Looking at Spanish seventeenth-century art as a whole (which became possible during the nineteenth century), it becomes apparent that this Italianate aesthetic has little validity. Especially if we add the works that Jardine and his generation did not know about – those of El Greco, Ribalta, and Zurbarán; the genre paintings of Velázquez; the remarkable still-life tradition – it is clear that the "faithful imitation of nature" means something special in Spain. Instead of the humanist contrast between real and ideal as understood in Italy, the Spanish substituted the more orthodox Catholic contrast between mortal and immortal. Glory in Spanish painting is a heavenly monopoly; nothing earthly, however noble or beautiful, is portrayed without some sensation of its mortality. A comparison of Murillo's *Madonna* and his *Flower Girl* (cat. 21 and 18) reveals a characteristic differentiation of mortal and immortal beauty – the latter fleshy, impudent, stained with the muddy and ashen colors of decay; the former ethereal, approachable only through divine forbearance and surrounded by the unfading brightness of Heaven. The peculiar contribution of Spanish painting lies in the earthly side of this contrast – in its intense physicality, which always disturbs but never quite disgusts. We are made to feel the mortal clay of all living things more powerfully and tangibly than in any other period of art; yet the sensation evokes love and pity rather than loathing. Spanish painting attempts to remind us of mortality and reconcile us to it. John Ruskin wrote of the two Dulwich peasant boy scenes (cat. 19 and 20), "Do not call this the painting of nature: it is mere delight in foulness" (*The Stones of Venice*, II, ch. VI). We see something subtly different: a delight in nature which can embrace foulness.

DST

18 Bartolomé Esteban Murillo

SEVILLE 1617–1682 SEVILLE

The Flower Girl, ca. 1670

Oil on canvas
47¾ × 38⅞ in. (121.3 × 98.7 cm), including additions of about 3 in. (7.5 cm) top, bottom and left, and about ½ in. (1.5 cm) right
DPG 199; Bourgeois bequest, 1811

REFERENCES: D. Angulo Iñiguez, *Murillo: Su vida, su arte, su ombra*, Madrid, 1981, no. 395; D. Angulo Iñiguez *et al.*, *Murillo*, exhib. cat., Madrid, Museo del Prado, and London, Royal Academy of Arts, 1982–83, no. 69; J. Fletcher in *Collection for a King*, Washington, D.C., National Gallery of Art, and Los Angeles County Museum of Art, 1985, no. 22; J. Fletcher in *Kolekcja dla Króla*, exhib. cat., Warsaw, Royal Castle, 1992, no. 17

Bartolomé Esteban Murillo's career was firmly bound up with his hometown of Seville. Trained there under Juan de Castillo, he was the leading painter in the town by the 1650s, receiving a string of major religious commissions and becoming president of the Real Academia de Belles Artes from 1660 to 1663. He was profoundly pious and became a lay member of the Franciscan Order in 1662. His reputation was extremely high in the eighteenth century, when he influenced many British artists, most notably Thomas Gainsborough (see cat. 86–89), who copied his work.

The Flower Girl has been extended on all four sides, probably in the eighteenth century. Murillo was innovatory in his development of genre scenes like this one, featuring simple peasant types. The face of his flower girl is recognizable from other works – it has been suggested that she may be Francisca, his only daughter, which is possible as there is evidence that he used members of his real and extended family as models. The motif of the flowers lends itself to interpretation – could she be a modern Flora, or an allegory of Summer? Similarly, her costume, with its faintly oriental combination of quasi-turban and draped shawl, has been described as everything from Andalusian peasant to Moorish. All of this is achieved with a typically restrained color scheme based on simple earth colors. The girl's charm has always been recognized, and in the nineteenth century this was one of the most extensively copied images at the gallery.

IACD

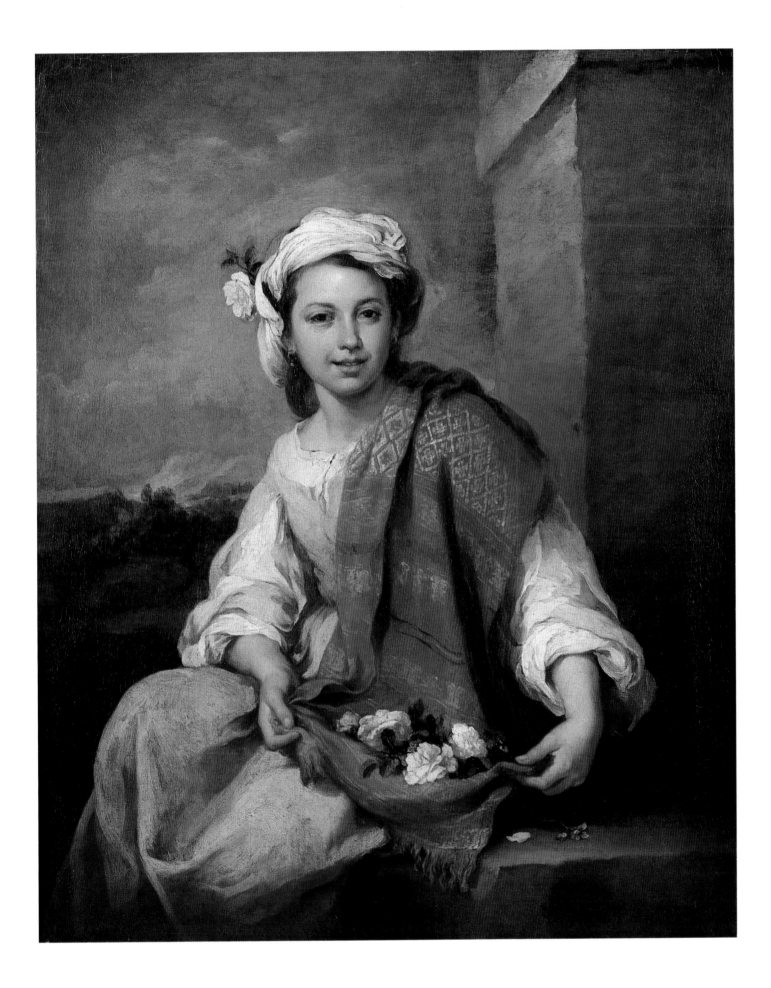

19 Bartolomé Esteban Murillo

SEVILLE 1617–1682 SEVILLE

Two Peasant Boys and a Negro Boy, ca. 1670

Oil on canvas
66¼ × 43¼ in. (168.3 × 109.8 cm)
DPG 222; Bourgeois bequest, 1811

REFERENCES: D. Angulo Iñiguez, *Murillo: Su vida, su arte, su ombra*, Madrid 1981, no. 383; D. Angulo Iñiguez *et al.*, *Murillo*, exhib. cat., Madrid, Museo del Prado, and London, Royal Academy of Arts, 1982–83, no. 68; E. Harris, "Murillo en Inglaterra," *Goya*, nos. 169–71, 1982, p. 10; J. Fletcher in *Collection for a King*, Washington, D.C., National Gallery of Art, and Los Angeles County Museum of Art, 1985, no. 23

This painting and its pair (cat. 20) were the most famous works by Murillo in England in the nineteenth century. Familiarity with eighteenth-century artists such as Thomas Gainsborough and Joshua Reynolds, whose "fancy" or genre pictures were profoundly influenced by Murillo, has perhaps detracted from the Spanish artist's credit in inventing this type of picture. The use of models presented as peasant boys, the simple "low-life" stories told by the paintings, and above all the sympathy and sharp observation of gesture and character that inform them, are all innovations characteristic of Murillo.

Here, two beggar boys are about to eat a tart that they have begged or stolen. On themselves being begged from by the passing black servant boy carrying water, the boy with the pie reacts with a protective gesture, and the boy on the left smiles out at the viewer, as if to emphasize the irony of this possessiveness among beggars.

Details such as the water crock, the basket, the jug, and the tart are wonderfully painted, and Murillo has clearly enjoyed recording the boy's filthy feet – a detail that outraged the critic John Ruskin, who ranted about Murillo's "mere delight in foulness." Contemporaries would have recognized the language immediately, however, as that of Spanish picaresque novels, which featured tales of life among the colorful but half-starved street children of Seville.

IACD

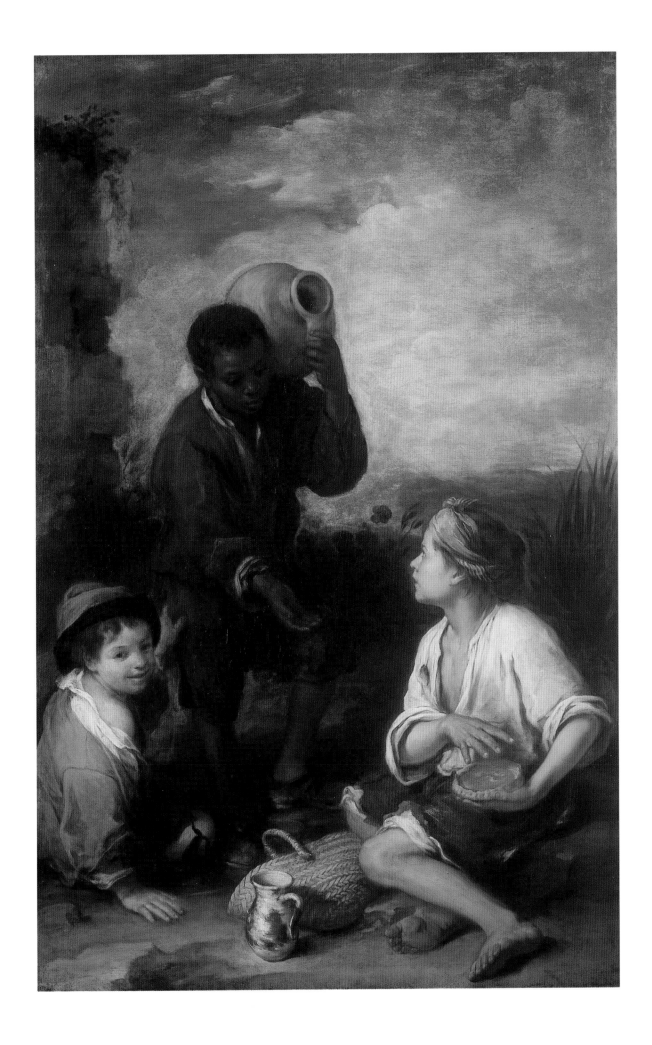

20 Bartolomé Esteban Murillo

SEVILLE 1617–1682 SEVILLE

Invitation to a Game of Pelota, ca. 1670

Oil on canvas
64⅞ × 43½ in. (164.9 × 110.5 cm)
DPG 224; Bourgeois bequest, 1811

REFERENCES: D. Angulo Iñiguez,
Murillo: Su vida, su arte, su ombra, Madrid
1981, no. 382; D. Angulo Iñiguez *et al.*,
Murillo, exhib. cat., Madrid, Museo del
Prado, and London, Royal Academy of
Arts, 1982–83, no. 67

This painting is the pair to catalogue 19.
In this case, the same boy who was so
reluctant to share his tart is dangling the
temptation of a game of *pelota* – a Basque
game played with the balls and bat seen in
the foreground – in front of another
errand boy. More than likely he has also
got an eye on the errand boy's food, which
he will have to put down if he plays the
game. The notion is reinforced by com-
parison with the little dog, whose hopes in
that respect are plain to see. The main
humor of the piece lies in the errand boy's
expression – mouth full, he hesitates in
mid-chew to review the proposal's pros
and cons, gripping all the harder on his
crust.

Eighteenth-century British artists were
particularly dazzled by the subtleties of
Murillo's handling of facial expression,
enabling the viewer to "read" a story in the
faces of the characters. They were also
impressed by the comparative austerity of
Murillo's color schemes, which in both
this painting and catalogue 19 remain
resolutely restricted to greys and browns,
allied to a painterly technique. Both of
these characteristics reinforce the "low-
life" origins of this particular form of
child-oriented genre painting.

IACD

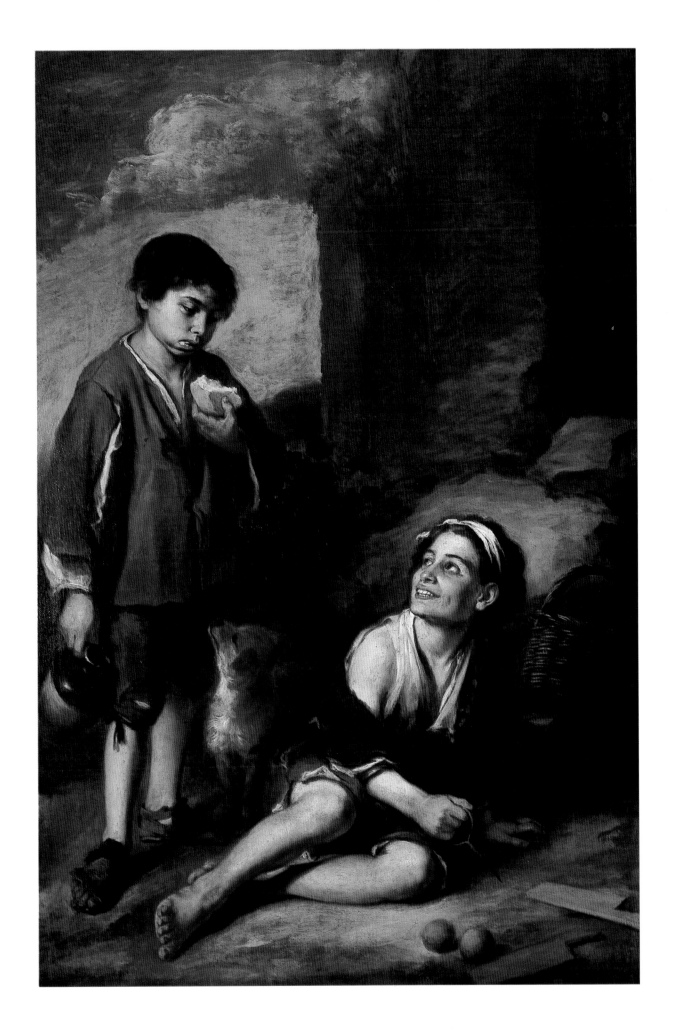

21 Bartolomé Esteban Murillo

SEVILLE 1617–1682 SEVILLE

The Madonna of the Rosary, ca. 1670–80

Oil on canvas

79 × 50½ in. (200.8 × 128.2 cm)

DPG 281; Bourgeois bequest, 1811

REFERENCES: D. Angulo Iñiguez, *Murillo: Su vida, su arte, su ombra*, Madrid, 1981, no. 152; X. Brooke in *Conserving Old Masters*, exhib. cat., London, Dulwich Picture Gallery, 1995, no. 6

All four of the masterpieces by Murillo in the Dulwich collection (cat. 18–21) testify to the influence on his style and technique of works by such artists as Rubens, Van Dyck, and Titian in the Royal Collections of Madrid, which he visited in 1658. This Madonna typifies Murillo's hugely influential and popular approach to the theme. His Madonna is sweet, pretty, and approachable; she could almost be any young village mother, but she is bathed in the golden glow of Heaven (an idea derived from the vision of the woman "clothed in the sun" from the Book of Revelation), which intensifies round her dark hair to form a naturalistic halo; the colors are soft. One cannot help noticing how neatly the Christ Child's hair has been parted. This is a profoundly reassuring vision of the Queen of Heaven and clearly deeply personal. The Virgin Mary had always been an object of special venera- tion for Franciscans (Murillo became a lay brother of the Order).

Murillo appealed enormously to foreigners, particularly the English. *The Madonna of the Rosary* was bought by Alleyne Fitz Herbert, Lord Saint Helens, while he was serving as ambassador to Spain (1791–94).

IACD

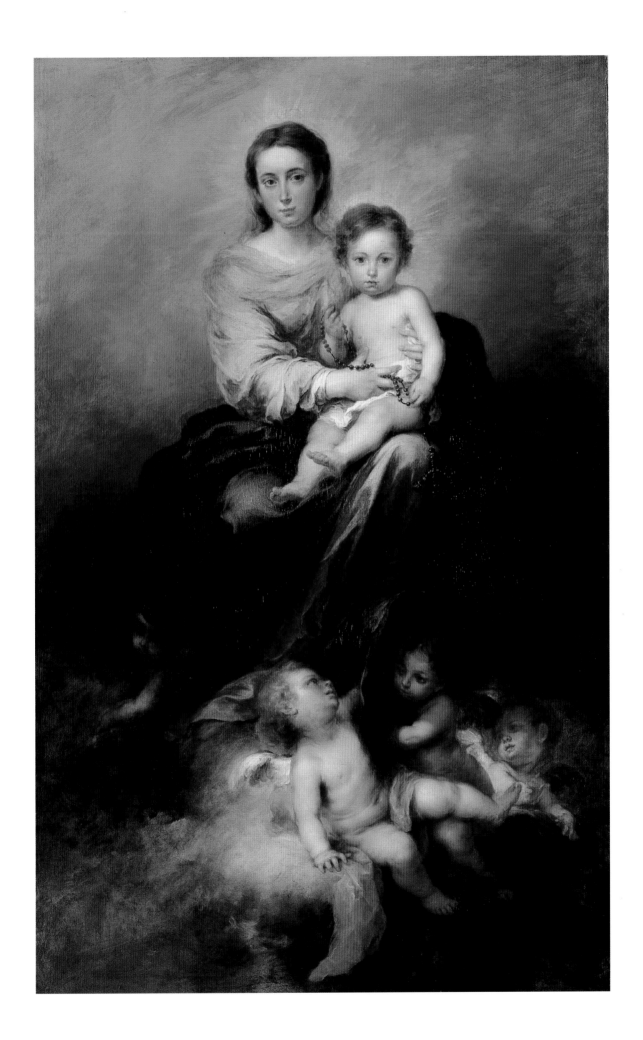

22 Studio of Diego Velázquez

SEVILLE 1599–1660 MADRID

Philip IV, King of Spain, after 1644

Oil on canvas
51¼ × 38½ in. (130.2 × 97.8 cm)
DPG 249; Bourgeois bequest, 1811

REFERENCES: A. de Beruete, *Velázquez*, Paris, 1898, pp. 93–94; R. Fry, "The Fraga Velazquez," *Burlington Magazine*, XIX, 1911, p. 5; J. López-Rey, *Velázquez: A Catalogue Raisonné of His Œuvre*, London, 1963, no. 256

In a European artistic community that included Rembrandt, Bernini, Poussin, Rubens, and Van Dyck, Diego Velázquez was one of the towering artistic figures. Born and trained in Seville, he made a short visit to Madrid in 1622 that led to an invitation from the first minister, the Count-Duke Oliváres, to return in the following year as court painter to Philip IV. Velázquez was the consummate court artist, and Philip IV and his family have come down to us in a dazzling series of royal portraits, culminating in one of the world's great masterpieces, *Las Meninas* (Prado, Madrid). However, Velázquez's achievements went far beyond portraiture. His simple genre subjects, mythologies, and religious works speak a naturalistic language that was entirely new.

The original version of this portrait, known as the Fraga *Philip* (Frick Collection, New York), was painted at Fraga during the Aragonese campaign against the French in 1644, which the king led. The sitter wears dress uniform of red and silver and holds a baton in his right hand, with his hat in his left. A detailed contemporary description of the dress worn by the king corresponds to the portrait. Just as the mere appearance of the king in uniform was thought sufficient to encourage the armies, the portrait fulfilled an important exercise in public relations. The king was pleased with it; he sent it to the queen, and the court all duly admired it. It became a kind of icon – the Catalans displayed it during their celebration of the recapture of Lérida at the church of Saint Martin in Madrid. Copies were soon required, and this is presumably one of the better of those, from the master's studio and perhaps painted by his pupil Juan Bautista del Mazo. Until 1911, however, it was generally accepted as the original; in that year Roger Fry was able to compare the Frick painting directly with the Dulwich version, and accepted the Frick picture's status. The Dulwich painting once belonged to the French sculptor Edmé Bouchardon (1698–1762), arriving in the collection of Noel Desenfans, via a Swiss owner, by 1804.

IACD

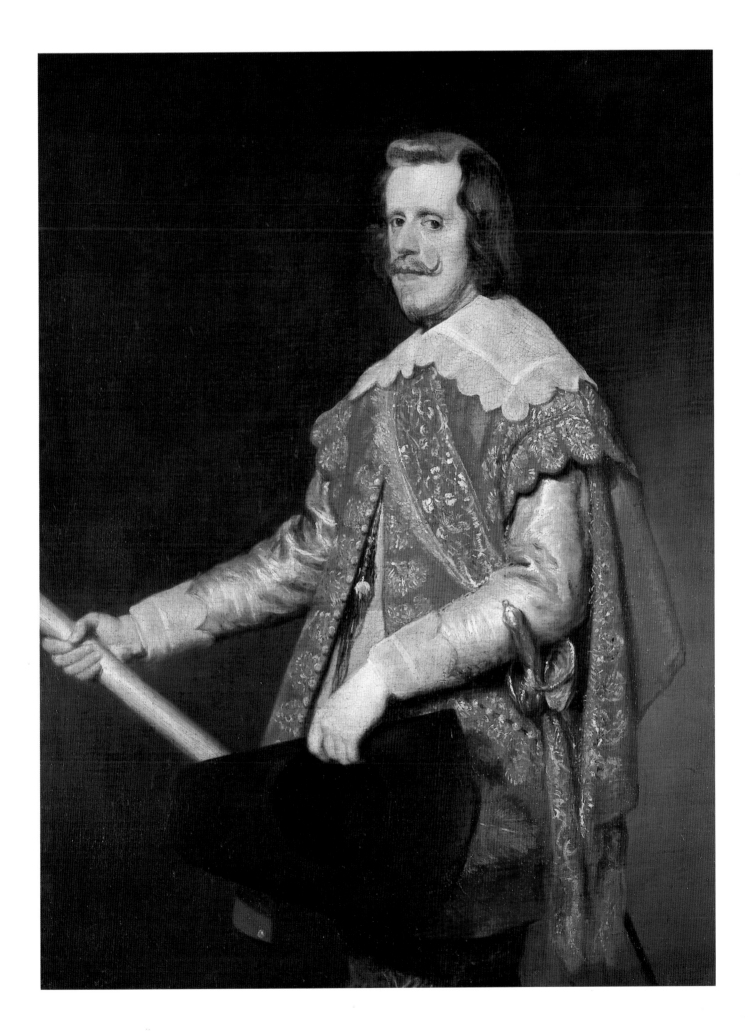

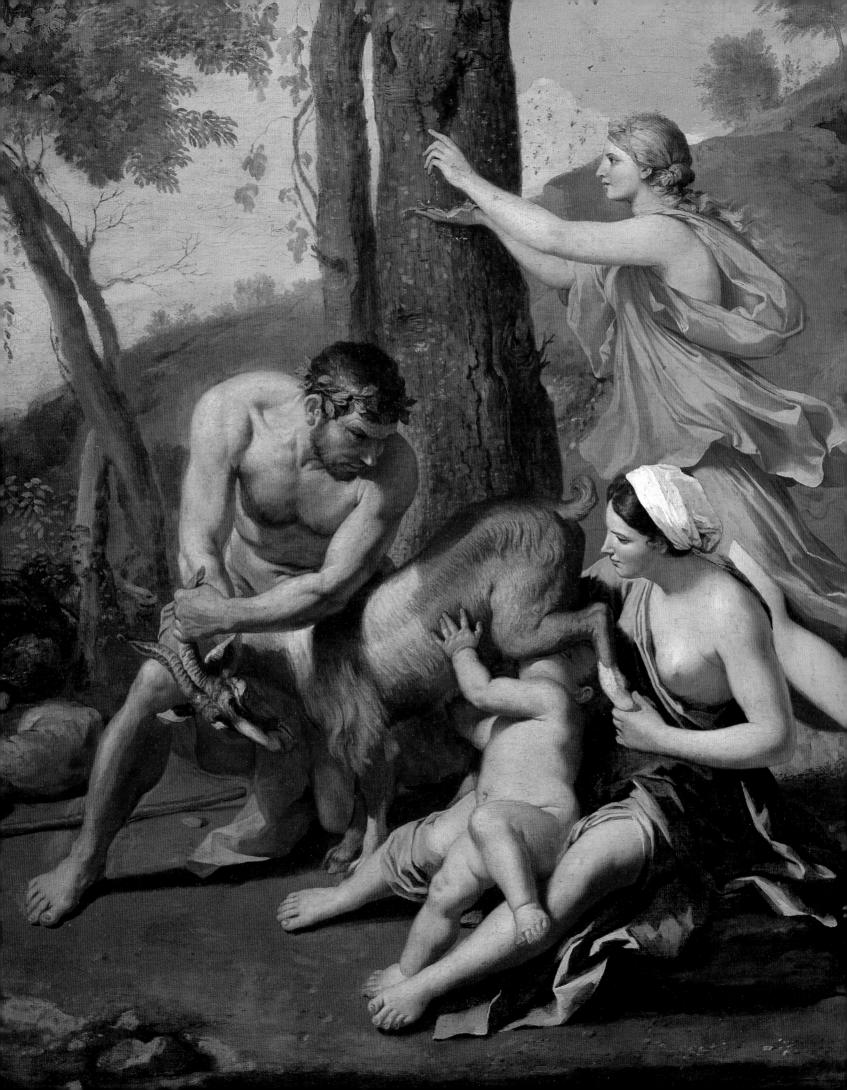

III The French School

In 1827 Jean-Auguste-Dominique Ingres painted a ceiling depicting *The Apotheosis of Homer* for the new Egyptian and Etruscan galleries of the Louvre in Paris. In a relief-like composition of classic severity, Ingres imagined a heavenly symposium of leading artists and writers paying tribute to the father of Greek and thus of European culture. In the foreground two recognizable characters look at the audience and gesture toward Homer, like saints mediating between the faithful and God – to the right the playwright Jean-Baptiste Molière, and to the left the painter Nicolas Poussin. Ingres's message is clear: French literature and art of the seventeenth century represent a direct line of descent from the Greeks and the best introduction to that classic style.

More than any other collection since put together in England, that at Dulwich delivers this same message. An unrivalled group of paintings by Poussin, in his most classical manner (cat. 23–27) is supported by two examples of his disciple, the first president of the French Academy, Charles Le Brun (cat. 28, 29). This is the foundation of the French tradition of painting, an aesthetic that was still being celebrated in the temple of French art some two hundred years later.

This is also an example of what has been called "the invention of tradition." For just how French was Poussin when he was painting? He learned nothing from his French masters; he spent his working life in Rome, painting nothing of consequence before his arrival in 1624, when he was already thirty years old; and he bitterly regretted his brief sojourn in Paris in 1640–42. As teachers he acknowledged only the Italian poet Giovanni Battista Marino (1569–1625) and the collection of drawings recording the remains of classical antiquity formed by his friend the Roman antiquarian Cassiano Dal Pozzo (1588–1657). Poussin is an artistic orphan suckled by antiquity. It is this that makes his mature paintings seem so natural, so traditional, and so inevitable.

Poussin was not alone in his inspiration: his friend Claude Lorrain (see cat. 30) spent his entire career in Rome, as did his brother-in-law Gaspard Dughet (see cat. 31). Sébastien Bourdon also spent formative years there, imitating with extraordinary brilliance the various styles of painting going on around him, sometimes that of Poussin and sometimes (as in cat. 32) that of the Dutch Bamb_occianti. Charles Le Brun also spent the years 1642–46 in Poussin's circle in Rome, during which time he painted his *Horatius Cocles Defending the Bridge* (cat. 28) and evolved a Roman style of painting that he took back to France (see cat. 29).

It was Le Brun more than anybody who ensured that Poussin was the chosen role-model for the French Academy after its foundation in 1648. This was not a surprising choice: Poussin was also at this time the artist most admired by Italian theorists. It does, however, demonstrate something fundamental about the state-sponsored cultural program conceived by Louis XIV and executed by his chief minister Jean-Baptiste Colbert during the later years of the seventeenth century. Louis wanted to wrest artistic supremacy from Italy, just as he wanted to wrest political and military supremacy from Spain. He did not, however, wish to create a French style of painting and architecture so much as to create a universal style of painting and architecture in France. In just the same way, given the choice between being the French king or the Sun King, he would certainly have chosen the latter. Poussin therefore becomes typically French precisely because he is such a universal classicist.

Another distinctive aspect of the French academic spirit during the later seventeenth century was that all the arts came under scrutiny at the same time. There was more awareness in France than there ever had been in Italy of the parallels between good taste in literature and in painting. It is no accident that Molière balances Poussin in Ingres's painting.

It is perhaps this bias that explains the main concern that the French added to Italian artistic theory – precision of expression. Poussin was personally absorbed by this problem: in his letters he claimed to envy the Egyptians their hieroglyphs, which could convey precisely the concepts in the author's mind, and elsewhere he refers to an ideal viewer of his paintings as one who knows how to "read" them (letters to Paul Fréart de Chantelou, November 5, 1643, and April 28, 1639). Acting in this spirit, the French Academy subjected Poussin's paintings to a hitherto unknown form of analysis: moving from left to right, they scrutinized each figure, explaining exactly who they were, what they were doing, and how they were feeling about it. The academy taught how paintings could be "read."

Le Brun also built upon Poussin's idea that expression could have the "clarity" of literature. Le Brun's *Conférence sur l'Expression*, one of the most serviceable artistic treatises in history, takes each emotion separately, describes its effect on the muscles of the face, and illustrates it with a diagrammatic head. If you want to know exactly what "Aversion arising from Jealousy" looks like, Le Brun will not only tell you, he will show you.

The problem with the technique of the academy and the theories of Le Brun is that they work just as well in prints after paintings as they do in the paintings themselves. Such a literary and cerebral approach to art was bound to have a backlash. This occurred during the last quarter of the seventeenth century and well into the eighteenth, when a group of anti-academic theorists championed the cause of the painterly Rubens against that of the cerebral Poussin – the Rubénistes fought the Poussinistes. The most distinguished Rubéniste was a theorist and collector called Roger de Piles (1635–1709), who attempted to undermine the strict academic tradition by reminding his readers of the first and universally agreed objective of painting – the imitation of nature. This, for De Piles, was not some duty to be dispatched before moving on to the serious business of idealizing and storytelling; it was the painter's best chance to excite interest: "The more powerfully and faithfully painting imitates Nature, the more rapidly and directly it leads us to its goal, which is to seduce our eyes" (*Cours de Peinture par Principes*, 1708, p. 6). Contemporary mainstream academic artistic theory demanded that painting should try to look as much like sculpture as possible; De Piles on the other hand, regarded sculpture as an altogether different enterprise, which lacked the imitative thrill of painting (*Conversations sur la Connoissance de la Peinture*, 1677, p. 96). Indeed, the most damning thing he can think to say about Poussin is that "he would have been an excellent sculptor", (*ibid.*, p. 246).

De Piles is worth examining at length because he was one of the first artistic theorists to describe a European (rather than a merely national or civic) tradition of painting. Previous writers had tended to describe what painting should be like and how the citizens of their particular country or city had made it thus. De Piles admired French art but allowed many other schools of art to be comparable. This was unlike the universal but standardizing conception of art taught by the academy, in that it accepted diversity and the possibility of irreconcilable virtues. This pluralistic sense of European art gained ground throughout the eighteenth century and ultimately dictated the collecting policy of Desenfans and Bourgeois (and of most later public galleries, especially in Britain and the United States).

The question, however, remained: did different schools of painting demand to be enjoyed in different ways? If so, how can they be qualitatively compared? In an attempt to standardize the criteria for the judgment of painting, De Piles developed his courageous

(and faintly absurd) *Balance des peintres*, a table of the fifty or so greatest painters of all time, whose work he awarded marks out of 20 for their composition, drawing, color, and expression. The judgments contained in the *Balance* are, of course, personal, but they offer a fascinating snapshot of taste at this crucial turning point between the didactic and nationalist seventeenth century and the more European and tolerant eighteenth century.

De Piles only really considers history painting and portraiture worthy of attention; moreover, with the exception of Dürer, Holbein, and Rembrandt, the artists listed all come from Italy, France, or Flanders. Within this relatively limited field of vision, however, De Piles does not set up one dominant tradition: Rubens, Raphael, Poussin, and Rembrandt compete on equal terms. So who are the top-scoring painters? Rubens is the outright winner with an average of nearly 17 (18 for composition, 13 for drawing and 17 each for color and expression). He is followed by Raphael, whose color at 12 lets him down, and Domenichino (both artists were represented in the original Bourgeois bequest though not in this exhibition). Next in order of merit comes a group of artists averaging between 11 and 14: Van Dyck, Carracci, Le Brun, Poussin, Rembrandt, Teniers, Veronese, and Guercino. In this batch are also some predictable names from the Italian sixteenth and seventeenth centuries, including Correggio, Titian, Tintoretto, Giulio Romano, Leonardo, and Pietro da Cortona. The low scores are always more informative than the high (some of the greatest names in art evidently have room for improvement): an insulting 6 is awarded for Poussin's color, Rembrandt's drawing, and Teniers's expression; Veronese, Guercino, and Bourdon all get low marks (3 or 4) for expression; Reni gets zero for composition. Eyebrows are especially raised at the 4 for color given to Leonardo and Michelangelo and the zero for expression given to Giovanni Bellini and Caravaggio!

What appear to us as eccentric scores indicate that De Piles had clearly not broken free of the aesthetic prejudices of his time. The enterprise as a whole was, however, advanced and open-minded, clearly anticipating the character of much eighteenth-century French painting in looking beyond the Franco-Roman tradition of Poussin and Le Brun to the less idealized painting of the Low Countries. The artist who, more than any other, epitomizes the anti-academic and Rubéniste faction of this time in France was Antoine Watteau. Born of Flemish parents within miles of the border, Watteau responded to the newfound respectability of the Flemish school of painting. *Les Plaisirs du bal* (*The Pleasures of the Dance*; cat. 33) is clearly inspired by Rubens's *Garden of Love* (Prado, Madrid), but its liberation from academic theory goes far beyond this. It is a painting impossible to define clearly in terms of its type or inspiration. The setting is Italianate, the landscape Claudean, and the figures Rubensian. It is a depiction of everyday life (a genre painting), yet it carries so strong and fanciful an implication of narrative that it can be read as a history (or poetic) painting. Even the classes are mixed in this imaginary idyll: aristocrats dance to the music of a rustic band in the company of characters from the *commedia dell'arte*. The scene anticipates the masked ball in Mozart's *Don Giovanni*, where two stage bands compete by playing low- and high-life dance tunes simultaneously.

There is a political dimension to the "indecorous" mixing of classes in the subject of this painting and to the mixing of styles in its execution: both express the idea of liberty, a freedom from the stultifying rituals of Versailles and from the notion of absolute authority in art, manners, and life. As the chorus sings in the same ball scene in Mozart's opera: "*Viva la Libertà*" (Long live Liberty).

DST

23 Nicolas Poussin

LES ANDELYS 1594–1665 ROME

Venus and Mercury, ca. 1627–30

Oil on canvas
34¼ × 37⅜ in. (80.2 × 87.5 cm), including a later addition of approximately 2 in. (5 cm) on the left
DPG 481; Bourgeois bequest, 1811

REFERENCES: A. Blunt, *The Paintings of Nicolas Poussin: A Critical Catalogue*, London, 1966, no. 184; *Nicolas Poussin, Venus and Mercury*, exhib. cat., London, Dulwich Picture Gallery, 1986–87; E. Cropper and C. Dempsey, *Nicolas Poussin, Friendship and the Love of Painting*, Princeton, 1996, pp. 231–37

Nicolas Poussin's early training was possibly with Noël Jouvenet in Rouen, and briefly with Georges Lallemant and Ferdinand Elle in Paris. An early determination to go to Rome was finally realized in 1624, after he had visited in Venice in 1623. Apart from an uncomfortable trip to Paris in 1640–42, he spent the rest of his life in Rome. An early commission, in Paris, from the Neapolitan poet Giovanni Battista Marino to illustrate Ovid's *Metamorphoses* seems to have set his early career on its course – he painted intensely poetic mythologies in a technique and color derived from Titian. In the mid-1630s there was a stylistic evolution away from Venetian coloring toward the late Raphael, and an ever more rigorous and learned approach to classical antiquity.

This painting is a fragment of a larger composition, having been cut down some time in the middle of the eighteenth century. The left-hand part, which shows putti making music, is now in the Louvre. Such was the popularity of the image that Poussin later made a drawing of it (now also in the Louvre), with some small alterations, for an etching made by Fabrizio Chiari in 1636. Drawing and etching show that both the surviving fragments have been cut at the top, the Louvre fragment more than the Dulwich. The composition originally included an airborne putto aiming a dart in the direction of Venus and Mercury, reminding us that these two divine beings were lovers, and, according to legend, the parents of Cupid.

Mercury's role, in this case epitomizing civilization, is defined by the still life at his feet, including his own attribute, the caduceus, symbol of eloquence, and a book, a lute, a musical score, and an artist's palette, representing the arts. He points to the scuffle going on in the foreground, as if explaining something to Venus. The fighting putti may be identifiable as Eros and Anteros, embodying in allegory the antagonism between spiritual and sensual love, both of which are qualities of Venus; and it is presumably this eternal conflict within the goddess herself that Mercury is pointing out. In the Louvre fragment another putto stands ready to award laurel crowns to the victor of the wrestling match, which the drawing and etching reveal to have been the central episode of the painting. It is clear that spiritual love (Anteros) is going to prevail. The characterization of Eros as a goat-legged satyr-like putto is peculiar, and it is quite likely that Poussin intended a more straightforward identification of the antagonists as Cupid and the infant Pan. Their allegorical significance would remain virtually the same. Whichever reading is correct, the painting is ultimately about the superiority of the pursuit of beauty and the arts over the pursuit of sensual pleasures – a variation on the Neoplatonist theme of Sacred and Profane Love, applied to the arts. This version of the allegory would appear to have been the invention of Poussin himself.

The painting has generally been considered to be one of Poussin's earliest works, perhaps from about 1627, or not very much later. Its coloring and handling certainly indicate Titian as its prime influence, and even in its butchered state its poetic power is undeniable.

IACD

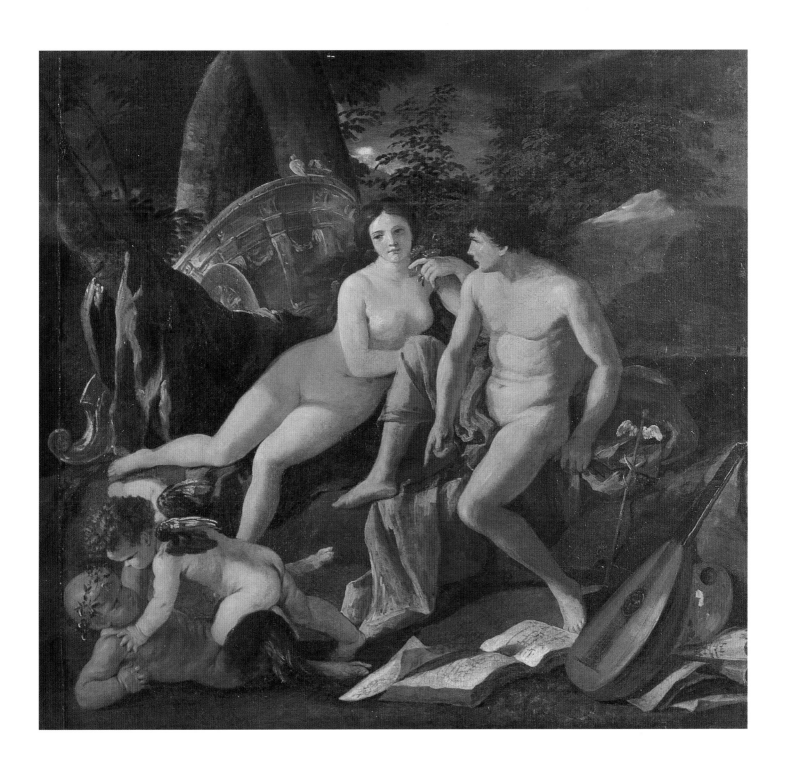

24 Nicolas Poussin

LES ANDELYS 1594–1665 ROME

Rinaldo and Armida, ca. 1628–30

Oil on canvas
32⅜ × 43 in. (82.2 × 109.2 cm)
DPG 238; Bourgeois bequest, 1811

REFERENCES: A. Blunt, *The Paintings of Nicolas Poussin: A Critical Catalogue*, London, 1966, no. 202; R. Verdi in *Collection for a King*, Washington, D.C., National Gallery of Art, and Los Angeles County Museum of Art, 1985–86, no. 25; P. Rosenberg and L.-A. Prat, *Nicolas Poussin, 1594–1665*, exhib. cat., Paris, Grand Palais, 1994–95, no. 25

Torquato Tasso's *Gerusalemme Liberata* is an idealized account of the First Crusade in the eleventh century. The pastoral interlude of the story of Rinaldo and Armida – an updated version of the Homeric story of Odysseus and Circe – was particularly popular with artists. The tale is set in Syria, in a magical garden by the River Orontes, where the beautiful sorceress Armida has been sent by Satan to use her witch's powers against the Crusaders, whom she changes into monsters. When Rinaldo, a Christian prince, manages to rescue his companions from her spells, Armida vows murderous revenge: Rinaldo is lured to an island in the middle of the Orontes, where he is bewitched into sleep. Armida comes to kill him, but at the sight of his beauty – fortunately he has cast aside his helmet – she falls in love. Poussin has chosen the precise moment when hate turns to love, dramatizing the theme with the inclusion of a flower-crowned Cupid who literally stays her hand.

Poussin portrays Armida as if she were frozen in the midst of movement – her draperies billow behind as if turned to ice. The beautiful arrangement of her arms, one hand forward to immobilize Rinaldo's hand, the other drawn back to deliver the fatal blow with the knife, metamorphoses into a nerveless embrace. This taut drama and arrested movement are poetically contrasted with the complete vulnerability of Rinaldo, whose limbs loll in total relaxation, his weapons and helmet useless by his side.

Like *The Return of the Holy Family from Egypt* (cat. 25), this painting exhibits Poussin's interest in full-scale sculptural figure composition during the years 1628–30. Poussin made a conscientious effort to give a quasi-historical context to the scene, having derived Rinaldo's clothing from Roman reliefs showing Persian warriors in their trousers.

IACD

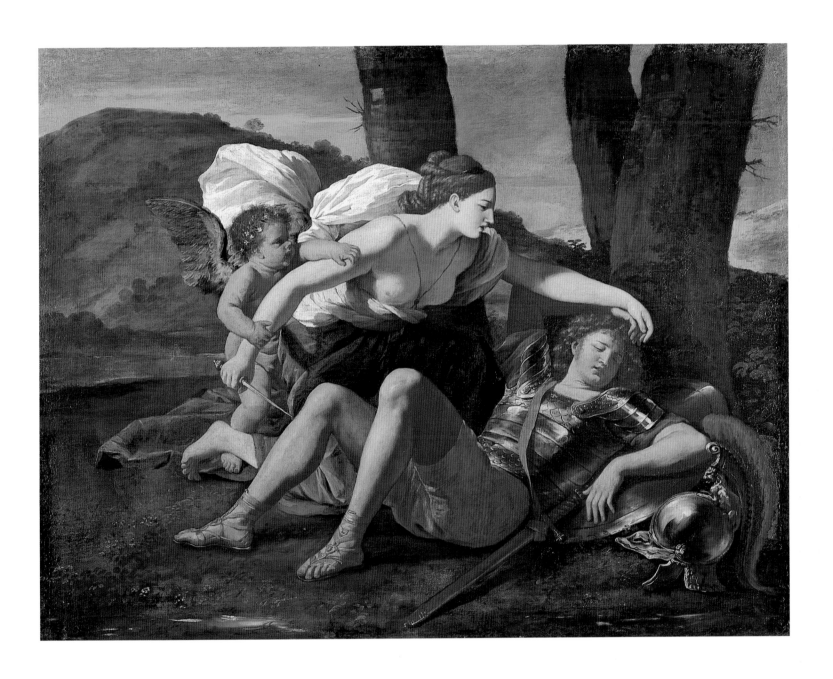

25 Nicolas Poussin

LES ANDELYS 1594–1665 ROME

The Return of the Holy Family from Egypt, ca. 1628–30

Oil on canvas
46⅜ × 39⅛ in. (117.8 × 99.4 cm)
DPG 240; Bourgeois bequest, 1811

REFERENCES: A. Blunt, *The Paintings of Nicolas Poussin: A Critical Catalogue*, London, 1966, no. 68; R.Verdi in *Kolekcja dla Króla*, exhib. cat., Warsaw, Royal Castle, 1992, no. 19

The Return from Egypt is a far less common subject than the standard Flight into Egypt. The defining factor is the age of the Christ Child – a baby in arms in the Flight, older in the Return. The subject is usually interpreted, as here, as the moment when Christ embraced the path that would lead to the Passion. Poussin has made this clear by including a vision, apparently visible only to the young Christ, of putti holding the Cross. The somber message is carried through the painting in the expressions and attitudes of the principal actors – the sad and pensive Mary and apprehensive Joseph – while even the donkey looks depressed. The dark storm-clouds upholding the putti cast a shadow over the landscape, and Poussin typically makes full play of a suitable classical reference – to Charon, the ferryman who transports souls across the River Styx to Hades. All of this adds up to a powerful and moving image. Only Christ, rapt by the vision, and lifted by Joseph, counteracts the stately downward movement from left to right.

The monumental figures in the picture and their dominance over the landscape recall Poussin's great altarpiece for Saint Peter's, *The Martyrdom of Saint Erasmus*, when the artist briefly strove toward a more sculptural and powerful style. The arrangement of figures in a shallow foreground clearly owes a debt to classical low-reliefs. As is so often the case in Poussin, the background – a sunlit glimpse of Egyptian buildings including obelisk and pyramid – is as interesting as the principal foreground scene.

IACD

26 Nicolas Poussin

LES ANDELYS 1594–1665 ROME

The Triumph of David, ca. 1631–33

Oil on canvas
46⅝ × 58⅜ in. (118.4 × 148.3 cm)
DPG 236; Bourgeois bequest, 1811

REFERENCES: A. Blunt, *The Paintings of Nicolas Poussin: A Critical Catalogue*, London, 1966, no. 33; R. Verdi in *Collection for a King*, Washington, D.C., National Gallery of Art, and Los Angeles County Museum of Art, 1985, no. 24; R. Verdi in *Kolekcja dla Króla*, exhib. cat., Warsaw, Royal Castle, 1992, no. 18; R. Verdi, *Nicolas Poussin, 1594–1665*, exhib. cat., London, Royal Academy of Arts, 1995, no. 24

Although there has been much dispute over the date of this picture, it is generally considered to be a key document for the effect of the influence of Raphael on Poussin as he moved away from the Titianesque poeticism of the 1620s. The subject derives from the story in I Samuel 17:54; the painting shows David's return to Jersusalem with the head of the Philistine giant Goliath, whom he has killed with a sling and stone, the damage from which is clearly visible on Goliath's forehead.

Although based on an engraving after Giulio Romano (Giorgio Ghisi, *The Triumph of Scipio, ca.* 1553), the composition is also clearly indebted to the later Stanze by Raphael and his assistants in the Vatican. The complex triple-plane structure of the painting has David's triumphal procession passing between two more static ranks of spectators, one raised on to a higher level. Some details catch the eye as unusually decorative for Poussin – for instance, the iridescent colors of some of the clothing and the detail of the embroidered neck band on the dress of one of the principal female onlookers on the left.

This is an early example of Poussin tackling a heroic subject intended to be read in an edifying manner. Such details of costume are best seen as intensifying the language of gesture used throughout. The crowd offers a cross-section of humanity, male and female, old and young, and it is Poussin's intention that their individual reactions should be recognized as characteristic – from the babies' uncomprehending indifference to the joy of the young women and the solemn thanksgiving of the old man to the right.

IACD

27 Nicolas Poussin

LES ANDELYS 1594–1665 ROME

The Nurture of Jupiter, ca. 1636–37

Oil on canvas
37⅞ × 47⅛ in. (96.2 × 119.6 cm)
DPG 234; Bourgeois bequest, 1811

REFERENCES: A. Blunt, *The Paintings of Nicolas Poussin: A Critical Catalogue*, London, 1966, no. 161; P. Rosenberg and L.-A. Prat, *Nicolas Poussin, 1594–1665*, exhib. cat., Paris, Grand Palais, 1994–95, no. 59

Jupiter, the future king of the gods, was the child of Rhea and Saturn. Saturn, warned that he would be overthrown by one of his children, came up with the radical solution of eating them as they were born. Five children were consumed before Rhea devised a plan to save the sixth, substituting a swaddled stone for the infant Jupiter. He was then transported to Mount Ida on Crete, where he was cared for by the nymphs Amalthea and Melissa and fed goat's milk and honey. This is the scene Poussin illustrates here.

Formally, the composition derives from an engraving by Bonasone after Giuilio Romano of *The Education of Jupiter*, which provides the inspiration for not only the central figure group, in particular the goat and shepherd, but also the general sense of the landscape, the central tree, and the attendant goats. From a crowded, relief-like composition, however, Poussin makes a complex pyramidal structure, infusing it with a strength, space, and distance that are profoundly different from his source. A preliminary drawing of the central group exists, at the Iris and B. Gerald Cantor Center for Visual Arts at Stanford University, with some minor differences in the head of the seated nymph and the posture of the shepherd restraining the nursing goat.

A later version of the same subject is more austere and uncompromising in its composition (Staatliche Museen, West Berlin), confirming this painting's status as a masterpiece in a transitional phase of Poussin's style.

IACD

28 Charles Le Brun

PARIS 1619–1690 PARIS

Horatius Cocles Defending the Bridge, ca. 1642–45

Oil on canvas
48 × 67⅝ in. (121.9 × 171.8 cm), a strip of about 3½ in. (9 cm) has been added to the bottom
DPG 244; Bourgeois bequest, 1811

REFERENCES: J. Montagu in *Courage and Cruelty*, exhib. cat., London, Dulwich Picture Gallery, 1990–91, no. 2

Charles Le Brun studied in Paris under François Perrier and Simon Vouet, but it was the influence of Poussin, who visited Paris in 1640–42, that truly galvanized him. In Rome from 1642 to 1645, Le Brun immersed himself in the master's style. On his return to Paris, he became the dominating force in French art: Louis XIV's first painter, the creator of decorative schemes at Vaux le Vicomte and Versailles, and director of the Gobelins tapestry factory. His devotion to the classical ideals of Poussin, though not always so apparent in his own decorative schemes, turned him into a formidable force in the foundation of academic teaching. As director of the French Academy, and as the author of the treatise *Conférence sur l'Expression*, he lay at the root of academic teaching for two centuries to come.

The story of Horatius Cocles, one of the most powerful mythical exemplars of Roman valor, is told in full in Livy's *History of Rome*. Under attack by the Etruscans, the Romans retreated over the Sublician Bridge to take refuge in the city. Recognizing that the same means of retreat would provide access to the city for the invaders, Horatius single-handedly defended the bridge, while his colleagues destroyed it behind him. Finally, he leapt into the Tiber and swam to safety. It is the exemplary nature of his courage that Le Brun emphasizes, by the introduction of the goddess Roma – the city deified – who floats across the breach to award her hero the laurel wreath of fame. This incident is emphasized further by the inclusion of another god, the river deity Tiber himself, watching directly below. Le Brun has clearly prided himself on his antique detail, particularly in the wooden bridge, the armor (closely if anachronistically observed from the Column of Trajan), and the severe Tuscan mode of architecture.

The work was conceived and painted in Rome, during Le Brun's stay there between 1642 and 1645, in a style derived directly from Poussin.

IACD

29 Charles Le Brun

PARIS 1619–1690 PARIS

The Massacre of the Innocents, ca. 1647–65

Oil on canvas
52⅜ × 73¾ in. (133 × 187.4 cm)
DPG 202; Bourgeois bequest, 1811

REFERENCES: M. Kitson in *Collection for a King*, Washington, D.C., National Gallery of Art, and Los Angeles County Museum of Art, 1985–86, no. 19; J. Montagu in *Courage and Cruelty*, exhib. cat., London, Dulwich Picture Gallery, 1990–91, no. 11; J. Montagu in *Kolekcja dla Króla*, exhib. cat., Warsaw, Royal Castle, 1992, no. 14

Le Brun's debt to Poussin is evident once again in this painting, which technical analysis has confirmed was finished long after its initial composition had been worked out in the underdrawing, probably around 1647. It reads almost like a lesson in Poussin's theories. The well-known biblical story, which is told in only one of the Gospels (Matthew 2:16–18), is carefully laid out to be "read" not purely as a narrative, but also as a catalogue of emotions leading to an intellectual understanding. Le Brun does not flinch from the violence and cruelty of the scene, which is portrayed as doubly sacrilegious since it takes place in a graveyard. The brutality of the soldiers and the desperation of the mothers, who flail and bite to no avail, are contrasted with the callousness of the counselors in their chariot, who, having advised Herod on the necessity of this carnage, observe the scene dispassionately.

The various scenes are arranged to lead the eye inward, reading each incident in turn, registering the extremes of emotion as it goes. With a historian's eye for detail, Le Brun has made the assumption that Herod, as a Roman puppet ruler, would have built in a Roman fashion, and so Bethlehem is given monuments that most people would have recognized as deriving from surviving monuments in Rome – the Pyramid of Cestius and Hadrian's Mausoleum (the Castel Sant'Angelo). Eventually the eye is led again to the right foreground, dominated by a woman leaning on a tomb (the tomb of Rachel, a reference to the prophecy of Jeremiah (31:15): "In Rama was there a voice heard, lamentation, and weeping, and great mourning, Rachel weeping for her children, and would not be comforted, because they were not"), who, in

accordance with Le Brun's theories of expressing the passions, is a model of despair. Her resigned gesture of arms crossed over her chest, upward glance, and grimace combine with her oblivion to the horrors around her – the stabbed baby, the dog lapping the blood of another dead child – to provide the viewer with the key emotion for making sense of the picture, a kind of horrified resignation to the will of God.

IACD

30 Claude Lorrain (Claude Gellée)

CHAMAGNE 1604/05?–1682 ROME

Jacob with Laban and His Daughters, 1667

Oil on canvas
28⅜ × 37¼ in. (72 × 94.5 cm)
Signed and dated, indistinctly, bottom center left: CLADIO IVF/ROM.1667
DPG 205; Bourgeois bequest, 1811

REFERENCES: M. Roethlisberger, *Claude Lorrain: The Paintings*, New Haven, 1961, LV188; M. Kitson in *Collection for a King*, Washington, D.C., National Gallery of Art, and Los Angeles County Museum of Art, 1985–86, no. 4; M. Kitson in *Kolekcja dla Króla*, exhib. cat., Warsaw, Royal Castle, 1992, no. 5

Claude Lorrain traveled to Rome as a teenager in about 1617–18. He first worked as a pastry cook, but soon took up study as a painter, first with Goffredo Wals in Naples and then with Agostino Tassi in Rome, where he remained (except for one brief trip to Nancy in 1625–26) for the rest of his life. He chose to concentrate entirely on landscape, developing unparalleled skills in evoking light and atmosphere, conjuring the effects of vast distances. The virtuosity of his painting attracted intense competition for his works; popularity led to attempts at imitation and even outright forgery. Claude took to recording his works in a book titled *Liber Veritatis* (British Museum, London). Like the work of Poussin, Salvator Rosa, and Gaspard Dughet, Claude's paintings found particular favor in England, even in his own lifetime. While hugely influential in artistic terms, he also affected the English landscape in a profound though indirect way, as the inspiration behind the eighteenth-century revolution in landscape gardening.

A late work, this serene landscape has a deceptively simple poetic quality reminiscent of the artist's earlier manner. This may have been in recognition of the tastes of his client Freihett Franz Mayer von Regensburg, adviser to the Elector of Bavaria, and also a friend of Claude's biographer, Joachim Sandrart. Mayer probably already owned four paintings by the artist, including two now in the Alte Pinakothek, Munich, which, like this one, were reworkings of earlier compositions, suggesting a preference for the artist's earlier style. Claude had treated the subject on at least two earlier occasions, the earliest, dated 1654, now at Petworth House; another is at the Norton Simon Museum, Pasadena. The landscape was repeated from an etching of *The Goatherd* dated 1663.

While it may be true that Claude is here tailoring a commission to reflect the rather conservative tastes of his client, the painting remains one of the most magical of his late works. The figures, acting out the story from Genesis 28–33, are placed centrally. Jacob, on the left, confronts Laban and his two daughters. Having fallen in love with Rachel, Jacob had worked for seven years tending Laban's sheep in order to win her hand, only to be presented with her older sister Leah. Another seven years of sheep tending was required to win Rachel's hand as well.

A tiny troupe of camels can be seen in the left distance below the hilltop settlement, the solid masses and simple forms of which suggest the archaic world of the Old Testament. Claude's figures are tall and willowy, dressed in classical mode. The light suggests evening, and the softness of Claude's late technique is visible in the featheriness of the dominating foreground trees. The light pervades every part of the composition, conveying an overwhelming sense of peace and distance. Claude's unique genius is perfectly illustrated here – a familiar biblical story interpreted in relation to a grand and eternal sense of nature. Jacob's fourteen years of labor – and indeed, by association, all human troubles – seem wholly insignificant in the face of something so huge, so timeless, so beautiful, and so awesome.

IACD

31 Gaspard Dughet

ROME 1615–1675 ROME

Landscape with Travelers, ca. 1638–39

Oil on canvas
57 × 86⅞ in. (144.7 × 220.9 cm)
DPG 656; presented by the Linbury
Trust, 1994

REFERENCES: M.-N. Boisclair, *Gaspard Dughet, 1615–1675*, Paris, 1986, no. 61

Gaspard Dughet's career benefited from an extraordinary piece of good fortune – his oldest sister married Nicolas Poussin, and Gaspard became the older master's pupil and was often referred to as Gaspard Poussin. Apparently an independent spirit, Gaspard struck out on his own in the field of landscape – his figures are incidental, and anonymous, though in a different way from those of Claude. Famous by the time he was twenty, Dughet was well paid, happy in a variety of media, and able to work on any scale from very small to huge.

This painting illustrates his brilliance and originality. He painted with tremendous speed and virtuosity: brushstrokes are always visible, and his bravura technique allows him to make maximum use of the red underpaint, or ground, which plays a full part in the overall tonality. His landscapes were exceptionally realistic, but he also enjoyed compositional challenges, in this case evident in the boldness of the diagonal that divides the painting. He also relished extremes of weather for their effects on the physical landscape. Here the wind and cloud that precede the approaching storm emphasize the shattered rocks and lightning-blasted trees. The figures, executed in the manner of Poussin, serve a typically non-narrative purpose – embodying in their flying draperies the rush of the wind.

IACD

32 Sébastien Bourdon

MONTPELLIER 1616–1671 PARIS

A Brawl in a Guardroom, ca. 1643

Oil on canvas
29½ × 23⅞ in. (74.9 × 60.6 cm)
DPG 557; Fairfax Murray gift, 1911

REFERENCES: G. Briganti, L. Trezzani, and L. Laureati, *The Bamboccianti: The Painters of Everyday Life in Seventeenth-Century Rome*, Rome, 1983, p. 240; C. Wright in *Collection for a King*, Washington, D.C., National Gallery of Art, and Los Angeles County Museum of Art, 1985–86, no. 2; C. Wright in *Kolekcja dla Króla*, exhib. cat., Warsaw, Royal Castle, 1992, no. 3

After his apprenticeship as a painter, Sébastien Bourdon served as a soldier in the French army. Discharged in 1634, he went to Rome, where his style was influenced by that of Pieter van Laer and his followers, known as the Bamboccianti. Something of a chameleon where painting styles were concerned, he was later to fall, just as completely, under the influence of Poussin.

This painting testifies to the pan-European popularity of guardroom themes. Derived from the genre painting of Flemish and Dutch low-life artists such as Van Laer, the universally recognized themes of a soldier's life – drinking, fighting, playing cards – had a particular resonance in a century during which Europe was so frequently at war. Bourdon's personal experience of soldiering has perhaps led here to a less romanticized view of that life. This brawl has literally spilled out of the frame on the left, but the painting has a somber atmosphere very different from the violent and comic caricatures of many low-life genre painters. The veteran soldier tries to reason with the hot-blooded combatants, but the man on the right seems too deadened by discomfort, sleep, or cold to care. Bourdon uses a device familiar from the works of the Le Nain brothers – that of the standing street urchin, rooted at the very center of the composition, looking directly out at the observer – as if to involve us in the scene. Barefooted and in rags, his appeal ensures that our reaction to the scene cannot be as detached as we might expect from a more conventional guardroom scene.

IACD

33 Antoine Watteau

VALENCIENNES 1684–1721 NOGENT-SUR-MARNE

Les Plaisirs du bal (The Pleasures of the Dance), ca. 1716–17

Oil on canvas
20¾ × 25¾ in. (52.6 × 65.4 cm)
DPG 156; Bourgeois bequest, 1811

REFERENCES: P. Rosenberg, M. Morgan Grasselli, *et al.*, *Watteau,* exhib. cat., National Gallery of Art, Washington, D.C.; Paris, Grand Palais; Berlin, Schloss Charlottenburg, 1984–85, p. 51; P. Rosenberg in *Kolekcja dla Króla*, exhib. cat., Warsaw, Royal Castle, 1992, no. 28

When Antoine Watteau was elected to the French Academy in 1712, he was registered as a painter of *fêtes galantes*, a genre he had himself invented. Born in Valenciennes, a town that had passed to France from the Spanish Netherlands only six years previously, he was considered in his lifetime a Flemish painter. Certainly his initial influences were Flemish – both Wouwermans and Rubens had a huge impact on his style – and his unique contribution was to marry straightforward Flemish genre painting to the sophistication of the Venetian *fête champêtre*. The result was something truly Parisian, exquisite, and dreamlike, in which apparent frivolity of subject matter was transformed into the purest poetry through an underlying melancholy.

Despite the tiny scale of this painting, the influences most clearly visible are those of Rubens and Veronese, both masters of huge, dramatic, colorful history scenes. Watteau replaces history and myth with a curious amalgam of present and past, a romantic fantasy of unreal courtly life. Watteau is one of the greatest draftsmen in the history of art, and his drawing of these tiny characters is exquisite. The elaborate architectural setting was adapted from a far more enclosed, Italianate building in order to open up the vision of landscape beyond, in which a fountain plays and lovers glide off into the shade of trees.

This work was described by John Constable as "painted in honey: so mellow, so tender, so soft and so delicious … . This inscrutable and exquisite thing would vulgarise even Rubens and Paul Veronese."

IACD

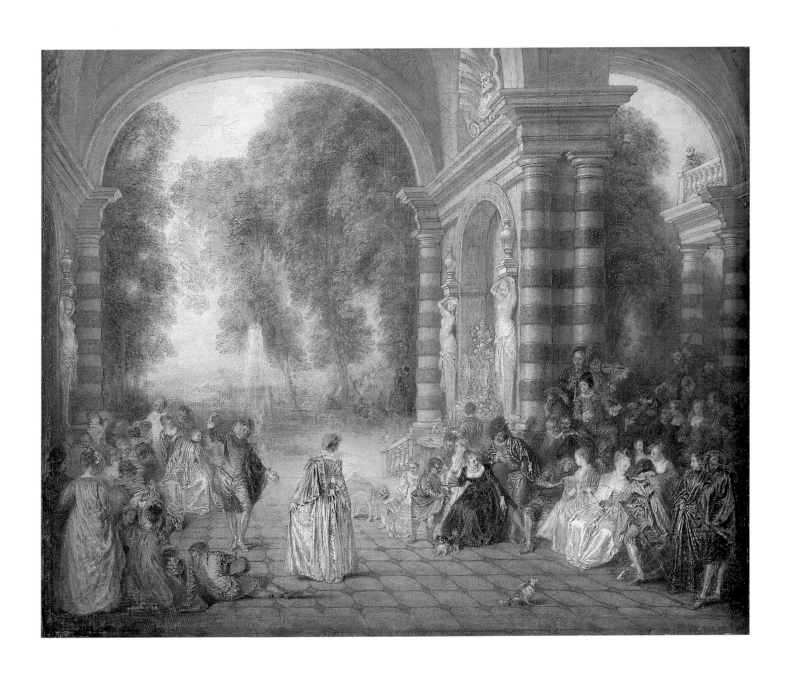

34 Jean-Honoré Fragonard

GRASSE 1732–1806 PARIS

Young Woman, ca. 1769

Oil on canvas
24¾ × 20¾ in. (62.9 × 52.7 cm)
Signed, lower right: *Frago* (overpainted);
and inscribed, below the signature:
Grimou
DPG 74; Bourgeois, 1811

REFERENCES: P. Rosenberg and
I. Compin, "Quatre nouveaux
Fragonards," *Revue du Louvre*, III, 1974,
pp. 183–92; P. Rosenberg, *Fragonard*,
exhib. cat., Paris, Grand Palais, and New
York, Metropolitan Museum of Art,
1987–88, no. 103

Jean-Honoré Fragonard studied briefly
with Chardin, and then with Boucher and
Carle van Loo. He won the Prix de Rome in
1752 and made full use of his time in Italy,
studying the work of Tiepolo, and touring
the South with Hubert Robert. He deve-
loped a popular style of small, erotic
canvases that was suited to the tone of the
court under Louis XV, and he was patron-
ized by both Mme de Pompadour and
Mme du Barry, the king's powerful
mistresses. His lush and spontaneous
handling of paint is well illustrated in this
painting. He died in poverty, ruined by the
French Revolution.

Until recently, this painting was
ascribed to Jean-Alexis Grimou (1678–
1733) on the basis of the inscription.
However, the discovery of an overpainted
genuine signature has necessitated a
reinterpretation. The false signature was
apparently added by Fragonard himself,
either as a joke or in self-deprecation. The
sheer bravura of the painting, with its bold
brushstrokes and coloring, is certainly
Fragonard's, as was first recognized by
Rosenberg and Compin. Rosenberg has
suggested a date of about 1769.

IACD

I V The Flemish School

While the centers of the Italian, French, and Spanish schools – Rome, Paris, and Madrid – lie on a triangle with sides of between 650 and 850 miles long, the centers of the Flemish and Dutch schools – Antwerp in Flanders and Amsterdam in the United Provinces (or "Holland" as it is imprecisely called in English) – are a mere 80 miles apart. Indeed, all the towns associated with Dutch and Flemish painting – Haarlem, Delft, Leiden, Utrecht, Rotterdam, The Hague, Dordrecht, Brussels, as well as Antwerp and Amsterdam – lie within an area the size of the English county of Essex or the suburbs of Los Angeles. This area had better and safer means of communication than any other in Europe. It would have been easier in the mid-seventeenth century to make a round trip, taking in every one of these centers, than to travel from Bologna to Rome.

It is possible to take this geographical approach still further: if one draws a circle centered on Brussels with a radius of two hundred miles, it covers the place of birth of most of the French and English artists in this selection as well as all the Dutch and Flemish. The northeast of France and the southeast of England are part of a "fertile crescent," which produced the vast majority of French and English artists of note during the seventeenth and eighteenth centuries. In France the recently independent eastern states of Champagne and Lorraine were especially important, producing Philippe de Champaigne (who was actually born in Brussels), the Le Nain brothers, Georges de La Tour, and Claude Lorrain, as, in England, were East Anglia and especially the county of Suffolk, where Gainsborough and Constable were born.

The explanation for this phenomenon of a geographical powerhouse of art is complicated. However, some factors may be listed: by the seventeenth century this area was the most densely populated and urbanized in Europe; it was the major center for the textile industry, which has many obvious parallels with painting, as well as for world maritime trade. There was a greater concentration of skilled artisans and a richer market for luxury goods than anywhere else. The same factors hold true of the other better-known cradle of art – the triangle made by Venice, Milan, and Florence in the north of Italy. If anything, communications were better in these "Greater Low Countries," as London was less isolated by a strip of North Sea than Florence was by the passes of the Appennines. There was, moreover, a shift in the epicenter of trade from Italy, which dominated the period 1400–1600, to the North Sea fringes, which established supremacy during the period 1600–1800.

Not only did Flanders lie at the center of the circle we have just described, but artistic activity can be seen to have spread from Flanders to its neighbors. In 1434, the date of Jan van Eyck's *Arnolfini Portrait* (National Gallery, London) and already a golden age of Flemish painting, Holland did not exist as an independent state; Flanders was controlled by the Dukes of Burgundy, who were also the leading patrons of French painting, while painting in England was generally of much lower quality. Two hundred years later, Dutch art was flourishing with its own distinctive style, though this owed a considerable debt to more recent Flemish masters, such as Pieter Breughel, Adriaen Brouwer, and Rubens; French painting was dominated by Dutch and Flemish influences, seen especially in the work of the artists from Champagne and Lorraine listed above; English painting was limited to Netherlandish imports, especially the recently arrived Fleming Anthony van Dyck, whose influence on the national style was incalculable. It is not important to establish

precedence in this matter, merely to demonstrate interconnection. Lely's *Nymphs by a Fountain* (cat. 79) is a painting of Flemish character by a Dutchman working in England; Le Brun's *Massacre of the Innocents* (cat. 29), for all its Roman severity, has a figure style based on Rubens; Claude's landscapes grew out of and in turn influenced a milieu of Dutch artists working in Rome.

This account of geographical interconnection neglects one thing – war. Antwerp and Amsterdam may have been neighbors, but for much of the period under discussion they were separated by a front line. The Dutch first rebelled in 1568 against the intolerant, Catholic, and absolutist rule of the Spanish Hapsburg king who had inherited the Netherlands from the Dukes of Burgundy; in 1648 peace was finally concluded and the Northern Provinces were officially recognized by Spain. The first half of this eighty-year war was far more eventful than the second. By the time of the twelve-year truce in 1609, and even after hostilities were resumed in 1621, the frontiers of the Northern and Southern Netherlands were relatively stable and the war was predominantly fought away from the important cities by foreign mercenaries. In this phase the war threatened the Southern more than the Northern Netherlands, notably when the Dutch Navy blockaded the estuary of the river Scheldt, thus debarring Flanders from international maritime trade. Amsterdam took over from Antwerp as the world's busiest port.

The separation of one people into two rival and warring states produced an ideal test case to explore how one tradition of painting adapts to two radically different societies. The Northern Provinces were predominantly Protestant and (up to a point) tolerant; the Spanish Netherlands were exclusively Catholic with a zeal exaggerated by their conflict with heretical neighbors. Flemish artists therefore enjoyed a market for public religious imagery which did not exist north of the border. The market was indeed boosted after many Flemish churches were attacked by iconoclastic Protestant mobs and stripped of their paintings during the 1570s, when the Dutch occupied many of the major Flemish cities. Once reconquered by Spanish troops these old churches (and the many new ones built in the early seventeenth century) all needed to be decorated by large-scale, public, and (for want of a better word) propagandist religious paintings. Catalogue 35 and 36 are examples of one such commission, the like of which made up a considerable part of Rubens's career.

Holland was a self-ruling republic; Flanders was a province of an absolute monarchy, ruled from Spain through governors selected from the King of Spain's immediate family and established at a court in Brussels. Rubens was court painter to the Archduke Albert and the Archduchess Isabella (daughter of the Spanish King Philip II) and to their successor as governor, the Infante Ferdinand (brother of Philip IV), although he was permitted to live and work in Antwerp rather than Brussels. This connection with the Hapsburg dynasty, and through them with the intermarried crowned heads of Europe, gave Rubens unique access to court patronage in Madrid, Paris, and London. A handsome man with perfect aristocratic manners, Rubens was a superb linguist, and was chosen for important diplomatic missions. He was knighted in England as well as Flanders and took over Titian's mantle as *the* court painter for Europe. One might say that he was a special case, except that his nearest rival, Anthony van Dyck, was a fellow countryman and pupil.

Rubens realized that court painting required something more in the seventeenth century than it had for earlier generations. The monarchs for whom he worked – the Gonzaga of Mantua, Philip IV of Spain, Marie de Médicis of France, Charles I of England, as well as the regents in Brussels – already had superb collections of Italian High Renaissance painting (and even some by the early Flemish masters), which had remained in fashion. He had to compete with the dead in a way that Titian never felt the need to. Whereas the artists of the Renaissance paid conscious homage to antiquity in their paintings, Rubens paid homage to antiquity *and* to the artists of the Renaissance. Art

historical resonance is a fundamental part of the pleasure of his paintings: to look at his *Venus, Mars, and Cupid* (cat. 40) without thinking of Titian is to understand it only partially. It feels like a Titian because it is a mythological scene with a nude woman, and Titian's late *poesie* painted for King Philip II of Spain are the obvious "competition." An Antwerp altarpiece, featuring local saints (cat. 35 and 36), looks quite different and more northern, more like a Dürer or a Quentin Massys. In the same way, a Rubens portrait of an Englishman (that of the Duke of Arundel in the National Gallery, London) looks like a Holbein; a local Flemish peasant dance (the *Kermesse* in the Louvre, Paris) looks like a Pieter Breughel the Elder. This chameleon allusiveness is part of Rubens's genius; it is also something that can only work for an audience of sophisticated aristocrats who have real Titians, Holbeins, and Breughels in their collections that allow them to appreciate the comparisons.

This distinctive character of public, religious, and court painting only really affects the highest genres – portraiture and history painting. The "lower" specialists in Flanders – genre, landscape, and still-life painters – might be court painters, such as David Teniers the Younger (see cat. 43–47), or might work for the Flemish (or even Dutch) middle classes; but their manner of painting is not fundamentally different from that of their Dutch colleagues. There is the same quality of meticulous realism and exquisite craftsmanship. It may be possible to detect differences in the way that Dutch landscape, genre, or still-life painting develops as a whole in comparison to Flemish. It may be possible to say that genre painting in Flanders could never have moved so far from its roots as to produce a Vermeer. However, it is quite impossible to look at David Teniers's depiction of a pig (cat. 46) and assert that such a painting could not have been painted in Amsterdam quite as well as in Brussels.

DST

35, 36 Peter Paul Rubens

SIEGEN 1577–1640 ANTWERP

Saint Amandus and Saint Walburga, ca. 1610–13

Saint Catherine of Alexandria and Saint Eligius, ca. 1610–13

Each, oil on oak panel
Each, 26¼ × 9⅞ in. (66.6 × 25 cm)
DPG 40, 40A; Bourgeois bequest, 1811

REFERENCES: M. Rooses, *L'Œuvre de Rubens*, 5 vols., Antwerp, 1886–92, II, no. 279 bis; J.S. Held, *The Oil Sketches of Peter Paul Rubens: A Critical Catalogue*, Princeton, 1980, no. 350A and B; M. Jaffé, *Rubens: Catalogo completo*, Milan, 1989, nos. 132–33; K. Downes, *Rubens*, London, 1980, pp. 108–10

After training with minor Mannerist masters in Antwerp, Peter Paul Rubens went to Italy in 1600 and entered the service of the Duke of Mantua. His travels included a diplomatic mission to Spain in 1603. He returned to Antwerp in 1608, in the same year marrying Isabella Brant and becoming court painter to the Archduke Albert and Archduchess Isabella. He became the most successful painter in the whole of Europe, and also enjoyed a distinguished career as a diplomat, visiting Spain and England in 1628, in order to promote peace in the Netherlands. Besides his prodigious output as a painter and his diplomatic activity, he was also a notable scholar, antiquarian, and collector.

The commission that established Rubens's reputation in Antwerp immediately after his return from Italy was for the church of Saint Walburga, a polyptych for the high altar executed in 1610–13 and now in Antwerp Cathedral. These two oil sketches are studies for the backs of the outer panels and show how the altarpiece would appear when closed. In the finished altarpiece, these two outer panels open like shutters to reveal a huge continuous scene of the Raising of the Cross, spread across the central area and the fronts of the two panels. At least three of the saints shown here have some local interest: Saint Walburga, although an Englishwoman who died in Germany, was the dedicatee of the church; Saint Amandus of Maastricht was known as the Apostle to the Low Countries; and Saint Eligius, patron saint of goldsmiths (which explains his hammer), was Bishop of Tournai in Flanders. Saint Catherine of Alexandria, identified by the sword with which she was martyred, has no obvious connection.

In these panels Rubens is obviously experimenting with the architectural setting of the figures. The church (since destroyed) was peculiar in having a raised choir – where the high altar stood – which was approached from the nave by a large flight of steps. This may explain Rubens's choice of a low viewpoint. He is also trying to fix upon the form of the arch and the niche behind the figures to show that, though in separate panels, they inhabit the same space. Saint Catherine's eyes rolled up in visionary contemplation may have been directed towards the panel depicting God the Father which originally crowned the altar. In the final version the architecture is lost in the dark and the angels hold miters over the heads of the two bishops, instead of flying down with crowns of martyrdom for the female saints, as they do here. Rubens set his scene at night, with deep shadows and yellow highlights suggesting candlelight, as if the altarpiece were lit by the real candles on the altar table immediately in front of it.

DST

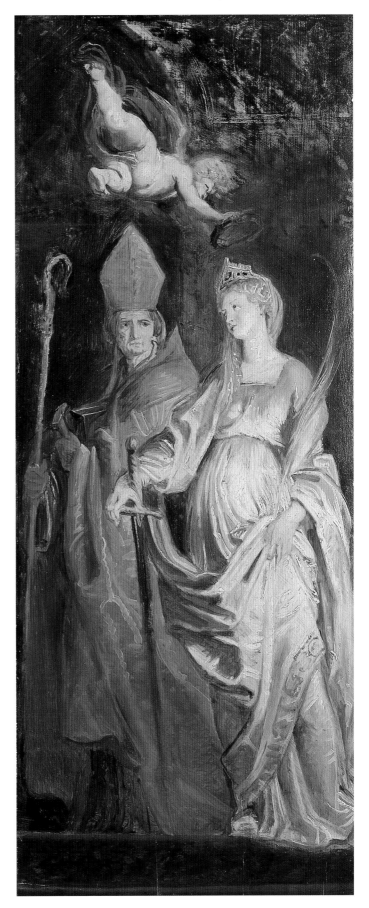

37 Peter Paul Rubens

SIEGEN 1577–1640 ANTWERP

Venus Mourning Adonis, ca. 1617

Oil on oak panel
19⅛ × 26⅛ in. (47 × 66.4 cm), excluding
an addition of 9⁄16 in. (1.6 cm) at the top
edge
DPG 451; Bourgeois bequest, 1811

REFERENCES: M. Rooses, *L'Œuvre de Rubens*, 5 vols., Antwerp, 1886–92, III, under no. 696; J.S. Held, *The Oil Sketches of Peter Paul Rubens: A Critical Catalogue*, Princeton, 1980, no. 267; M. Jaffé, *Rubens: Catalogo completo*, Milan, 1989, no. 253; M. Jaffé in *Conserving Old Masters*, exhib. cat., London, Dulwich Picture Gallery, 1995, no. 3

Venus and her attendants discover the body of her mortal lover, Adonis, who has been gored in the thigh by a wild boar while hunting. His spear lies nearby and his dogs watch over his corpse, one bending to lick the stream of blood. Venus cradles her lover's head and feels the pulse in his neck with the back of her hand. While her attendants mourn, her son Cupid discards his quiver of arrows in disgust at the misery they can cause. The myth is told in Ovid's *Metamorphoses* X and in Bion's *Lament for Adonis*.

This oil sketch can be related to two very similar paintings, one lost and the other in a private collection in New York. The purpose of Rubens's technique in this sketch is to achieve the maximum of description with the minimum of actual painting. The panel is prepared with a brown underpaint, visible throughout through the streaky pattern of the coarse brush. This underlayer is made to suggest the dogs, Cupid, and the three attendants, with a mere flicker of overpainting to give the outlines and highlights. The principal figures are more thickly and completely painted, but the underpaint still serves for the shadows around the contours. As well as being labor saving, his use of the underpaint also gives the panel its luminous transparent quality.

Rubens is here at his most Michelangelesque, disposing heroic nude figures across the front of the picture plane like high-relief marble sculpture. In two respects Rubens is more painterly than his forebear. First, he models with color rather than just light and dark. The transitions of pink, blue, and brown create the three-dimensional form of Venus's body, as well as contrasting her living flesh with the sallow yellow and blue of Adonis's dead arm. Secondly, Rubens is concerned with the atmospheric potential of color and light: he creates a nocturnal mood out of the subtle transition from dark grey to lighter blue across the bushes and sky, and out of the contrast between the warmly colored figure group and the uniformly cool background.

DST

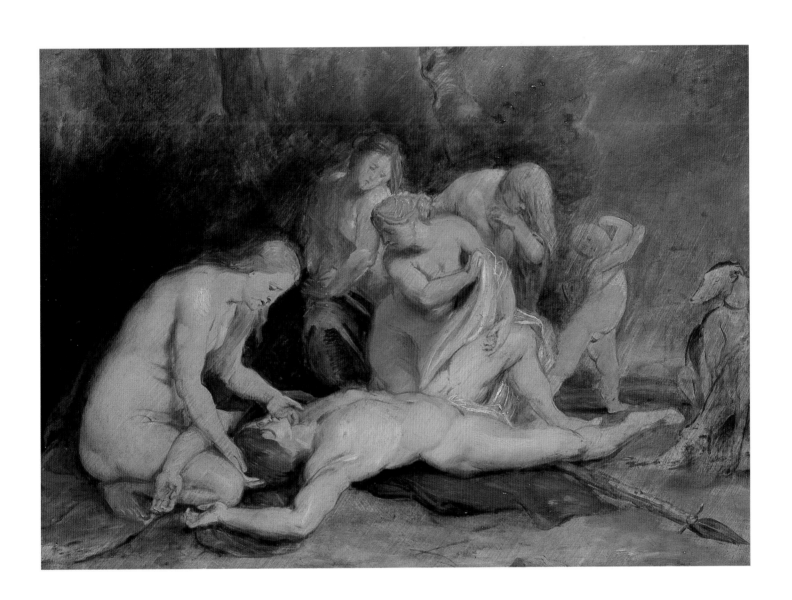

38 Peter Paul Rubens

SIEGEN 1577–1640 ANTWERP

Ceres (?) and Two Nymphs with a Cornucopia, ca. 1625–27

Oil on oak panel
12⅛ × 9⅝ in. (30.9 × 24.4 cm)
DPG 43; Bourgeois bequest, 1811

REFERENCES: M. Rooses, *L'Œuvre de Rubens*, 5 vols., Antwerp, 1886–92, III, under no. 651; J.S. Held, *The Oil Sketches of Peter Paul Rubens: A Critical Catalogue*, Princeton, 1980, no. 255; M. Jaffé, *Rubens: Catalogo completo*, Milan, 1989, no. 440

This is an oil sketch for a painting (now in the Prado, Madrid) presented to Philip IV of Spain by Rubens on the king's arrival in Madrid in 1628, and probably painted shortly before. Though one of the figures was described as Ceres as early as 1636, there is no compelling reason to suppose that any of them are anything more than nymphs, the female inhabitants of the mythological Arcadia. They are decorating a horn of plenty (or cornucopia) in order to symbolize the profusion of nature and the happy indolence of life during the Golden Age. Even the highlights on the figures are golden to suggest the warm light of the setting sun.

The strips added to both sides of this panel have clearly been painted in slightly later to join up with the central area. This is not unusual in Rubens's oil sketches: he seems to have developed his compositions not by dividing up an existing rectangle, as most artists did, but rather by expanding almost organically from the center outward. He began with his principal figure group, usually bound together in a tight anatomical knot; if he found that the group needed more figures or more breathing space he added strips of panel.

DST

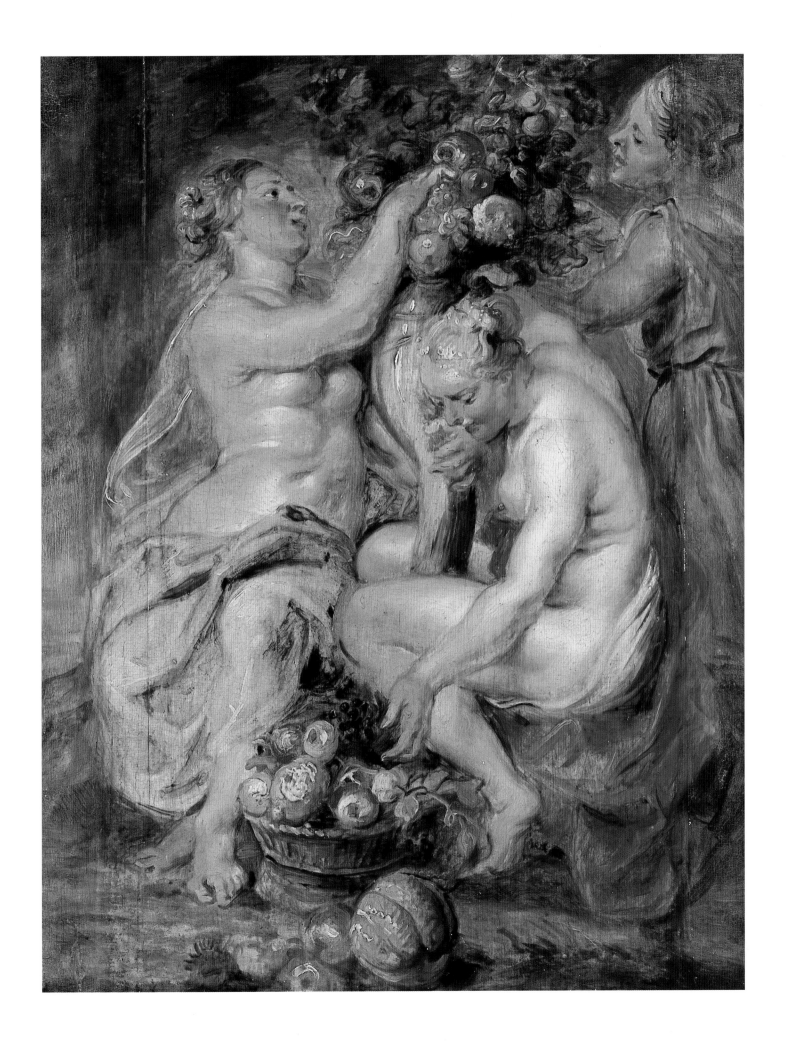

39 Peter Paul Rubens

SIEGEN 1577–1640 ANTWERP

The Three Graces, ca. 1625–28

Oil on oak panel
15¾ × 15¾ in. (39.9 × 39.9 cm)
DPG 264; Bourgeois bequest, 1811

REFERENCES: M. Rooses, *L'Œuvre de Rubens*, 5 vols., Antwerp, 1886–92, III, p. 100 (as doubtful); J.S. Held, *The Oil Sketches of Peter Paul Rubens: A Critical Catalogue*, Princeton, 1980, no. 239; M. Jaffé, *Rubens: Catalogo completo*, Milan, 1989, no. 1224

No work of art survives based on this oil sketch. The absence of color suggests that it was not originally for a painting but rather for an engraving or perhaps even a piece of silverware. Either would also explain the strict relief-like composition, with a clear articulation of the contour or ridge where the salient figures meet the smooth, flat background. Though a *grisaille* sketch, Rubens has included just enough color to allow for a contrast between the cool greys and warm browns. Even more miraculously than in his other oil sketches, this panel seems to conjure a fully realized scene from nothing. The face and legs of the right-hand figure are created almost entirely out of underpaint, marshaled in the direction of anatomy by the slightest touches.

The three Graces – Euphrosyne, Thalia, and Aglaea – were the daughters of Jupiter and the personification of those things that made women loveable – beauty, grace, and kindness. They are often shown, as here, linking hands with sisterly affection, which also symbolizes the giving and taking of gifts. Rubens shows them dancing to the accompaniment of the tambourine in a landscape in front of their own temple. Though it is difficult to see where the dance would go from here, it gives Rubens a chance to demonstrate anatomy in movement by showing front, back, and side views of what appears to be the same model. The three figures can almost be read as the same figure at successive moments in time.

The relationship of this panel to Raphael's painting of the same subject (Musée Condé, Chantilly) and to antique statuary reminds us that Rubens's women are not classically proportioned. Rubens revered the antique, but checked its forms against nature and positively accentuated certain areas of discrepancy, especially the heavy hips and stomachs of his models. Though unclassical in build, Rubens's figures have a rhythm – in their serpentine postures and evenly curvaceous outlines – that he had learned from his artistic sources. They may be heavy, but there is nothing awkward about these Graces.

DST

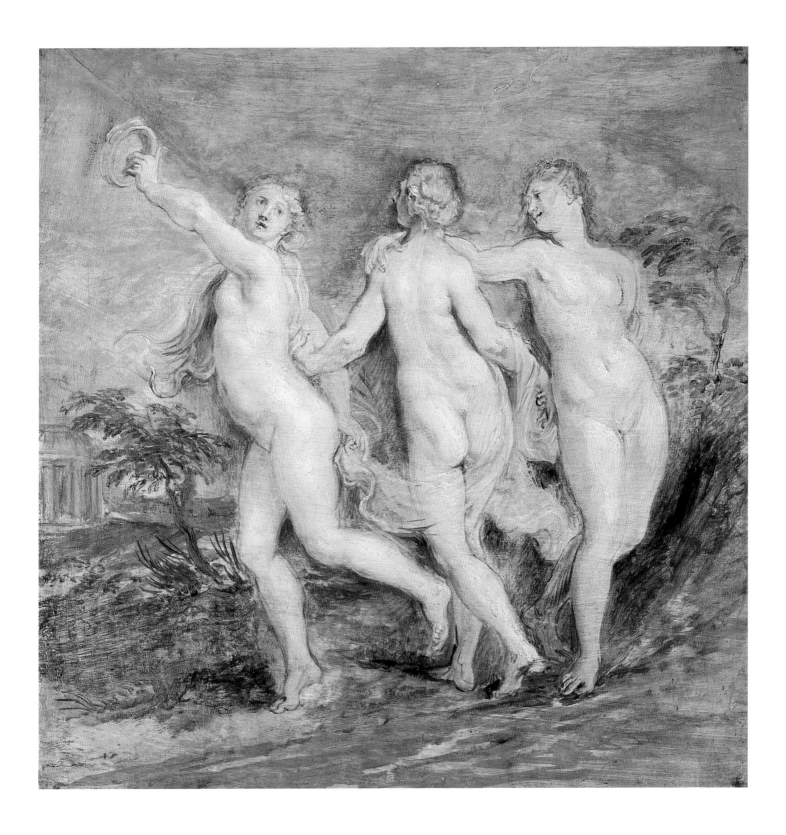

40 Peter Paul Rubens

SIEGEN 1577–1640 ANTWERP

Venus, Mars, and Cupid, ca. 1635

Oil on canvas
76⅞ × 52⅜ in. (195.2 × 133 cm)
DPG 285; Bourgeois bequest, 1811

REFERENCES: M. Rooses, *L'Œuvre de Rubens*, 5 vols., Antwerp, 1886–92, III, no. 704 (as the work of a pupil); M. Jaffé, *Rubens: Catalogo completo*, Milan, 1989, no. 974; M. Jaffé in *Conserving Old Masters*, exhib. cat., London, Dulwich Picture Gallery, 1995, no. 2

Peter Paul Rubens believed that painters should imitate statues, but not too closely. They should be particularly careful to record those creases, dimples, and areas of fat that distinguish real bodies from marble. This is certainly evident here, where Venus is a *painterly* nude – soft, fleshy, beautiful (though faintly imperfect), and boldly executed with a coarse brush. Rubens makes the viewer aware of the sense of touch – whether we imagine the real surface of the paint or the fictitious surface of the skin or armor.

But this painting is not merely sensual: Rubens also wished to give substance to his ideas. He uses Greek and Roman gods as the embodiments of abstract virtues. What at first seems to be a mythological family posing for their portrait is in fact an allegory of the triumph of Peace over War, of Love over Hate. Mars (the god of war and appropriately set against a dark blood-red cloth) is literally disarmed by love – a little cherub cuts him from his armor. Meanwhile, Venus (the goddess of love and suitably light, white, and tender) nourishes her baby Cupid. Narrowly saved from falling, the child clutches at his mother. Below him lies Mars's shield, with a monstrous face carved on it and looking like an evil black hole cut through the painting. A baby seems to be dangling over the mouth of Hell. Protecting the spirit of love is difficult, especially at the height of the Thirty Years War.

An X-ray has revealed that Cupid's left leg was originally tucked back, that Venus's drapery at which Cupid tugs was originally taut, and that Venus's left leg swayed to the right, ending in front of the shield.

DST

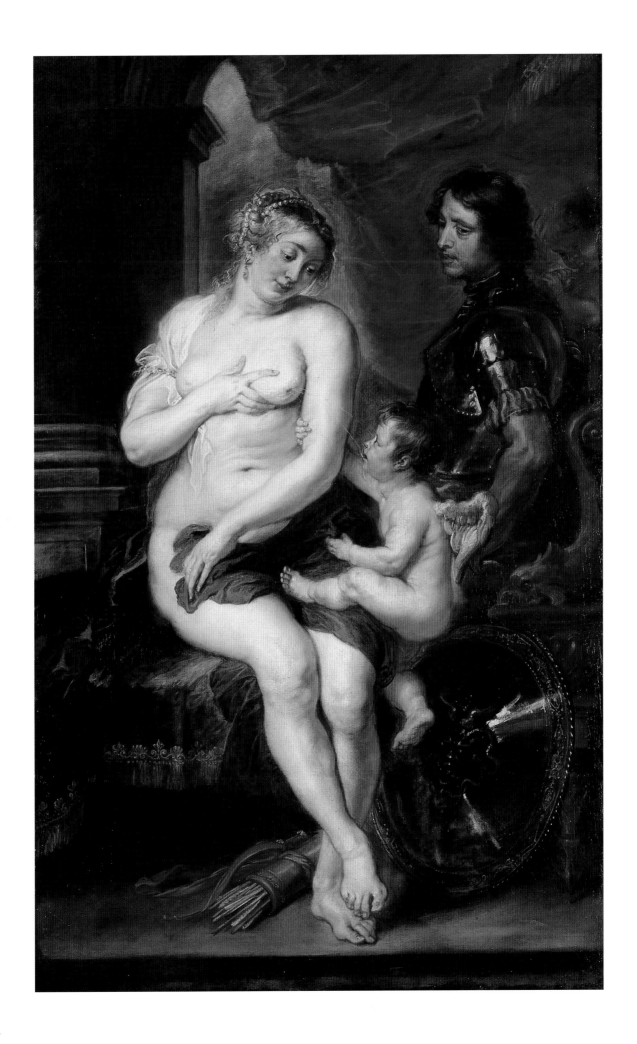

41 Peter Paul Rubens

SIEGEN 1577–1640 ANTWERP

Portrait of a Woman, Known as Catherine Manners, Duchess of Buckingham, ca. 1625

Oil on oak panel
31⅜ × 25⅞ in. (79.7 × 65.7 cm)
DPG 143; Bourgeois bequest, 1811

REFERENCES: F. Huemer, *Corpus Rubenianum*, XIX, *Portraits*, 2 vols., Brussels, London, and New York, 1977, I, no. 6; M. Jaffé, *Rubens: Catalogo completo*, Milan, 1989, no. 390

This portrait, which is unfinished (especially around the hands and lace cuffs), has been identified as that of Catherine Manners, Duchess of Buckingham, based on an inscription on a chalk study for the painting in the Albertina, Vienna. Such inscriptions are notoriously unreliable, however, as collectors naturally want their works to depict famous rather than obscure sitters. The portrait does not resemble any known image of the duchess.

The liveliness and warmth of this unknown woman is conveyed by Rubens's use of light, which clings to or belongs with the sitter's body almost as if it emanates from it, like warmth. Ringed by the wine-dark background, the flesh is built around a single pool of light with its brightest point on the sitter's breast. Although fringed with a soft shadowy area, around the hair and shoulders, the face and chest are almost uniformly bright. The modeling of the face is achieved entirely through colors – with pinks, yellows, browns, and blues – and almost no shadow.

The face is also typical of Rubens and of his Flemish sources in its rounded, animated, and asymmetrical features and in the way we see more of the far side than would be strictly possible from this angle. We are more aware of the expressiveness of the face – the full cheeks, the curving lip, the raised eyebrows – than of its structure, just as we are when meeting a living person.

DST

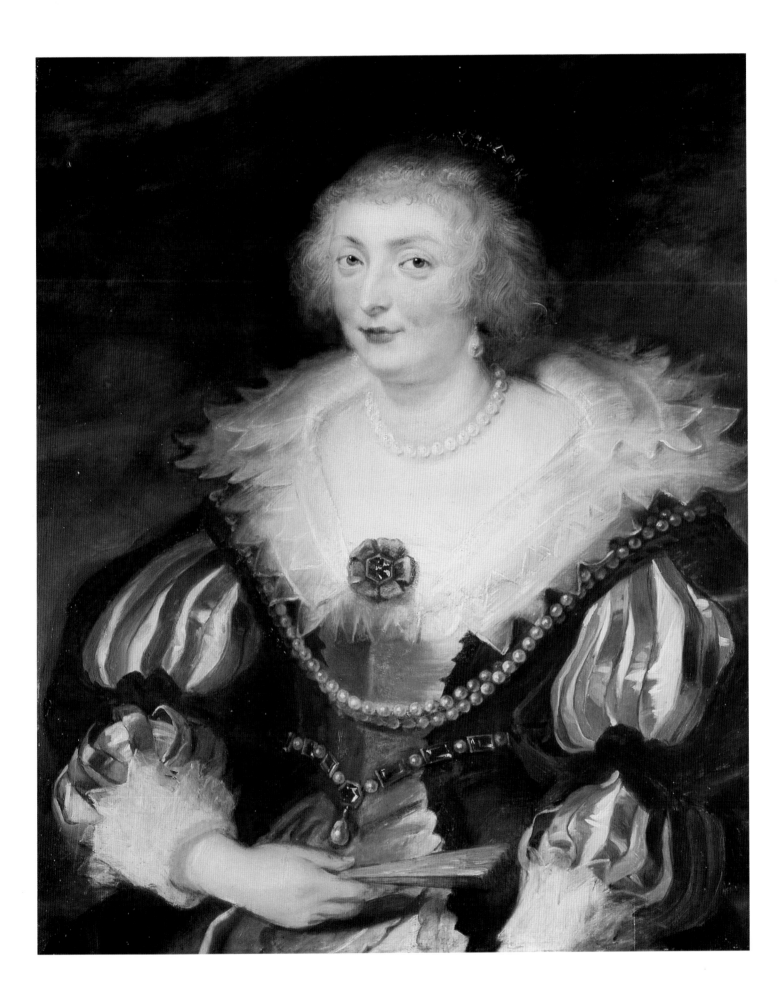

42 Peter Paul Rubens

SIEGEN 1577–1640 ANTWERP

Hagar in the Desert, ca. 1630–32

Oil on oak panel
28⅝ × 28⅞ in. (71.5 × 72.6 cm)
DPG 131; Bourgeois bequest, 1811

REFERENCES: M. Rooses, *L'Œuvre de Rubens*, 5 vols., Antwerp, 1886–92, II, no. 471; R.-A. d'Hulst and M. Vandenven, *Corpus Rubenianum*, III, *The Old Testament*, London and New York, 1989, no. 11; M. Jaffé, *Rubens: Catalogo completo*, Milan, 1989, no. 1052

At his wife Sarah's insistence, Abraham banished his concubine Hagar and their son, Ishmael. The two outcasts found themselves in the desert fearing for their lives until an angel came, led them to water, and proclaimed that Ishmael would be forefather to a great nation (Genesis 21:17–18). An engraving by Frans de Roy of about 1750 shows this composition extended at the top to include the angel and at the left to include the prostrate figure of Ishmael. The wing and arms of an angel are still just visible behind Hagar's head, though they have been overpainted, presumably when the panel was cut down to its present proportions.

The model here is probably Rubens's second wife, Helena Fourment, and the painting wavers between being a portrait and a simple biblical scene. Rubens could be fussy about historical costume, so it is not an oversight that his Old Testament woman is wearing the completely unadjusted costume and hairstyle of 1630s' Flanders. Even the flask is anachronistic. It is also unusual for biblical figures to look out at the viewer with such coy and beguiling intimacy. It is likely that Rubens intended some private joke in this modern-dress retelling of the biblical story.

DST

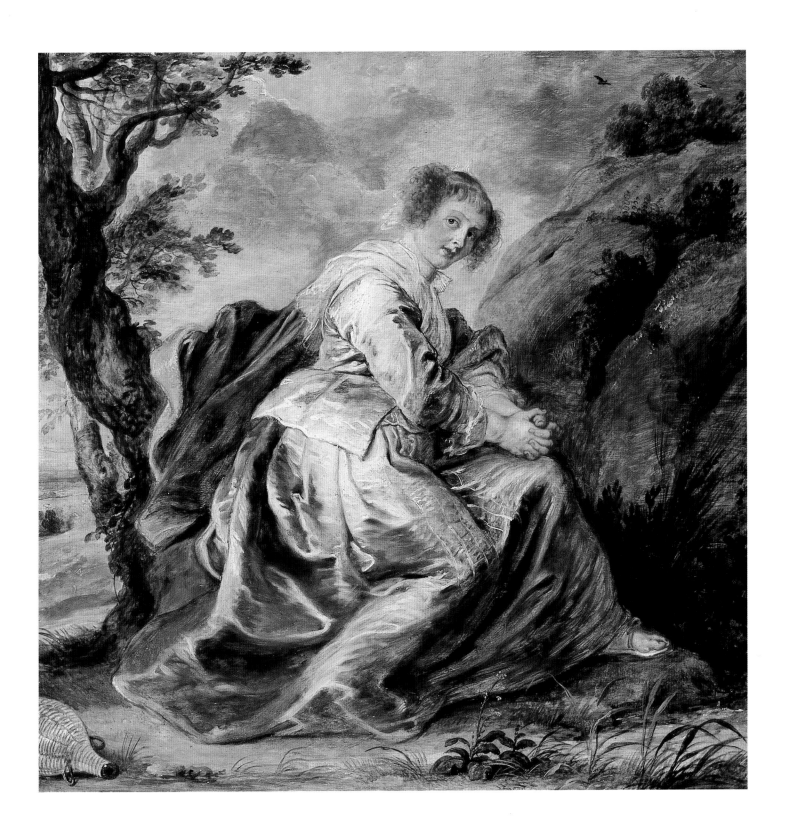

43 David Teniers the Younger

ANTWERP 1610–1690 BRUSSELS

Peasants Conversing, ca. 1660

Oil on canvas
51¼ × 69⅞ in. (130 × 177 cm), including
additions of 15¾ in. (40 cm) top, 7⅟₁₆ in.
(18 cm) bottom, and 2 in. (5 cm) right
Signed, lower center left: DT.F (DT in
monogram)
DPG 76; Bourgeois bequest, 1811

REFERENCES: G.A. Waterfield in
Conserving Old Masters, exhib. cat.,
London, Dulwich Picture Gallery,
1995, no. 4

Though famous for his paintings of
peasants – an inferior genre despised by
academic art theory as requiring only the
mechanical skill of the journeyman –
David Teniers was himself a courtier and
an academician. In 1651 he became painter
to the governor of the Southern Nether-
lands, Archduke Leopold Wilhelm, and
also served as curator to his collection,
visiting England in 1651 to acquire pictures
from the collection of Charles I. In 1663 he
was granted noble status and through his
influence at court succeeded in establish-
ing an academy at Antwerp in 1665.

This painting does not today appear as
Teniers intended. Sir Francis Bourgeois,
founder of Dulwich Picture Gallery,
decided that it would make an attractive
pair with another Teniers in his collection
(*A Castle and Its Proprietors*, DPG 95), which
had a considerably squarer format. To
achieve this he himself painted the two
strips at the top and the bottom of the
painting. His contributions are clearly
visible through the changes of tone in the
sky and the ground.

DST

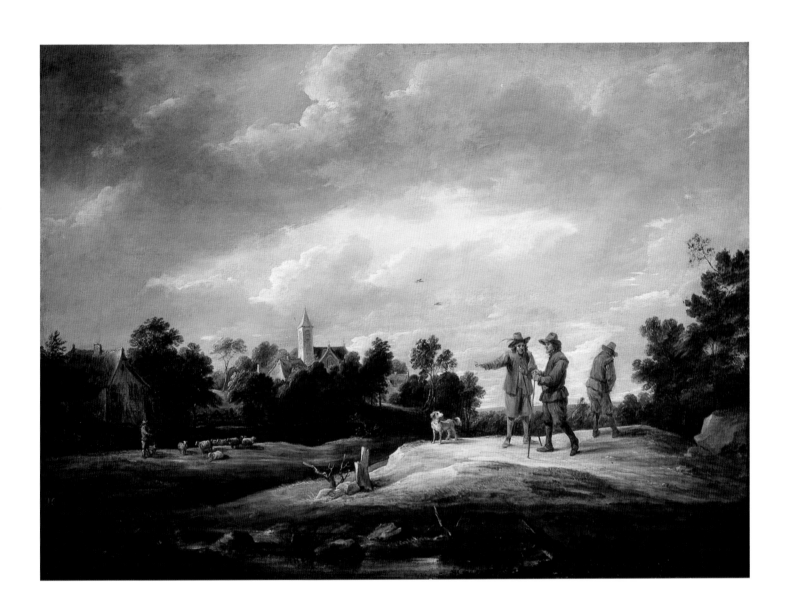

44, 45 David Teniers the Younger

ANTWERP 1610–1690 BRUSSELS

Saint Peter in Penitence, 1634?

Saint Mary Magdalen in Penitence, 1634

Saint Peter in Penitence
Oil on oak panel
12¼ × 21⅛ in. (31.1 × 53.5 cm)
Signed, bottom right: *Tinier*
DPG 314; Bourgeois bequest, 1811

Saint Mary Magdalen in Penitence
Oil on oak panel
12¾ × 20⅝ in. (31.3 × 53.4 cm)
Signed and dated, bottom center left:
D Tenier Iv 1634
DPG 323; Bourgeois bequest, 1811

REFERENCES: M. Klinge, *David Teniers the Younger: Paintings, Drawings*, exhib. cat., Antwerp, Koninklijk Museum voor Schone Kunsten, 1991, nos. 8A and B

These two landscapes with hermit saints were previously attributed to David Teniers the Elder (1582–1649); it now seems certain that they were painted by his famous son and pupil, David Teniers the Younger, especially as they can both be glimpsed in a 1635 view of the son's studio.

To understand these paintings we must unlearn our love of wilderness. Hermits sought out inhospitable terrain not in order to enjoy its "unspoilt" beauty (as we might) but to contemplate its ugliness. Fertile gardens reminded their visitors of the Earthly Paradise in the Garden of Eden; infertile mountains and deserts (the words were often used interchangeably) reminded those forced to pass through them of the Fall of Man and the simultaneous fall of nature, spoilt by the Creator of its original perfection. Hermits sought out the dangers and privations of the mountains in order to mortify the flesh and to contemplate the mysteries of sin and death. The wilderness is nature's answer to the hair shirt.

Teniers revels in the gothic horror of his scenes. Everything is barren, broken, dead, and decaying, and the forms are extravagant and misshapen, with rock arches, skeletal branches, plunging cataracts, grotesquely clinging roots, and, behind Saint Peter, an open cave-mouth with a fiendish leer. Of course this horror is rather over-designed; there is a tangled species of beauty even in this scene. The wilderness was already beginning to attract as well as repel; within a century wildernesses and hermitages had become an essential part of a tasteful landscape garden. There may also be some humor intended in Teniers's painting, especially in the Magdalen's rather literal-minded

larder of Lenten fare – cabbages, turnips, and parsnips.

Saint Peter is not usually associated with the wilderness; he is, however, often paired with Mary Magdalen, who is. Their connection lies in the idea of penance: Mary for her life of sin; Peter for denying Christ. The cock that crowed after this event is seen on a nearby rock (Mark 25:30, 60–72).

DST

46 David Teniers the Younger

ANTWERP 1610–1690 BRUSSELS

A Sow and Her Litter, ca. 1650–60

Oil on oak panel
9⅝ × 13½ in. (24.4 × 34.3 cm)
Signed, bottom right: D. *TENIERS. FEC.*
DPG 146; Bourgeois bequest, 1811

REFERENCE: J. Smith, *A Catalogue Raisonné of the Works of the Most Eminent Dutch, Flemish and French Painters*, 8 vols., III, London, 1831, no. 300

The essence of this painting is artlessness. In an age when every country family kept a pig, the subject is as banal as an automobile in a garage. The scene appears casually chosen and haphazardly composed, the disorder of the foreground made absurd by a single discarded shoe. It could even be taken for a fragment of a larger composition (which it is not). It seems to have been executed as casually as it has been conceived: the paint layer is mostly thin, the touch sketchy for such a small picture, with a sort of controlled shakiness in some of the detail.

The goal of artlessness is the direct depiction of life – what Teniers's contemporaries would have called nature. The vivid and intricate rendering of surfaces – pig hide, wood, plaster, and pottery – is achieved without "finish" or apparent labor. The image is not frozen by the process of recording it: the swineherd has animation; the piglets have personalities; the composition has the character of a glance.

DST

47 David Teniers the Younger

ANTWERP 1610–1690 BRUSSELS

A Winter Scene with a Man Killing a Pig, ca. 1660s

Oil on canvas
27⅛ × 37⅝ in. (68.9 × 95.7 cm)
Signed, bottom center: DT.F. (DT in monogram)
DPG 112; Bourgeois bequest, 1811

REFERENCES: J. Smith, *A Catalogue Raisonné of the Works of the Most Eminent Dutch, Flemish and French Painters*, 8 vols., III, London, 1831, no. 603; I. Gaskell in *Collection for a King*, Washington, D.C., National Gallery of Art, and Los Angeles County Museum of Art, 1985–86, no. 29; I. Gaskell in *Kolekcja dla Króla*, exhib. cat., Warsaw, Royal Castle, 1992, no. 24

The unfortunate pig is serving its purpose and providing supplies of meat for the entire festive season. In countless series of prints and paintings devoted to the Four Seasons, the slaughter of the pig is an activity as much associated with winter as skating and snow. It is not known whether this painting comes from such a set or is an isolated landscape building upon familiar seasonal images.

Teniers's landscape clearly belongs to the tradition initiated by his wife's grandfather, Pieter Brueghel the Elder, who was the first artist to depict winter scenes convincingly. Like his model, Teniers observes that after snowfall the sky, even at its brightest, is darker than the land. Brueghel's scenes have a bird's-eye perspective, a more extensive vista, and a more universal manifestation of the life of a town. Teniers, by contrast, concentrates on a ground-level view of a more limited corner of a village.

It is perhaps no accident that the great age of the snowscape, extending from Brueghel to Teniers (*ca.* 1550–*ca.* 1650), corresponds with a phase in the world's climactic cycle so cold that it has been called a mini-ice age.

DST

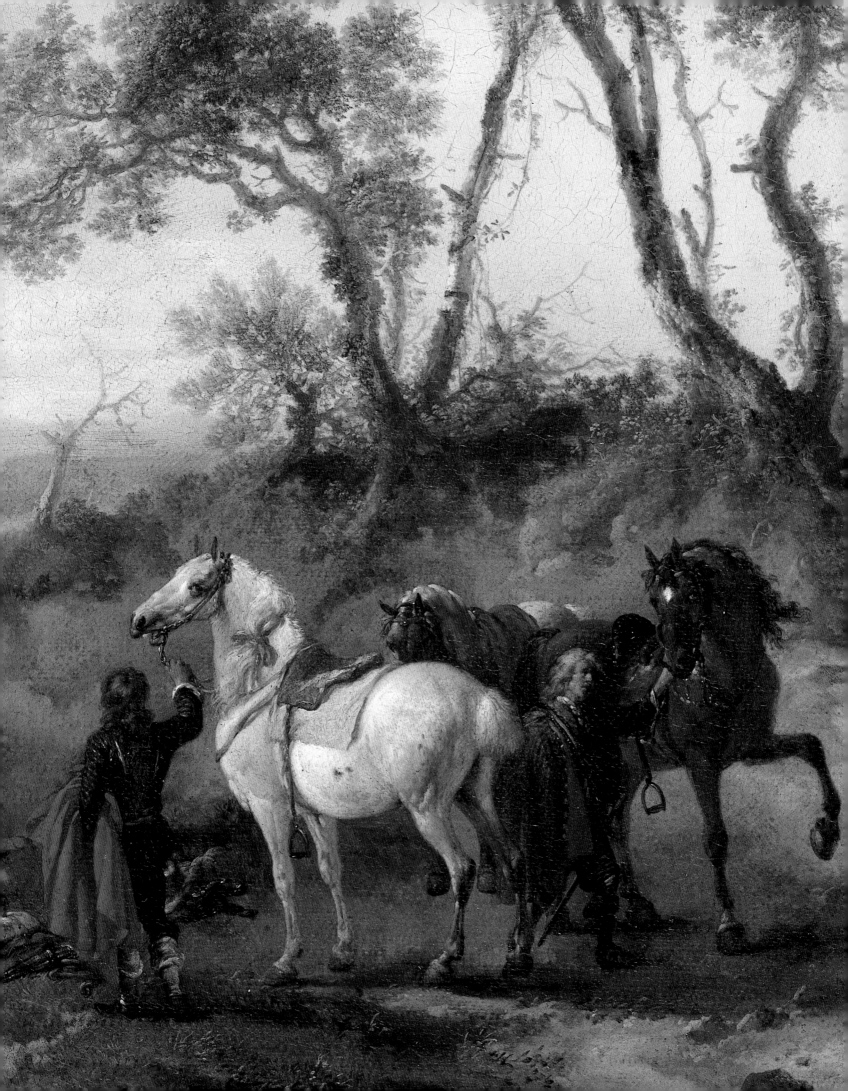

V The Dutch School

Dutch seventeenth-century art is a special case. Everything about it is extraordinary: the number of artists working; the number of paintings they produced; their remarkable quality; and the fact that the work is so unlike that of artists elsewhere.

This distinctness of Dutch painting has often made it difficult for theorists or even collectors to place it. As stated earlier, Roger de Piles thought Rembrandt the only Dutch artist worth mentioning. Joshua Reynolds excluded the Dutch completely from his early *Discourses*, in spite of an obvious admiration for their work. When he made the trip to Holland and Flanders in 1781 he was embarrassed to realize how little he had found to say about Dutch art. He concluded that since their merit consisted in "truth of representation alone" they necessarily made "but a poor figure in description" (Sir Joshua Reynolds, *A Journey to Flanders and Holland*, ed. H. Mount, Cambridge, 1996, p. 107). Bourgeois and Desenfans were remarkable in devoting such a significant proportion of their collection to Dutch artists, and in giving its many specialties such a fair and comprehensive showing. The National Gallery collection of the 1840s, while boasting fine Rembrandts, neglected small-scale Dutch landscape, genre, and still-life paintings almost altogether, presumably thinking them out of place in the grand and edifying environment of a public museum. A similar policy is still reflected in the collection of the National Gallery of Art in Washington, D.C. Bourgeois and Desenfans allow us to see how varied, how odd, and how good Dutch painting is.

To what extent is Dutch art the product of a society that made a fetish of being the European odd man out? The Dutch were predominantly Calvinist Protestants, though private Catholicism was tolerated and many significant artists, including Vermeer and Jan Steen, were Catholics. Protestants felt that religious imagery was idolatrous, and there was therefore no demand for public religious paintings to relieve the simple white-washed walls of Dutch church interiors. There was some religious painting produced in Holland at the time, especially by Rembrandt and his school, but it is private, contemplative, and mostly small-scale, more like an imagined reading of scripture than a public doctrinal statement.

In spite of its name, the Dutch Republic had a monarch or Stadholder, the Prince of Orange. Even though they were constitutional monarchs empowered only to fight for and to represent the United Provinces abroad, and decision-making power was otherwise vested in an oligarchy of city burghers, the Princes of Orange commissioned large-scale decorative schemes and rhetorical allegories, the sort of painting one associates with a court. There was a tradition of mythological and historical painting in Holland, which was neglected for many years by collectors like Bourgeois and Desenfans, and is therefore best represented in the Dulwich Picture Gallery by Lely's *Nymphs by a Fountain* (cat. 79) from the Fairfax Murray Gift. However, history painting still represents a relatively minor episode within Dutch art as a whole.

Dutch society was unique in the size and the prosperity of its middle classes. Visitors were impressed not just by the fabulous wealth of merchants but the affluence of peasants and minor tradesmen. Visitors were also amazed at the Dutch fondness for painting: at the many dealers; at the painting stalls in fairs; at the fact that there appeared to be no home or inn so humble that it did not contain a painting. This gives us some insight into the Dutch art market. Painters (those who were not dealers themselves) sold their works

to dealers, who would sell to a wide cross-section of the public.

What difference does it make how paintings are sold? This question is best answered with a schematic comparison of two types of patronage: the Italian model (followed in all the major aristocratic societies of Europe) and the Dutch one. A typical Italian artist painted his important works on commission to decorate the chapels and palaces of a circle of some forty or so noblemen. These noblemen belonged to society: they knew each other; they could therefore have seen an excellent sample of their chosen artist's entire output in what were to them public spaces. The Italian artist could not have afforded to repeat himself. Major Italian patrons would also have known their artist personally and, being educated and not especially busy, they would have known something of art and its theory. The subject matter of their altarpiece, ceiling painting, or entire chapel decoration will have been carefully chosen; they may have consulted with the artist; they may actively have enjoyed participating in the progress of his artistic development. A Dutch artist, by contrast, would have painted for a dealer who would have attempted to put his small-scale works onto the walls of hundreds of modest homes. There was no special reason why these owners should have known each other or have become aware of it if their artist had wanted to repeat himself. This encouraged Dutch artists to become specialists, and to refine their technique in the depiction of one particular type of landscape, still life, or other genre. Such owners could never have been called "collectors"; they were people wanting to decorate a home. It is unlikely that they would have enjoyed a liberal education or have known much about artistic theory or have had the leisure to learn. They probably would not have known their artist personally or have cared about his art, except insofar as it manifested itself in their particular painting. What they wanted was a user-friendly package: a painting that announced of itself the qualities by which it wished to be judged. They bought their art off the peg, because of some obvious, eye-catching, self-explanatory virtue. In this respect Dutch painting sold itself.

The most obvious self-explanatory virtue in painting is resemblance to nature. This is the supreme virtue of Dutch art and, we may assume, its conscious objective. The Dutch returned to the first principle of artistic theory (see above, "The Italian School"). The rest of the superstructure of mainstream European artistic theory, especially the notion of ideal beauty, was largely ignored in Holland. So, too, was the intellectual world of artist and patron: from the comparison set out above, it is no surprise that there are letters written by Italian artists about their art and few by the Dutch; that there are revealing documents surrounding Italian commissions and few for Dutch; that there are near-contemporary biographies of Italian artists and only much later biographies of the Dutch.

There are exceptions to this principle: Rembrandt's intentions are richly documented in his own letters and contemporary eulogies, especially arising from his friendship with the Stadholder's secretary, Constantijn Huygens (see cat. 48). But this is really only to say that Rembrandt was an honorary court painter. It should also be said that, while Dutch art might not have taken much notice of Italian art theory, the Dutch élite certainly knew about it. The theory of art expressed in Carel van Mander's collection of artist's biographies, *Het Schilderboeck* (Painter's Book) of 1604, is the routine European model (though it is significant that no such compilation of biographies was published subsequently until the three volumes of Arnold Houbraken's *De Groote Schouburgh der Nederlantsche Konstschilders en Schilderessen* in 1718–21). It would be a mistake to suppose that Rembrandt painted his *Girl at a Window* (cat. 49) instinctively, not knowing about Titian, Rubens, the antique or the artistic roads he had decided not to go down.

Artistic theory was not unknown to Dutch artists, just inapplicable. It may have been a result of the peculiar market in Holland that painting adapted itself in a way not encountered elsewhere. While most individual artists had narrow specialties and little

stylistic development, the different types of painting evolved rapidly during the period to achieve a bewildering variety. This can be seen in the many specialties represented in this selection – portraiture, genre (high- and low-life), landscape (Italianate and northern), seascape, flower painting – and in some new ones not represented – cityscape and nocturnal scenes. Types of painting evolved and developed because artists and their buyers were careless of the intellectual systems that defined them (and that therefore potentially limited them).

Comparison with Flanders is instructive. David Teniers the Younger worked for the court of the governor of the Southern Netherlands in Brussels and established an academy in Antwerp in 1665. This courtly and academic background did not prevent him from painting pigs, but it encouraged him to remember that painting pigs was one thing and painting princes, quite another. In Flanders, artists knew the pedigrees of the different genres of painting. They knew their place. Teniers's *Sow and Her Litter* (cat. 46) is an inferior type of painting depicting an inferior type of person, in an entertainingly inferior type of way. But what do we make of Dou's *Woman Playing a Clavichord* (cat. 51)? This is a genre painting and therefore theoretically inferior to portraiture and history painting, yet the girl is quite refined enough for a portrait; the painting itself would have cost more than that of any other Dutch contemporary, including Rembrandt; and the image has somehow strayed far from any recognizable tradition within the history of art. Look for its deeper roots and one comes up with a portrait and a religious scene – Jan van Eyck's *Arnolfini Portrait* and Antonello's *Saint Jerome in His Study*, both in the National Gallery, London. In the same way, Teniers's *Winter Scene with a Man Killing a Pig* (cat. 47) is "traditional": it reminds us of the origins of landscape painting in the illustration of the labors of the months in medieval Books of Hours; it reminds us of the literary tradition of the seasons; it reminds us of Pieter Breugel the Elder. Ruisdael's *Landscape with Windmills near Haarlem* (cat. 66), on the other hand, reminds us of a blustery day.

The naturalism of Dutch art, which made it so accessible to its original audience, has subsequently become its greatest stumbling block. To those who inexplicably seem to have a problem with the imitative function of painting, one can do no better than to quote Ruskin: "The object of the great Resemblant Arts is, and always has been, to resemble; and to resemble as closely as possible" (*Aratra Pentelici*, Lecture IV). Yet even someone capable of such sterling circularity had a blind spot when it came to "the common Dutch painters," as he called them, who were "*merely* imitative painters of still life, flowers, etc." (*The Stones of Venice*, II, chapter VI; my emphasis). That "merely" gets into almost all discussions of Dutch art, insidious and undetected. How can we identify its source and efface its stigma? This malevolent "merely" implies that imitation is easy; that it is one-dimensional (that there cannot be two different, equally close ways of imitating the same thing); that it requires no imagination or creativity; and that the purpose of painting is to build something nobler upon this "mere" foundation. All one can say as a preparation for the enjoyment of Dutch painting is that all these implications are manifestly false. Few of us have tried to paint like Dou, but it cannot be a simple matter of setting aside sufficient time. The variety of Dutch landscape is partly inspired by different motifs; but there are also clearly different ways of approaching the problem of interpreting the world. Few Dutch artists set up their easels in front of the subject they wished to paint; but their creative imagination goes far beyond this crude fact. There is, in the interpretation of a scene, a process of actively noticing – seizing upon – particular phenomena in nature and inventing ways of re-creating them in paint that is profoundly imaginative, though manifested in a physical rather than conceptual form. As a final defense of the "common Dutch," one must ask: is it not enough to remind viewers of the excitement, the variety, and the beauty of their experience of the world?

48 Rembrandt Harmensz van Rijn

LEIDEN 1606–1669 AMSTERDAM

Jacob III de Gheyn, ca. 1632

Oil on oak panel
11¾ × 9¾ in. (29.9 × 24.9 cm)
Signed and dated, top left: RH 'van Ryn /
1632 (RH in monogram)
DPG 99; Bourgeois bequest, 1811

REFERENCES: C. Hofstede de Groot,
*A Catalogue Raisonné of the Works of the
Most Eminent Dutch Painters of the Seven-
teenth Century*, 10 vols., London, Stuttgart,
and Paris, 1907–26; A. Bredius (revised
by H. Gerson), *Rembrandt: The Complete
Edition of the Paintings*, London, 1971, no.
162; G. Schwartz, *Rembrandt: His Life, His
Paintings*, Harmondsworth, 1985,
pp. 72–77; J. Bruyn *et al., A Corpus of
Rembrandt Paintings*, II, Dordrecht,
Boston, and Lancaster, 1986, A56

Rembrandt's early work in Leiden reflects the influence of his master, Pieter Lastman, a specialist in small-scale narrative scenes. When Rembrandt moved to Amsterdam in 1631–32, he became the most versatile, innovative, and, for a while, successful artist in Holland. Working in a variety of media (drawing, etching, and oil paint) and in every known genre (producing portraits, landscapes, mythologies, and religious scenes), he managed a large and productive studio.

In these early years, as Rembrandt established himself in Amsterdam, he came close to becoming a court painter to the Dutch Stadholder, Frederik Hendrik, Prince of Orange. The creation of this portrait involved several leading characters of the Dutch court at the time. The sitter, Jacob III de Gheyn (*ca.* 1596–1641), was a court artist, like his more distinguished father Jacob II de Gheyn (1565–1629). This portrait was paired with another, of identical size and also by Rembrandt, depicting De Gheyn's friend, Maurits Huygens, a court secretary (now in the Hamburg Kunsthalle). Originally each portrait belonged to its sitter with the understanding that they would each bequeath to the other their own portrait as a token of friendship. The two portraits were reunited accordingly on the death in 1642 of Jacob de Gheyn, as recorded in an inscription on the back of the painting: "Jacques de Gheyn Junior gave Huygens his portrait as the last gift of a dying man."

Maurits's more famous brother, Constantijn Huygens, also a court secretary, was an enthusiastic champion of the young Rembrandt and wrote eloquently in praise of his painting. Unfortunately he was not impressed with this portrait, which he thought nothing like his friend De Gheyn and attacked in a series of Latin epigrams. It is difficult to say if Constantijn was seriously turning against his protégé or merely teasing him on account of one misfired likeness.

The modern viewer, having no original with which to compare the features, marvels at how much Rembrandt can make of such an unpromising commission – a head and shoulders of a man in black on a tiny scale. Rembrandt seized upon two vital elements to infuse life into the image. The first is light. The cheek is so brilliantly lit that the detail appears to have been lost in the glare. A glowing aura surrounds the head like the rings of Saturn; there is no obvious wall or surface reflecting this light, which seems rather to have a substance of its own.

Rembrandt also observed that paint has texture as well as color, and that it can be used to create form by building up a crust, almost like plaster relief; the texture of the right cheek and the creases around the right eye are as literally in the paint surface as they were in De Gheyn's face.

DST

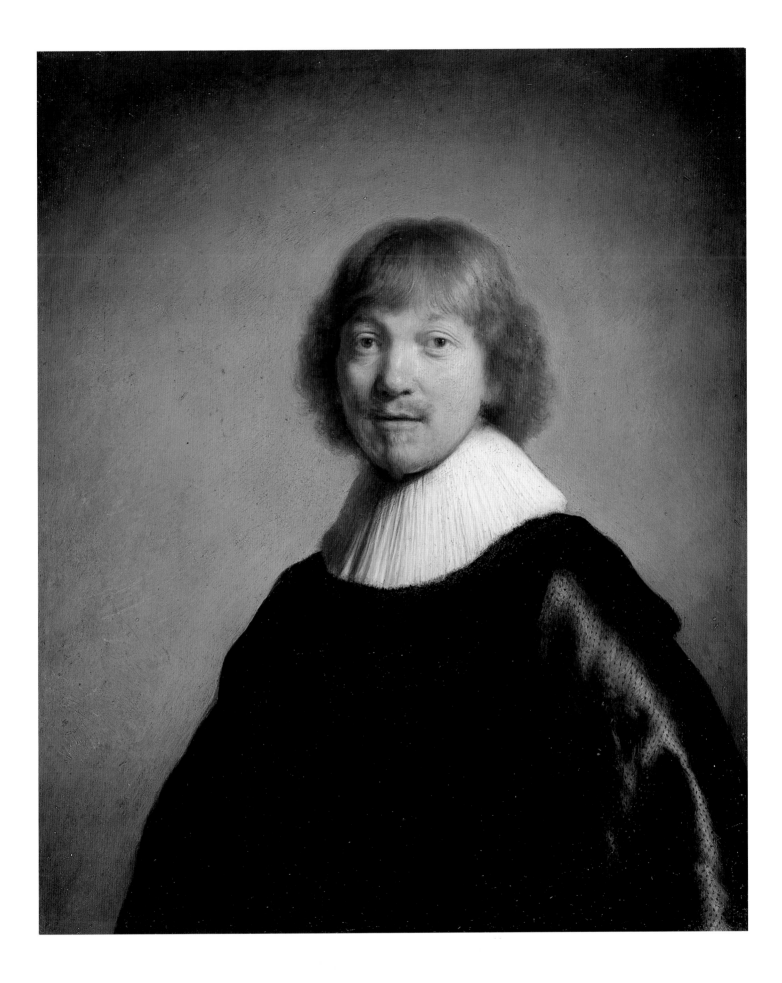

49 Rembrandt Harmensz van Rijn

LEIDEN 1606–1669 AMSTERDAM

A Girl at a Window, 1645

Oil on canvas
32⅛ × 26 in. (81.6 × 66 cm)
Signed and dated, lower right:
Rembrandt / ft. 1645.
DPG 163; Bourgeois bequest, 1811

REFERENCES: C. Hofstede de Groote, *A Catalogue Raisonné of the Works of the Most Eminent Dutch Painters of the Seventeenth Century*, 10 vols., London, Stuttgart, and Paris, 1907–26, no. 327; A. Bredius (revised by H. Gerson), *Rembrandt: The Complete Edition of the Paintings*, London, 1971, no. 368; C. White in *Collection for a King*, Washington, D.C., National Gallery of Art, and Los Angeles County Museum of Art, 1985–86, no. 26; C. White in *Rembrandt's Girl at a Window*, exhib. cat., London, Dulwich Picture Gallery, 1993, no. 1

This is a figure study rather than a commissioned portrait, based on an unknown model sometimes assumed to be Rembrandt's servant. Though the architecture is ambiguous in its lines, there is no reason to suppose that it does not represent a window; that type of simple and massive stone-arched aperture occurs elsewhere in Rembrandt's work, for example in the *Girl with Dead Peacocks* (Rijksmuseum, Amsterdam).

This painting was once owned by the French art theorist, and ardent Rubéniste, Roger de Piles (1635–1709), and seems to have exerted an important influence on his thinking. De Piles tells the improbable story that, when Rembrandt set this painting facing out of a window in his house, passersby took it for a real servant girl until disabused by her prolonged immobility. De Piles believed that this type of illusionism was a fundamental goal that many revered artists had forgotten. According to him reality in painting should "call out" to the spectator, as Rembrandt's did to the Dutch passersby – an effect gained by pleasing the eye with color, light, and shade rather than appealing to the mind with beauty of design or grandeur of expression. Even as great an artist as Raphael might not achieve this eye-catching effect, as shown by the fact that many visitors to the Vatican Stanze (decorated throughout by Raphael's frescos) have been heard to ask where the Raphaels are to be found (De Piles, *Cours de Peinture par Principes*, 1708, pp. 7–13). This was the first time in the history of art that Rembrandt and Raphael were compared to the latter's detriment.

De Piles's arguments provide an approach to Rembrandt's painting that is valid today. A vivid sensation of reality is still one of the fundamental pleasures of painting, and is found here more than in any other work in the Dulwich collection. The effect is achieved by the use of texture. The paint layer is applied so thickly, so coarsely, and with so much improvisation (using a palette knife and fingers as well as brushes) that it appears almost to *become* the plaster, the stone, and the linen that it depicts. If we do not believe our eyes, we feel that we could reach out and touch these surfaces, each with their distinctive texture.

To bring reality within reach, Rembrandt has pushed everything in the painting forward, so that the girl and the ledge she leans upon seem to project out of the front of the frame. But Rembrandt is not interested in a simple trick of deception. On the one hand he offers solid reality; on the other he veils forms in mystery and uncertainty. The light is impossible: a bright pool covers the figure and the wall beside, leaving the top and the sides of the image swallowed up by darkness. Rembrandt has given his light unnatural properties in order that it can suggest supernatural (or at least invisible) phenomena. It radiates from the figure like body heat. Without our being aware of the device, this pattern of light conveys to our subconscious the idea of human or spiritual warmth.

DST

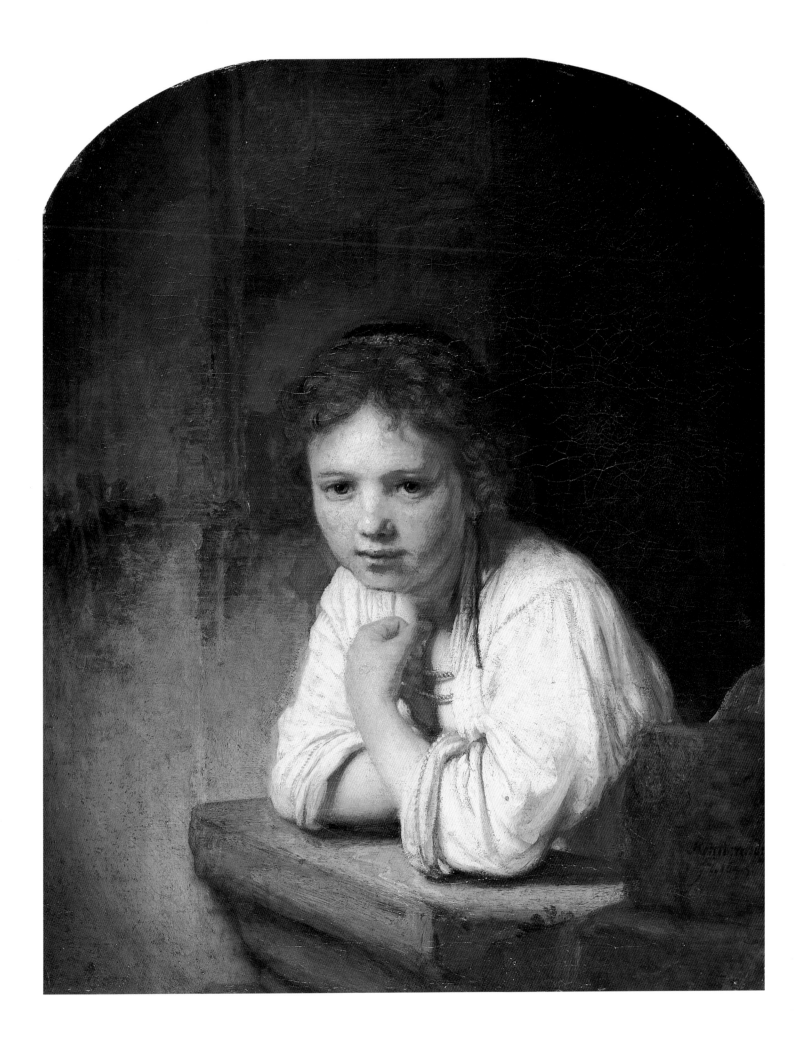

50 Rembrandt Harmensz van Rijn

LEIDEN 1606–1669 AMSTERDAM

Portrait of a Young Man, 1663

Oil on canvas
31 × 25¼ in. (82.6 × 67.2 cm), including
additional strips of ¹³⁄₁₆ in. (2.1 cm) at the
top, ¾ in. (2 cm) at the bottom, ⅝ in.
(1.5 cm) on the left, and ¾ in. (2 cm) on
the right; the original canvas measures
30¹⁵⁄₁₆ × 25¼ in. (78.6 × 64.2 cm)
Said to be signed and dated: *R … f … 63*
DPG 221; Bourgeois bequest, 1811

REFERENCES: C. Hofstede de Groote,
*A Catalogue Raisonné of the Works of the
Most Eminent Dutch Painters of the Seven-
teenth Century*, 10 vols., London, Stuttgart,
and Paris, 1907–26, no. 705; W.R.
Valentiner, *Rembrandt: wiedergefundene
Gemälde*, Berlin and Leipzig, 1921, p. xxiii,
no. 86; C. White in *Collection for a King*,
Washington, D.C., National Gallery of
Art, and Los Angeles County Museum of
Art, 1985–86, no. 27; C. White in *Kolekcja
dla Króla*, Warsaw, Royal Castle, 1992, no.
20 (all as Rembrandt); C. Tümpel,
Rembrandt, All Paintings in Colour,
Antwerp, 1993, A97 (as Circle of
Rembrandt)

This portrait has been widely accepted as an autograph work; the artist's inscription is indistinct, but the barely legible date of 1663 certainly accords with the style of the picture. There has been less enthusiasm about Valentiner's identification of the sitter as Rembrandt's son Titus (1641–1668), although there are enough similarities with the portrait of Titus of about 1660 in the Louvre, Paris, to suggest that this is a fanciful image of the same young man a few years later, when he would have been aged twenty-two.

This image is typical of Rembrandt's late work in having a timeless and generalized costume – a chemise and gown with no fastenings or decoration, with only the black cap to tell us that the sitter belongs to a world more modern than that of the Old Testament. The color is similarly more resonant than informative, comprising a dramatic contrast of white and black and a narrow harmony of reds and chestnut browns. Facial details are given (or rather withheld) in the same high-handed fashion; how much more Rembrandt tells us about Jacob de Gheyn (cat. 48) in so much less space. With crucial shapes articulated by emphatic shadows around the cheek, chin, and the hanging bunches of hair, the bare elements are provided, but within each area everything is indistinct. The sitter's lower body scatters into the background like the tail of a meteor against the night sky. The areas are distinguished more by texture than color: the face plasterlike, the hair soft and cloudy, and the cloak grained like wood, an effect created by thick paint dragged in long streaks. This use of thick, dry paint is crucial to Rembrandt's effect because its physical reality (and the sharpness of its edges) gives an impression of palpability and distinctness at odds

with the imprecision (or non-existence) of the drawing.

The surface here, especially of the hair, seems strange and precious; yet the mood seems somber, with shadows creeping over every contour, even the dark staring eyes. The result is an image at once luxurious and haunting.

DST

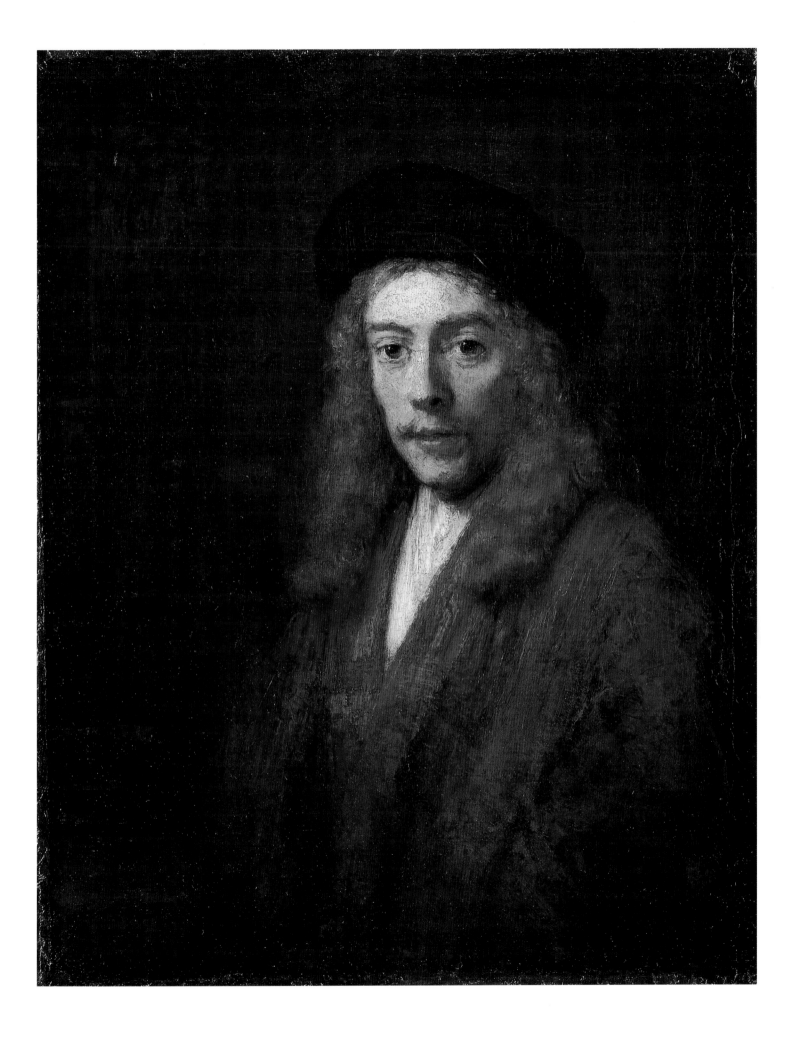

51 Gerrit Dou

LEIDEN 1613–1675 LEIDEN

A Woman Playing a Clavichord, ca. 1665

Oil on oak panel
14⅞ × 11⅝ in. (37.7 × 29.8 cm)
DPG 56; Bourgeois bequest, 1811

REFERENCES: C. Hofstede de Groote, *A Catalogue Raisonné of the Works of the Most Eminent Dutch Painters of the Seventeenth Century*, London, Stuttgart, and Paris, 1908–27, nos. 132 and 133a; W. Sumowski, *Die Gemälde der Rembrandt-Schüler*, 6 vols., Landau in der Pfalz, 1983, I, no. 287; P. Hecht in *De Hollandse fijnschilders: Van Gerrit Dou tot Adriaen van der Werff*, exhib. cat., Amsterdam, Rijksmuseum, 1989, no. 8; R. Baer, *The Paintings of Gerrit Dou (1613–1675)*, diss., New York University, 1990, no. 111

Gerrit Dou began his career in his father's footsteps as a glass-engraver, working in Dou senior's studio and entering the glaziers' guild. In 1628 he became Rembrandt's first pupil, developing his own personal style out of his master's early manner. Rembrandt moved to Amsterdam in 1631–32, but Dou stayed on in Leiden, becoming one of the most successful and celebrated artists of the century. He was the founder of the Leiden school of *fijnschilders* ("fine painters"), favoring a technique of almost miniaturist finish, which he brought to bear principally on genre scenes painted with astonishing accuracy. Dou, however, was also a master of atmospheric light effects, very much in emulation of the young Rembrandt, and his apparently simple genre scenes often contain allegorical elements and hidden meanings. At a time when many collectors put together "cabinets" of small-scale and precious works of fine and decorative art, Dou became one of the most sought-after artists of the age. The painting's provenance reflects this: possibly in the De Bye collection in Leiden by 1665, it passed through the collections of the comte de Dubarry (sale, Paris, November 21, 1774) and the Prince de Conti (sale, Paris, April 8, 1777) before making its way to England via one Paul Benfield to Noel Desenfans.

Painted on oak panel, this is a perfect example of a "cabinet" painting, and typical of Dou's output. For the lady interrupted at the clavichord, music is almost certainly "the food of love," and the viewer is cast as the arriving lover, whom we can assume plays either the viola da gamba leaning against the table, or the flute resting on the open page of music. The gentle light filtered through the side windows draws our attention to examples of Dou's remarkable skills – the floorboards with their nails and graining, the halo effect in the musician's hair, the sumptuous hanging (of which Dou has taken extraordinary pains to interpret the special effect of the back), the half-empty wineglass, and the wine cooler. Dou often framed his scenes with theatrical devices – in this case the arch and the hanging tapestry, the latter drawn back as if to reveal a scene on a stage. At first sight this may seem to distance the viewer, but the device is set up only to be broken down by the directness of the lady's gaze.

The clavichord is nearly always characterized as a lady's instrument, partly, no doubt, because of its gentle tone. The imagined sound is a key factor in the picture's evocation of atmosphere, equal to the softness of the light and of the velvet cushion waiting for the lover's arrival. It is no surprise that the most famous painter of light, Jan Vermeer, was inspired by this painting.

IACD

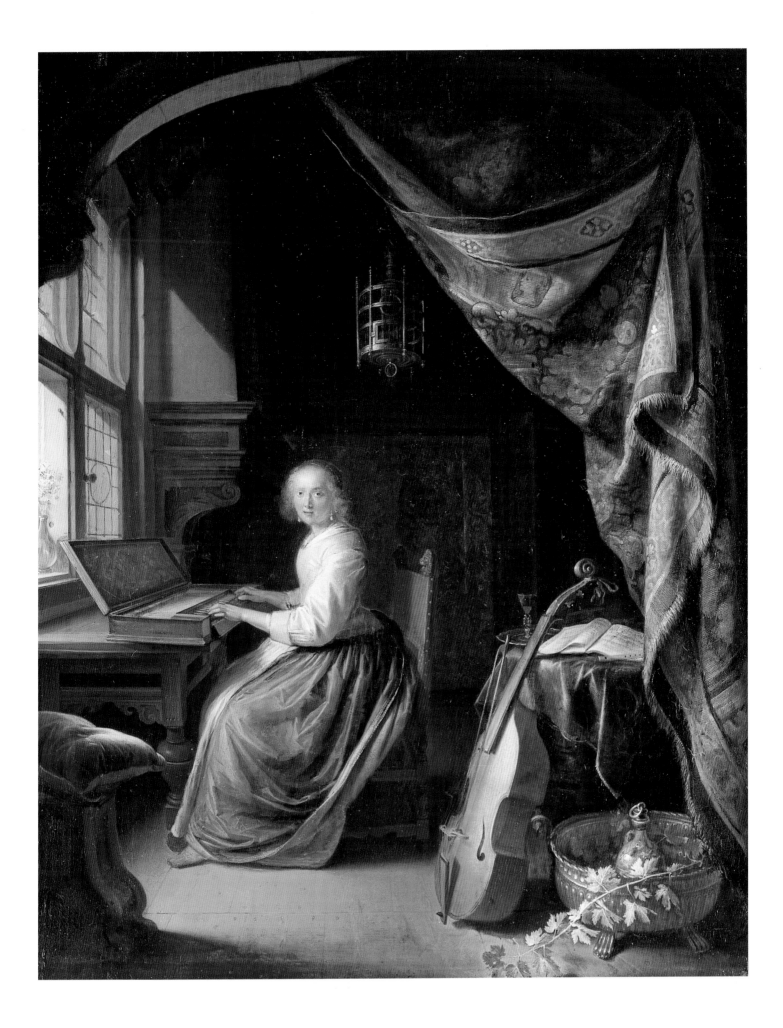

52 Adriaen van Ostade

HAARLEM 1610–1685 HAARLEM

Three Peasants at an Inn, 1647

Oil on oak panel
10⅝ × 8½ in. (27.1 × 21.6 cm)
Signed and dated, bottom right: *Av Ostade 1647* (*Av* in monogram)
DPG 115; Bourgeois bequest, 1811

REFERENCE: C. Hofstede de Groote, *A Catalogue Raisonné of the Works of the Most Eminent Dutch Painters of the Seventeenth Century*, 10 vols., London, Stuttgart, and Paris, 1908–27, no. 327

Adriaen van Ostade specialized in a type of comical, boorish peasant in the tradition of Pieter Breughel the Elder. Those depicted here toast, fiddle, and smoke with characteristically coarse abandon. The setting derives from the work of the Flemish artist Adriaen Brouwer (1605–1638), which was popular and influential in both Flanders and Holland and was collected by Rubens and Rembrandt. Both Brouwer and Ostade were pupils of Frans Hals in Haarlem, at which time Ostade may have learned these effects of a dusky interior, painted in dull browns and greys, with a confused pattern of brick, wood, earth, and plaster peered at through a smoky atmosphere.

Ostade here plays a game with his viewers to see how much detail he can conceal. At first sight we do not expect to see much in a painting so small, dark, and sketchy, but in fact much can pleasurably be retrieved from the shadows. The plethora of mundane objects and variegated surfaces are not picked out by color or light; they are, however, given just sufficient shape to be recognized. Our surprise particularly derives from the fact that we expect detail to be built up on the surface of a painting; detail in Ostade is sunken, often needing to be discovered in the underpaint, almost as if the image had been sealed in the panel like a watermark.

DST

53 Karel Dujardin

AMSTERDAM(?) 1621/22–1678 VENICE

A Smith Shoeing an Ox, ca. 1655–60

Oil on canvas
15 × 16⅞ in. (38 × 42.8 cm)
Signed, bottom right: .K.DV.IARDIN. fe
DPG 82; Bourgeois bequest, 1811

REFERENCES: C. Hofstede de Groote,
*A Catalogue Raisonné of the Works of the Most
Eminent Dutch Painters of the Seventeenth
Century*, 10 vols., London, Stuttgart, and
Paris, 1908–27, under no. 336;
E. Brochhagen, *Karel Dujardin. Ein Beitrag
zum Italienismus in Holland im 17. Jahrhundert*,
diss., Cologne, 1958, p. 128; C. Brown in
Collection for a King, Washington, D.C.,
National Gallery of Art, and Los Angeles
County Museum of Art, 1985–86, no. 5;
C. Brown in *Kolekcja dla Króla*, Warsaw,
Royal Castle, 1992, no. 7

Karel Dujardin was a genre painter only ten years younger than Adriaen van Ostade and, like him, studied in Haarlem, though with the Italianate landscape painter Nicolaes Berchem rather than Frans Hals. The remarkable difference between this painting and *Three Peasants at an Inn* (cat. 52) derives from Dujardin's experience in Italy, which he visited in the late 1640s. He fell in with a group of Dutch artists working in Rome, called the *schildersbent*, and in particular with the followers of Pieter van Laer, who were called the Bamboccianti after their leader's nickname Il Bamboccio. The subject of this painting – an unidealized glimpse of artisans at work – is Dutch, but the setting is unmistakably Italian, with high plastered walls, tiled roofs, and exotic costumes.

The style of the painting has also been adapted to the more glamorous subject: the color is brighter than Ostade's, the detail is crisper, and the paint is more thickly applied, with a brilliant flickering touch. Also characteristic of the Bamboccianti is the idea of setting the entire scene in shadow, as the sun sets behind the wall. An atmosphere that at first glance seems dull suddenly evokes a hot Italian evening as we register the bright sunlight filtering through the tree and dramatically raking across the upper wall of the forge.

DST

54 Adriaen van der Werff

KRALINGEN (NEAR ROTTERDAM) 1659–1722 ROTTERDAM

The Judgment of Paris, 1716

Oil on canvas on oak panel
24⅞ × 18 in. (63.3 × 45.7 cm)
Signed and dated, lower left:
Chev^r vand^r / Werff Fec / an^o 1716
DPG 147; Bourgeois bequest, 1811

REFERENCES: C. Hofstede de Groote, *A Catalogue Raisonné of the Works of the Most Eminent Dutch Painters of the Seventeenth Century*, 10 vols., London, Stuttgart, and Paris, 1908–27, no. 117; B. Gaehtgens, *Adriaen van der Werff, 1659–1722*, Berlin, 1987, no. 33

Though Adriaen van der Werff studied and worked all his life in Rotterdam, he was the last artist to work in the manner of the Leiden *fijnschilders* ("fine painters"), a school originated by Gerrit Dou (see cat. 51). First recorded as an independent artist in 1676, a year after Dou's death, Van der Werff could almost be said to have inherited his position as the most internationally successful Dutch painter. He was especially popular with princes: the Elector Palatine appointed him court painter and knighted him in 1703 (hence the signature *Chev^r vand^r Werff* for chevalier or knight); the Regent of France, the duc d'Orléans, acquired this very painting from the artist in 1719.

Paris, a Trojan prince disguised as a shepherd upon Mount Ida, has been chosen by Mercury, the messenger of the gods seen in the left background, to adjudicate in an Olympian beauty contest. He awards the golden apple for the most beautiful goddess of them all to Venus, goddess of love. The bribe that Venus has offered to Paris in order to secure the apple – that is, the love of Helen of Troy, the most beautiful woman in the world – precipitates the Trojan War, and the enmity of the two losing goddesses, Juno and Minerva, ensures Troy's destruction.

The mythological subject of the painting, the idealized nude figures, and the draftsmanship that lies behind their elegant postures and rhetorical gestures epitomize the international character of eighteenth-century Dutch art, which reflected the ideals of mainstream European artistic theory and specifically the teaching of the French Academy. This is not to say that French artists could paint like this. Van der Werff was so eagerly collected because he could turn the miracles of Dutch technique to this new

end. Take the light, for example. Modeling flesh with a light side and dark side so as to suggest sculptural form was routine academic practice; peculiar to Van der Werff is the finesse of the surface, with such soft and imperceptible transitions that the figures seem to glow like pearls. Van der Werff also thinks more about the source of the light than his French contemporaries: the whole scene is bathed in the rays of the setting sun, which cast a shadow from Paris's right hand on to his chest, irradiating and seeming to infuse the winning figure of Venus, while grazing Juno and Minerva behind. Most accomplished of all is the way in which figures sink into the dusk of the background, with Mercury a mere shadow against the hillside. Even the different positions of Venus and Juno are recorded by the contrast between their adjacent faces, Juno's a fraction greyer in color, darker in tone, and softer in focus than her sister's.

Cupid struggling with his mother's discarded clothes and the literal-minded inclusion of a shepherd's crook and gourd on the left are comic touches typical of Dutch art.

DST

55 Jan van Huysum

AMSTERDAM 1682–1749 AMSTERDAM

Vase with Flowers, ca. 1718–20

Oil on mahogany panel
31⅛ × 23⅞ in. (79.1 × 60.6 cm)
Signed, bottom left: *Jan van Húÿsúm fecit*
DPG 120; Bourgeois bequest, 1811

REFERENCES: C. Hofstede de Groote, *A Catalogue Raisonné of the Works of the Most Eminent Dutch Painters of the Seventeenth Century*, 10 vols., London, Stuttgart, and Paris, 1908–27, no. 125; M.H. Grant, *Jan van Huysum, 1682–1749*, Leigh-on-Sea, 1954, no. 86; Paul Taylor, *Dutch Flower Painting, 1600–1750*, exhib. cat., London, Dulwich Picture Gallery, 1996, no. 29

Jan van Huysum studied with his father, Justus van Huysum the Elder, a flower painter, and is not known ever to have left his native city of Amsterdam. Although he painted some landscapes, he chiefly specialized in paintings of flowers and fruit, a genre in which he achieved unparalleled success.

Van Huysum is one of many Dutch painters capable of producing detail unequalled in any other period in the history of art. The surfaces are miraculously defined: the transparency of a dewdrop distinguished from the waxy gloss of a tulip petal; the sheen of a bird's egg from the matted weave of the nest.

So much incident – so many flowers, leaves, and insects – could, in the wrong hands, make for a tangle of conflicting areas of interest. Here, however, the stems are looped and knotted with an enjoyable complexity that would be impossible to match in a real flower arrangement. The light also serves to accentuate the center and suppress the margins, giving the bunch an overall three-dimensional shape, while at the same time setting up a wealth of intricate patterns of light outlines against dark and dark against light. The deep blue-grey background gives this vase of flowers a nocturnal mood.

DST

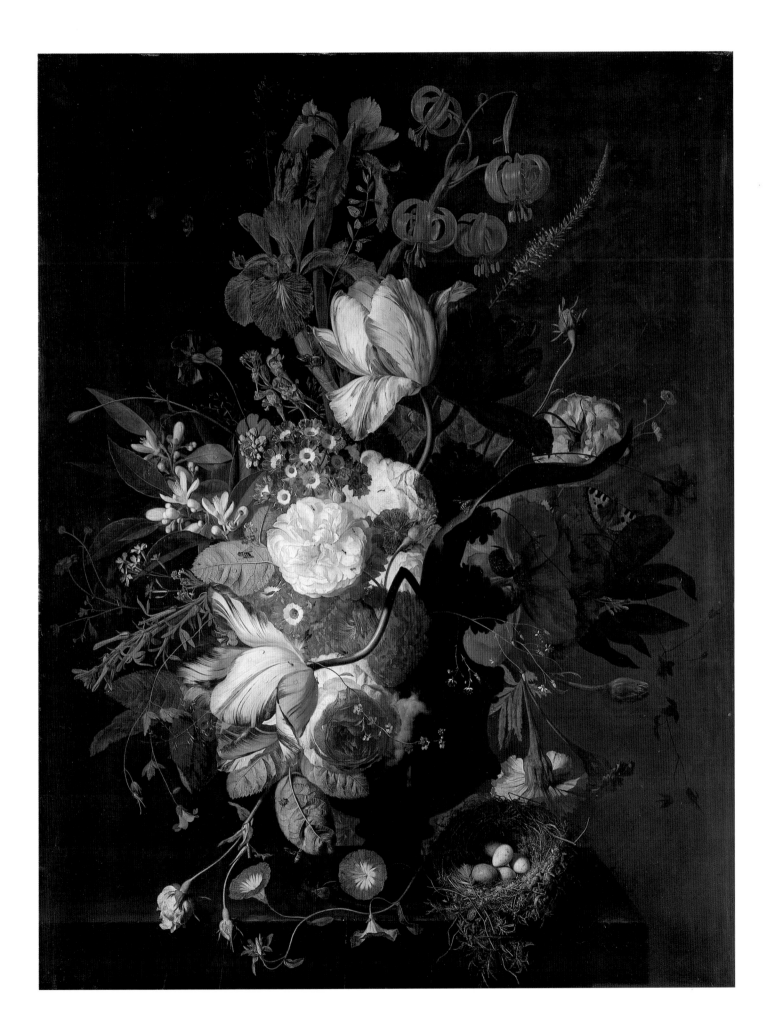

56 Cornelis van Poelenburch

UTRECHT 1594/95–1667 UTRECHT

Valley with Ruins and Figures, ca. 1627

Oil on poplar panel
13⅝ × 17½ in. (34.5 × 44.5 cm), oval
DPG 338; Bourgeois bequest, 1811

REFERENCES: M. Chiarini, "Filippo Napoletano, Poelenburgh, Breenbergh e la nascita del paesaggio realistico in Italia," *Paragone*, CCLXIX, 1972, p. 30, pl. 41a; M. Roethlisberger, *Bartholomeus Breenbergh, The Paintings,* Berlin and New York, 1981, no. 58; N. Sluijter-Seiffert, *Cornelis van Poelenburch (ca. 1593–1667),* diss., University of Leiden, 1984, p. 116

Cornelis van Poelenburch trained with Abraham Bloemaert, from whom he learned to paint with a glossy and decorative touch, which gives this landscape something of the appearance of porcelain. The other formative influence on Poelenburch was the decade he spent in Italy, from 1617 to 1627. This landscape is typical of the southern Italian countryside as seen through the eyes of the Dutch colony of artists in Rome at this time: herdsmen drive their flocks over baked earth, through tracts of mountainous and uncultivated grazing land; antique ruins are so integral to the landscape that they are almost indistinguishable from the natural rock formations nearby. Even the figures are glamorous and exotic in their brightly colored, picturesque costumes and extravagant attitudes.

This landscape was formerly catalogued as by another artist working in Rome at the time, Bartholomeus Breenbergh. The attribution to Poelenburch, suggested by M. Chiarini in 1972, has been widely accepted. The probable date of the work, around the time of Poelenburch's return to his native Utrecht in 1627, offers a fascinating insight into an important turning point in landscape painting. During these years the Mannerist style of Paul Bril – reflected to some extent in the composition of Saftleven's Rhenish view (cat. 65) – was yielding to the more natural observation of Claude and his followers. Poelenburch's composition recalls some of the tricks by which Bril's generation achieved the illusion of distance. The landscape is arranged in terraces, without a consistent viewpoint. Hillsides are reduced to contrived wedges of light and dark, creating an inviting meandering path and the necessary steps through the landscape. The colors

similarly move through three clear zones: brown for the foreground, green for the middle ground, and blue for the distance. On the other hand, the atmospheric effects here clearly anticipate Claude: the slant of the evening sunlight, the reflection in the lake, the soft edges to the foliage, and the glowing mist veiling the distant slopes.

DST

57 Jan Both

UTRECHT(?) CA. 1615–1652 UTRECHT

Road by the Edge of a Lake, ca. 1637–42

Oil on oak panel
22½ × 20¼ in. (44.1 × 39.4 cm)
DPG 15; Bourgeois bequest, 1811

REFERENCES: C. Hofstede de Groote, *A Catalogue Raisonné of the Works of the Most Eminent Dutch Painters of the Seventeenth Century*, 10 vols., London, Stuttgart, and Paris, 1908–27, no. 142; J.D. Burke, *Jan Both (ca. 1618–1652), Paintings, Drawings, and Prints*, New York and London, 1976, no. 63

Jan Both's career was similar to that of Cornelis van Poelenburch (see cat. 56), insofar as he was born in Utrecht, studied with Abraham Bloemaert, and formed his style during a visit to Italy. Being a generation younger, however, Both arrived in Rome in 1637 when Claude was already in his prime. This intimate landscape, usually dated to these Italian years (1637–42), demonstrates what Both learned there.

This is less of a panoramic survey than Poelenburch's landscape (cat. 56) and reflects a consistent viewpoint at eye level. In this respect the comparison parallels that between the landscapes of Saftleven and Ruisdael (see cat. 65 and 66). Jan Both makes even more than Poelenburch of the hot red of the Italian earth, the lazy idyll of herdsmen wandering into the sunset, and the drama of the slanting light trailing long shadows from the slightest molehill.

The most important lesson that Both and an entire generation of Dutch artists learned from Claude was the ability to render the tones and colors of the sky at sunset. These effects can be observed in nature: if one looks toward the setting sun, the air (whether seen against the ground or sky) appears bright, yellow, and misty; if one looks away from the setting sun, it appears darker (though only very slightly) and much bluer and clearer. Claude compresses this phenomenon into the compass of a single painting, using the sky to record the transitions with seamless continuity. In the same way, Both here moves from the bright, yellowish haze of the lower left, where the sun is setting, to the darker, clearer blue of the top right.

DST

58 Aelbert Cuyp

DORDRECHT 1620–1691 DORDRECHT

View on a Plain, ca. 1644

Oil on oak panel
19⅜ × 28⅞ in. (48 × 72.2 cm)
Signed, bottom center: *A. cúÿp*
DPG 4; Bourgeois bequest, 1811

REFERENCES: C. Hofstede de Groote, *A Catalogue Raisonné of the Works of the Most Eminent Dutch Painters of the Seventeenth Century*, 10 vols., London, Stuttgart, and Paris, 1908–27, no. 694; E. Reiss, *Aelbert Cuyp*, London, 1975, no. 42; A. Chong, *Aelbert Cuyp and the Meaning of Landscape*, diss., New York University, 1992, no. 69; A. Chong in *Conserving Old Masters*, exhib. cat., London, Dulwich Picture Gallery, 1995, no. 7

Unlike most of his contemporaries, Aelbert Cuyp was not a specialist, but executed both portraits and religious scenes as well as the landscapes for which he is most famous. He cannot properly be called an Italianate landscapist either: he never traveled further south than the Rhinelands and never depicted an unequivocally Mediterranean scene. On the other hand, he rapidly moved away from the grey-skied, northern manner of Jan van Goyen (1596–1656) seen in his early works and instead learned, probably from Jan Both (who had returned from Italy in 1642), the art of depicting the golden spectrum of evening light.

This early work, of about 1644, shows Cuyp beginning to Italianize his native Holland. The city in the background looks very much like the small Dutch town of Rhenen, which he drew in 1641 (Teylers Museum, Haarlem). Yet he has invented an escarpment in the foreground, from which the city can be viewed with a suitably panoramic sweep.

Cuyp realized, as did Pynacker a decade later (see cat. 63 and 64), that a low viewpoint encourages the artist to look upward at the sky, which here occupies four-fifths of the painting's height. The light in the sky sets the tone of the painting. Rather than the atmosphere of impending rain seen in his earliest works, Cuyp here shows clouds saturated in the red tones of the setting sun and a thick haze hanging over the distance created by slanting light suffusing the moisture of a low-lying river valley.

The low viewpoint also creates a dramatic contrast between the foreground and the background, an effect reminiscent of that achieved by a zoom lens: the imposing shepherd dreamily contemplating the sunset is pushed upward through the horizon line, setting him against the distant haze in a dramatic silhouette.

DST

59 Aelbert Cuyp

DORDRECHT 1620–1691 DORDRECHT

Herdsmen with Cows, ca. 1645

Oil on canvas
39 × 56¾ in. (101.4 × 145.8 cm)
Signed, lower right: *A. cúyp*
DPG 128; Bourgeois bequest, 1811

REFERENCES: C. Hofstede de Groote,
*A Catalogue Raisonné of the Works of the
Most Eminent Dutch Painters of the Seven-
teenth Century,* 10 vols., London, Stuttgart,
and Paris, 1908–27, nos. 237e (?), 330; E.
Reiss, *Albert Cuyp*, London, 1975, no. 44;
A. Chong, *Aelbert Cuyp and the Meaning of
Landscape*, diss., New York University, no.
80; A. Chong in *Conserving Old Masters*,
exhib. cat., London, Dulwich Picture
Gallery, 1995, no. 8

One fundamental difference between the
native and Italianate schools of Dutch
landscape is that, generally speaking, the
former chose to concentrate on the object,
the latter on the light; one chose earth, the
other sky. All landscape painters must to
some extent balance these two elements:
the weight and solidity of the ground
itself, or the light and air through which it
is seen. Whatever actual scene he depicts,
Cuyp chooses sky. As in *View on a Plain*
(cat. 58), he adopts the lowest possible
viewpoint to give it due prominence, so
that even the nearby cows project above
the horizon. Nothing is seen for itself:
everything is affected by the quality of the
light striking it. Even the weeds, stumps,
and grasses of the foreground are lit up in
strange patterns by the slanting light of the
setting sun. Beyond the foreground ridge
we see veils of glowing misty air, through
which we have to peer to make out the
river and distant mountains.

Color is again dictated by light, with
golds and blues of the sunset predomin-
ating over the greens and browns of the
grass and the earth. There is a ring of
colored air surrounding the sun, almost
like a rainbow, which extends over the
earth as well as the sky, an effect that can
be observed in nature. In this example, if
in no other work by Cuyp, such individual
observations go beyond those of his
sources, Jan Both and Claude.

This painting is probably only a year
or so later than *View on a Plain* (cat. 58),
and yet the setting has become more
mountainous, idealized, and unspecific.
It still, however, depicts an estuary flowing
into the North Sea rather than the
Mediterranean. With effects of light Cuyp
transfigures a scene without losing its
recognizable local character; it is perhaps
this ability that made him such an
inspiration for two great nineteenth-
century artists creating their own national
styles of landscape, J.M.W. Turner and
George Caleb Bingham.

DST

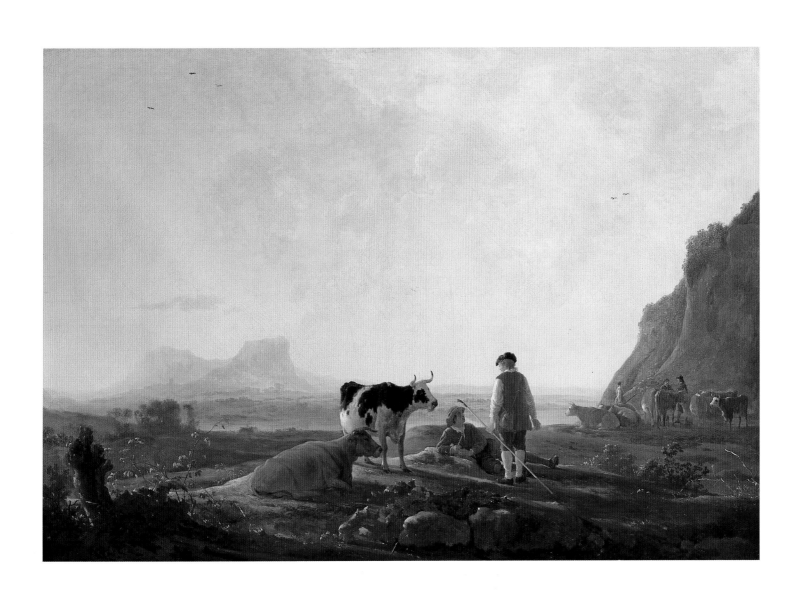

60 Aelbert Cuyp

DORDRECHT 1620–1691 DORDRECHT

A Road near a River, ca. 1658

Oil on canvas
44½ × 66 in. (115.6 × 170.6 cm)
DPG 124; Bourgeois bequest, 1811

REFERENCES: C. Hofstede de Groote, *A Catalogue Raisonné of the Works of the Most Eminent Dutch Painters of the Seventeenth Century*, 10 vols., London, Stuttgart, and Paris, 1908–27, no. 435; E. Reiss, *Aelbert Cuyp*, London, 1975, no. 138; A. Chong, *Aelbert Cuyp and the Meaning of Landscape*, diss., New York University, no. 170; P. Sutton in *El siglo de oro del paisaje holandés*, exhib. cat., Madrid, Fundación Colección Thyssen-Bornemisza, 1994, no. 19; A. Chong in *Conserving Old Masters*, exhib. cat., London, Dulwich Picture Gallery, 1995, no. 9

In this late work, Cuyp takes a familiar motif in Dutch art – the river or canal-side view – and transforms it into something more generalized and heroic. The distant mountains are the only element that could not be found within Holland and that depend upon poetic license. The treatment, on the other hand, is recognizably Italianate. The sun setting just behind the left hand bank, the giant trailing shadows and the principal group of trees, and the foliage fine and translucent against the light are all reminiscent of Jan Both's *Road by the Edge of a Lake* (cat. 57).

On this huge scale one is particularly aware of the mannerisms of Cuyp's later paintings: the patterns of the foliage, the reflections in the water, and above all the abstracted and schematized clouds. It is as if Cuyp wished to make the viewer aware of the artifice of painting.

DST

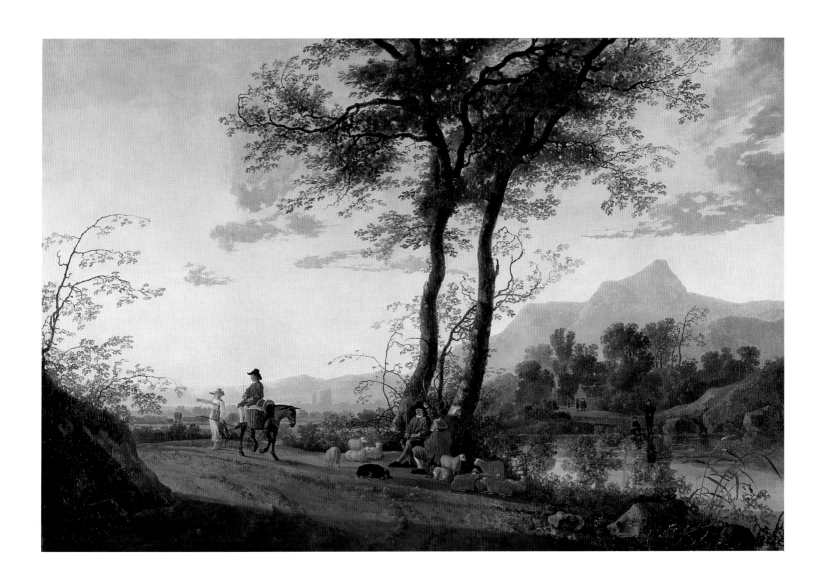

61 Nicolaes Berchem

HAARLEM 1620–1683 AMSTERDAM

Traveling Peasants (Le Soir), ca. 1655–60

Oil on oak panel
13½ × 18 in. (34.4 × 45.6 cm)
Signed, bottom left: *Berchem f*
DPG 157; Bourgeois bequest, 1811

REFERENCE: C. Hofstede de Groote, *A Catalogue Raisonné of the Works of the Most Eminent Dutch Painters of the Seventeenth Century*, 10 vols., London, Stuttgart, and Paris, 1908–27, no. 380

Nicolaes Berchem was a great friend of his slightly younger fellow Haarlem citizen Jacob van Ruisdael. The two artists visited northern Germany together in 1650 and there are many parallels in their careers, but their mature styles could not be more different. Berchem visited Italy in 1653 and became the most important exponent of the imaginative, Italianate style of Dutch landscape, whereas Ruisdael's style reflected more closely the sky and countryside of Holland.

This small panel shows the attributes that made Berchem so popular with his contemporaries and later collectors: brilliant colors; a light, flickering touch; and an idealized vision of Italian peasant life. Many of these qualities, as well as an enamel surface and soft hazy distance, can be directly related to the Poelenburch landscape of twenty years earlier (cat. 56). In the present work, however, a consistent viewpoint has been employed, which bears comparison with Ruisdael's contemporary (and otherwise totally contrasting) view of the chilly north (cat. 66).

DST

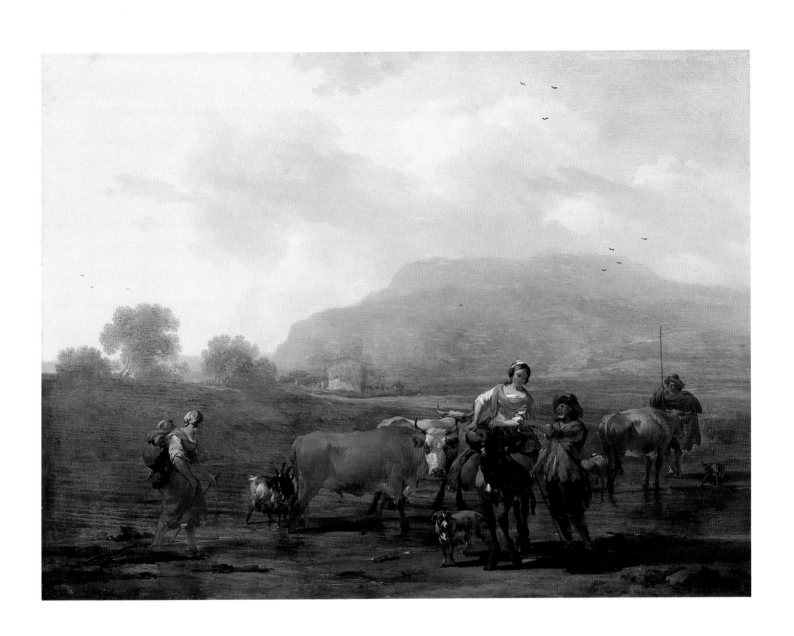

62 Nicolaes Berchem

HAARLEM 1620–1683 AMSTERDAM

Roman Fountain with Cattle and Figures (Le Midi), ca. 1645

Oil on oak panel
14½ × 19 in. (36.8 × 48.4 cm)
Signed, bottom left: *Berchem.*
DPG 166; Bourgeois bequest, 1811

REFERENCES: C. Hofstede de Groote, *A Catalogue Raisonné of the Works of the Most Eminent Dutch Painters of the Seventeenth Century*, 10 vols., London, Stuttgart, and Paris, 1908–27, no. 192; E. Schaar, *Studien zu Nicolaes Berchem*, Cologne, 1958, p. 20

This landscape has been paired with *Traveling Peasants* (cat. 61), at least since 1769, when both appeared in the Gaignat sale, Paris. Its size, however, is slightly different and it has been dated by E. Schaar to about 1645, ten years before catalogue 61. It is likely, therefore, that this pairing is a collector's (or dealer's) "marriage of convenience."

In general outline, the fountain here is similar to one that stood in the Roman forum until the nineteenth century. In the seventeenth century the forum had become Rome's principle cattle market and was called the Campo Vaccino or "Field of Cows"; the fountain was put there in the 1590s as a beast's drinking trough. The fact that the center of the known world in Roman times had sunk so low in the modern world was a powerful symbol to the seventeenth-century mind. Berchem here uses his reminder of the Campo Vaccino to suggest that these modern peasants are living among the ruins of a greater civilization and that an ancient city had once stood on this barren hillside.

DST

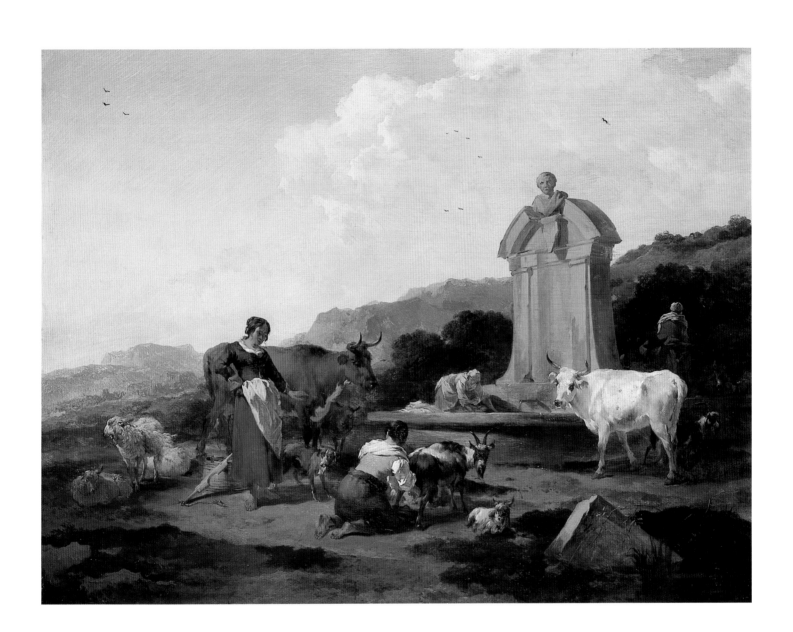

63 Adam Pynacker

SCHIEDAM 1620/21–1673 AMSTERDAM

Bridge in an Italian Landscape, ca. 1653

Oil on oak panel
17¼ × 20¾ in. (43.8 × 52.7 cm)
Signed indistinctly above lily leaves,
lower right: *APijnaker* (AP in monogram?)
DPG 183; Bourgeois bequest, 1811

REFERENCES: C. Hofstede de Groote,
*A Catalogue Raisonné of the Works of the
Most Eminent Dutch Painters of the Seventeenth Century*, 10 vols., London, Stuttgart,
and Paris, 1908–27, no. 74; L.B. Harwood,
Adam Pynacker, Doornspijk, 1988, no. 32;
L.B. Harwood, *A Golden Harvest, Paintings
by Adam Pynacker*, exhib. cat., Williamstown, Sterling and Francine Clark Art
Institute, and Sarasota, John and Mable
Ringling Museum of Art, 1994–95, no. 6

Like so many of his generation, Adam
Pynacker developed his style during a visit to
Italy in 1645–48, an experience that was
probably kept fresh by continued observation of the work of Jan Both after his return
to Holland. It is difficult to imagine a more
perfect example of the Dutch vision of Italy
than this landscape, probably painted in
about 1653. The spectrum of evening light,
from the yellow of the setting sun on the left
to the blue on the right, is here effected with
a daring intensification of the colors. At the
same time the transitions are so imperceptible and the paint surface of such unblemished smoothness that it looks as if a sunset
has been sealed in glass. The importance of
the sky for the mood of this landscape can
be seen in the way in which it is brought
right down to the lower margin – a serene
heaven perfectly reflected in an unruffled
sheet of water.

Evening light affects the way we see the
earth as well as the sky, right up to the
ground in front of our feet. Pynacker
observes the way it picks out individual
elements and makes them glow as if on fire –
especially the reeds, the bark, and the fringes
of the foliage to the right of the painting.
This penetration of the evening sun makes
the viewer especially conscious of the space
between objects in this landscape and of a
peculiar thickness and palpability of the
evening air, charged with the day's
accumulation of moisture and dust.

The Italian landscape was not just idyllic
for the Dutch, it was also grand and heroic.
This is an ancient Roman bridge; it has a
nobility even in decay; these shepherds are
the descendants of those described by
Virgil. Pynacker pays homage with a
suitably low viewpoint, looking
dramatically up through the arch, the
figures silhouetted against the sky.

64 Adam Pynacker

SCHIEDAM 1620/21–1673 AMSTERDAM

Landscape with Sportsmen and Game, ca. 1665

Oil on canvas
54¼ × 78¼ in. (137.8 × 198.7 cm)
Signed, bottom center right: *A Pynacker*
(AP in monogram)
DPG 86; Bourgeois bequest, 1811

REFERENCES: C. Hofstede de Groote, *A Catalogue Raisonné of the Works of the Most Eminent Dutch Painters of the Seventeenth Century*, 10 vols., London, Stuttgart, and Paris, 1908–27, no. 9 (and possibly 72); L.B. Harwood, *Adam Pynacker*, Doornspijk, 1988, no. 77

In art, hunting is often associated with the wilder aspects of nature, because it took sportsmen off the beaten track and because of the obvious violence involved. This huntsman has strayed to the borders of the forest on a mountainside, looking down over the plain (in contrast to cat. 63, where the view is toward the mountains from the safety of the path).

Traditionally in European culture the forest is considered another type of wilderness, containing terrors as well as delights, an idea clearly related to the belief that trees are inhabited by spirits or can imprison the souls of humans. From the very earliest landscape paintings, especially in the north, artists used tree trunks and the vegetation of the forest floor to express this unease. Adam Pynacker belongs to this tradition, which runs from Albrecht Dürer to Max Ernst (and is, incidentally, familiar to a wider audience through the classics of Walt Disney). Pynacker has devoted at least half his painting to the untrod forest in a stylishly unbalanced composition. His tree trunks suggest decay through broken stumps and bark peeling like skin.

What makes the effect so surreal is the hyper-focus brought about by the extreme proximity of the foreground objects and the way the brilliant, grazing light of the setting sun exaggerates every cut and snag on the surface of the bark. Also surreal is the curling, gnarled, and tortured pattern given to every natural form.

With its elegant patterns and glossy and intricately tangled surface, this painting is also part of the tradition in European art that uses the grotesque for ornamental purposes. This may have been one of a series of paintings by Pynacker which filled an entire room in the house of Cornelis Backer on the Herengracht, one of the most fashionable canals in Amsterdam.

The defecating dog derives from the work of Ludolf de Jongh (R.E. Fleischer, *Ludolf de Jongh*, Doornspijk, 1989, p. 57 and fig. 48). The foreground leaves have turned blue through the fading of a yellow pigment.

DST

65 Herman Saftleven

ROTTERDAM 1609–1685 UTRECHT

View on the Rhine, 1656

Oil on oak panel
16⅞ × 22¾ in. (42.8 × 57.8 cm)
Signed and dated, bottom left: *HSL 1656*
(HSL in monogram)
DPG 44; Bourgeois bequest, 1811

REFERENCES: W. Schulz, *Herman Saftleven, 1609–1685: Leben und Werke*, Berlin and New York, 1982, no. 92

Herman Saftleven worked for most of his life in Utrecht, where he was influenced by the contemporary trends in Dutch landscape painting, especially as seen in the work of Van Goyen and Cornelis van Poelenburch. The more dramatic mountainous landscape of the Moselle and Rhine valleys, which Saftleven visited in the 1650s, seems to have encouraged him to look again at the older landscape tradition of Pieter Breughel the Elder, his son Jan Breughel (1568–1625), and Paul Bril (see cat. 56).

This landscape is of a type almost universal among northern artists in 1600 but rare in 1656. It is impossible that such a scene could be viewed in this way in real life: the viewpoint from which the distance is seen could be gained only by climbing a mountain, and yet the foreground clearly shows that we are a short scramble from river level. Rather than using a single consistent viewpoint, Saftleven has revived the trick that might be called the successive bird's-eye view. The viewpoint is just high enough to see over the cottage in the left foreground; it is then just high enough to see over the next bank of trees, and then over the brow of the hill and so on, as if the landscape were made up of series of separate images as the bird's eye glides over the terrain.

The advantage of this method is that it allows the viewer a godlike power of seeing into every part of the landscape simultaneously. The artist's extraordinarily intricate technique seems even to overcome the problem of distance, and allows Saftleven to present a universal picture of the lives of the river communities. We see men at work in the fields and dancing in taverns; we see the layout of villages and towns linked by paths and roads; we see an inventory of vessels and gain an entire knowledge of the economy of the river.

DST

66 Jacob van Ruisdael

HAARLEM 1628/29–1682 AMSTERDAM

Landscape with Windmills near Haarlem, ca. 1650–52

Oil on oak panel
12⅜ × 13⅜ in. (31.5 × 33.9 cm)
Signed, bottom right: *JvR* (monogram)
DPG 168; Bourgeois bequest, 1811

REFERENCES: C. Hofstede de Groote, *A Catalogue Raisonné of the Works of the Most Eminent Dutch Painters of the Seventeenth Century*, 10 vols., London, Stuttgart, and Paris, 1908–27, no. 175; K.E. Simon, *Jacob van Ruisdael, Eine Darstellung seiner Entwicklung*, Berlin, 1927 (reprinted with errata and addenda, 1930) p. 74, no. 175 (as eighteenth-century); J. Rosenberg, *Jacob van Ruisdael*, Berlin, 1928, no. 115

Jacob van Ruisdael was trained by his uncle Salomon van Ruisdael in Haarlem, and his own work followed Salomon's example of innovation. This early work of about 1650–52 shows how mainstream Dutch landscape was developing at the time, especially in contrast to Saftleven's *View on the Rhine* (cat. 65) of a few years later. The comparison between the two is in many respects comparable to that between Poelenburch's *Valley with Ruins and Figures* (cat. 56) and Jan Both's *Road by the Edge of a Lake* (cat. 57). Ruisdael's is a landscape seen from a single viewpoint at eye level – and it is therefore only a partial view. Haarlem is almost completely obscured by a silage mound; it is only the distant outline of the Groote Kerk that allows the city to be recognized. The land is so flat and the eye so low that the horizon occurs at only a quarter of the height of the painting. The actual subject of the landscape – a ditch, a shack, some dunghills, and a couple of windmills – is banal in the extreme.

An eighteenth-century owner of this painting clearly felt that it needed livening up, and he therefore painted in a man with a horse in the center (below the further windmill) and a gentleman rider out hawking to the extreme right. The painting was copied with these additional figures by John Constable in 1831. The date of these additions was revealed by pigment analysis and they were removed in 1997.

What is the advantage of so partial a view and so drab an image? The answer is that with a "real" (or at least possible) viewpoint the spectator is no longer invited to survey the landscape but to enter it. We experience directly the sensation of standing on this road at this point (a few yards in front of the scene shown in the painting). This is what we would see, but,

more important, this is how we would feel, weather conditions being crucial to Dutch art of this period. Ruisdael creates the impression of a cold, predominantly grey, blustery day, with isolated bursts of sunshine, sending dramatic strips of light over the ground. This bleakness is well supported by Ruisdael's own figures – a single woman in a doorway giving alms to a beggar boy.

DST

67 Jacob van Ruisdael

HAARLEM 1628/29–1682 AMSTERDAM

A Waterfall, ca. 1665–70

Oil on canvas
38¾ × 32⅞ in. (98.5 × 83.4 cm)
Signed, lower center right: *JvRuisdael* (JvR in monogram)
DPG 105; Bourgeois bequest, 1811

REFERENCES: C. Hofstede de Groote, *A Catalogue Raisonné of the Works of the Most Eminent Dutch Painters of the Seventeenth Century*, 10 vols., London, Stuttgart, and Paris, 1908–27, no. 247; K.E. Simon, *Jacob van Ruisdael, Eine Darstellung seiner Entwicklung*, Berlin 1927 (reprinted with errata and addenda, 1930), p. 74, no. 247 (as Van Kessel); J. Rosenberg, *Jacob van Ruisdael*, Berlin, 1928, no. 190

It is unlikely that Jacob van Ruisdael traveled extensively in northern Europe, but in his later years he was strongly influenced by the waterfalls and mountain views of Allart van Everdingen, who had visited Scandinavia. This painting of the late 1660s uses a device of Everdingen's whereby the viewer is pitched into the middle of a dramatic and dangerous scene. It is as if the eye has to shoot these rapids in order to gain the relative safety of the distant slopes. The painting also shows Ruisdael's use of tonal contrasts in order to achieve a theatrical and somber mood: like the sunlight flashes in catalogue 66, the white spray is dramatic against the darkness of the scene as a whole.

DST

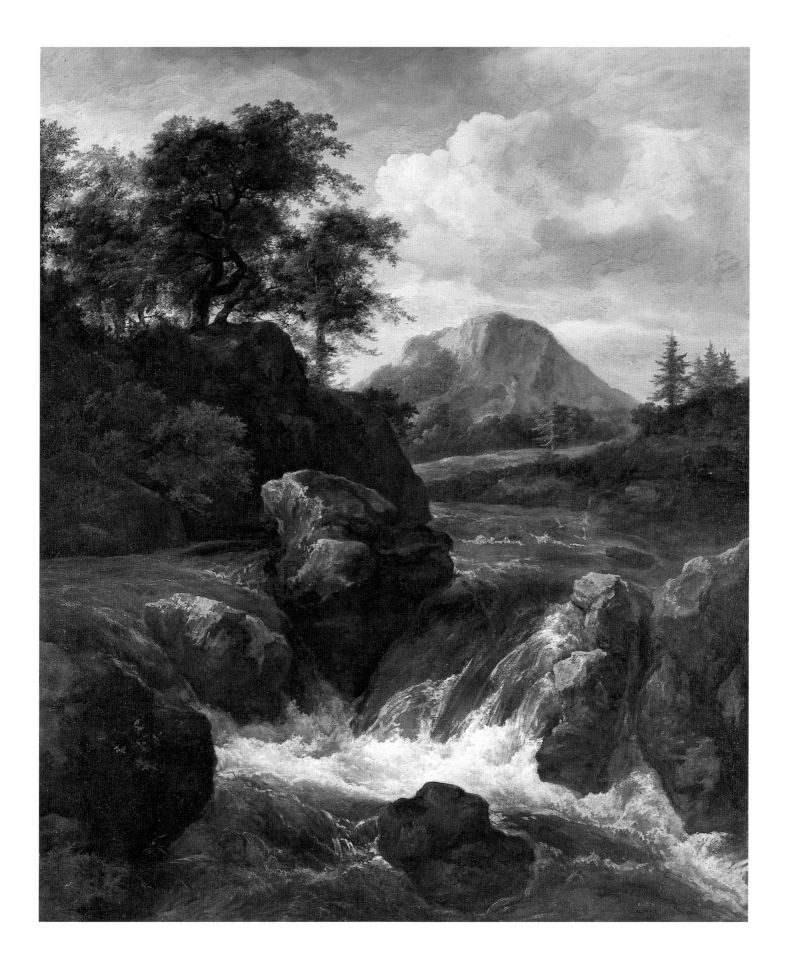

68 Meindert Hobbema

AMSTERDAM 1638–1709 AMSTERDAM

Wooded Landscape with Water Mill, early 1660s?

Oil on oak panel
24⅜ × 35⅝ in. (61.9 × 85.4 cm)
Signed, bottom center right: *m Hobbema*
DPG 87; Bourgeois bequest, 1811

REFERENCES: C. Hofstede de Groote,
*A Catalogue Raisonné of the Works of the
Most Eminent Dutch Painters of the Seven-
teenth Century*, 10 vols., London, Stuttgart,
and Paris, 1908–27, no. 82; G. Broulhiet,
Meindert Hobbema (1638–1709), Paris, 1938,
no. 218; C. Brown in *Kolekcja dla Króla*,
exhib. cat., Warsaw, Royal Castle, 1992,
no. 13

Meindert Hobbema studied with Jacob
van Ruisdael soon after Ruisdael's arrival
in Amsterdam in 1657. This painting
reflects Hobbema's characteristic use of
devices borrowed from Ruisdael: gnarled
trunks of trees; jagged patterns of foliage;
abrupt contrasts of light and dark;
changeable weather conditions, with rain
threatening in the top left corner. It also
shows how Hobbema domesticated
Ruisdael through the introduction of
anecdotal figures (couples strolling and
children playing) and reassuring elements
such as a mill and village green symboli-
cally protected by the arch of the tree.

The group of buildings recurs with
differences of detail in another painting by
Hobbema of unknown whereabouts
(Broulhiet 1938, no. 219), suggesting that
the site is a real one.

DST

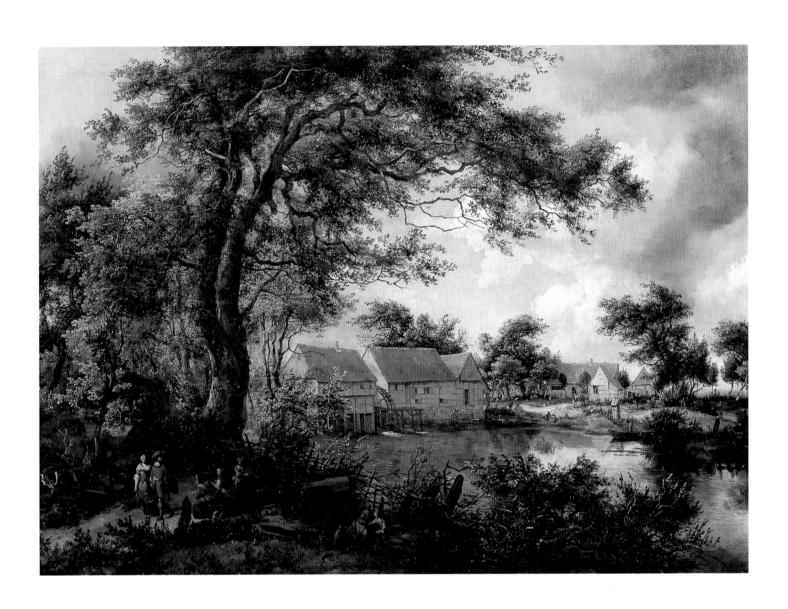

69 Philips Wouwermans

HAARLEM 1619–1668 HAARLEM

Courtyard with a Farrier Shoeing a Horse, ca. 1656

Oil on canvas
18¼ × 21⅞ in. (46.3 × 55.6 cm)
Signed, bottom right: *PHILS W* (PHILS in monogram)
DPG 92; Bourgeois bequest, 1811

REFERENCE: C. Hofstede de Groote, *A Catalogue Raisonné of the Works of the Most Eminent Dutch Painters of the Seventeenth Century*, 10 vols., London, Stuttgart, and Paris, 1908–27, no. 131

Philips Wouwermans was a contemporary of Berchem, and, like him and Jacob van Ruisdael, a native of Haarlem. There is no evidence that he traveled to Italy, and yet this painting has a clearly Mediterranean subject. Like Dujardin's *Smith Shoeing an Ox* (cat. 53), the painting – with its picturesque figures, high plastered walls, and heroic decay – reflects the view of Italy embedded in the popular imagination of the Dutch.

DST

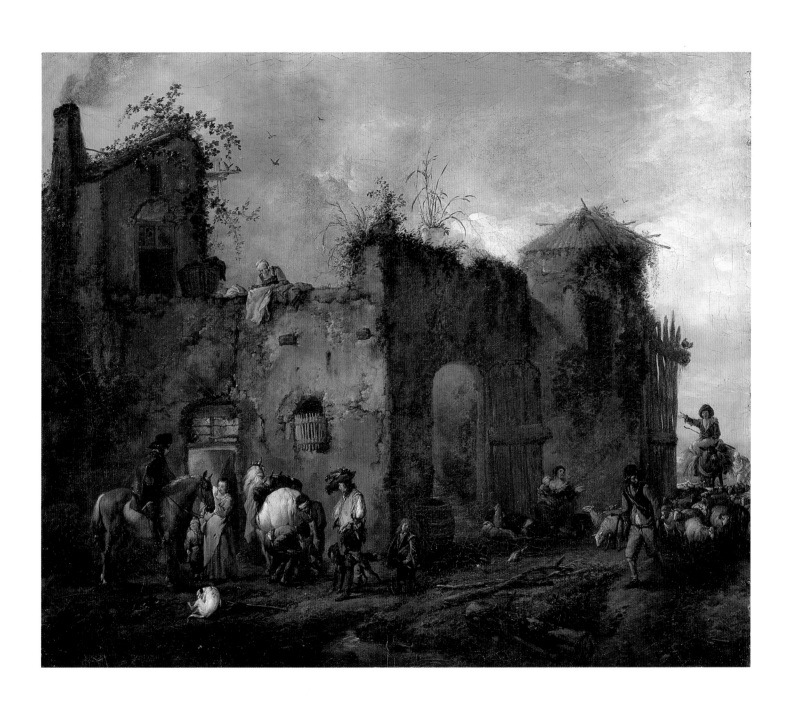

70 Philips Wouwermans

HAARLEM 1619–1668 HAARLEM

Halt of a Hunting Party, 1660s

Oil on canvas
21⅞ × 32⅝ in. (55.6 × 82.9 cm)
Signed, bottom right: *PHILS W*
(*PHILS* in monogram)
DPG 78; Bourgeois bequest, 1811

REFERENCES: C. Hofstede de Groote, *A Catalogue Raisonné of the Works of the Most Eminent Dutch Painters of the Seventeenth Century*, 10 vols., London, Stuttgart, and Paris, 1908–27, no. 659; C. Brown in *Collection for a King*, Washington, D.C., National Gallery of Art, and Los Angeles County Museum of Art, 1985–86, no. 37; C. Brown in *Kolekcja dla Króla*, exhib. cat., Warsaw, Royal Castle, 1992, no. 29

The landscape depicted in this work is clearly based on the dunes of Holland on a typical summer's day – blustery with intermittent sun. What distinguishes this scene from most other northern landscapes is its aristocratic character. Because it required extensive land, hunting was traditionally the sport of the landed nobility and especially of kings. It was as enthusiastically pursued in the Netherlands as anywhere else in Europe, by the Dutch aristocracy and by the court of the House of Orange, the Dutch constitutional monarchs (or Stadholders).

This shooting and hawking party is made up of two couples, with their servants, horses, and dogs. They are pausing to water their animals in the stream and buy some oranges from a local vendor. The mannered elegance of the couples is something of a novelty in Dutch landscape painting, especially the gentleman taking an apple with such affected courtesy.

The fact that an eighteenth-century artist added to Ruisdael's *Landscape with Windmills* (cat. 66) a horseman with a hawk (very much in the manner of Wouwermans) makes it especially tempting to contrast these two visions of the Dutch scene. Now that the hunter is removed from the Ruisdael it seems unthinkable that anyone should have added anything so incongruous to that picture. Wouwermans's style of landscape suits the subject in a way that Ruisdael's emphatically does not. Though painting a flat scene, Wouwermans makes the dunes decoratively hilly and adds an improbable mountain, castle, and hill town to the background. The color is bright, the detail intricate, and the touch of the brush frilly and ornamental. It is not surprising that Wouwermans was popular with

the European aristocracy in the early eighteenth century. This painting came from one of the most celebrated aristocratic collections of the day, that of the duc d'Orléans. One might say that this is the landscape equivalent of Adriaen van der Werff's *Judgment of Paris* (cat. 54), which also belonged to the duc d'Orléans. Ruisdael's painting was obviously tampered with to appeal to the same sort of aristocratic market.

Though it may seem to us rather superficial, Wouwermans's vision of the aristocracy disporting themselves in a landscape had a considerable influence on the early work of Watteau (see cat. 33).

DST

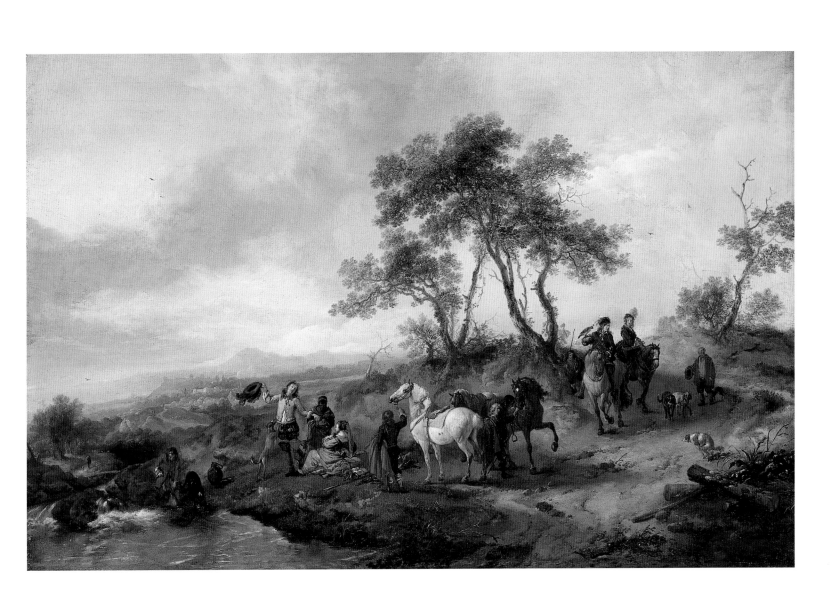

71, 72 Jan Wijnants

HAARLEM 1631/32–1684 AMSTERDAM

Landscape with Cow Drinking, ca. 1660?

Landscape, ca. 1660?

Landscape with Cow Drinking
Oil on oak panel
6⅛ × 7⅜ in. (15.6 × 18.7 cm)
Signed, bottom right: *J wijna*[n]*t*[s]
DPG 114; Bourgeois bequest, 1811

Landscape
Oil on oak panel
6¼ × 7⅜ in. (15.8 × 18.8 cm)
DPG 117; Bourgeois bequest, 1811

REFERENCES: C. Hofstede de Groote, *A Catalogue Raisonné of the Works of the Most Eminent Dutch Painters of the Seventeenth Century*, 10 vols., London, Stuttgart, and Paris, 1908–27, nos. 312 and 590

Born in Haarlem, Jan Wijnants was influenced by the two most successful Haarlem landscapists of his generation, Ruisdael and Wouwermans. This exquisite pair of dune landscapes provides a perfect example of his brilliant colors and jewel-like finish. They also show how much atmosphere can be distilled within such a tiny compass. Wijnants even took the trouble to set up a contrast between the two images, the one blustery and threatening, the other sunny and calm.

This is exactly the type of landscape that influenced the young Gainsborough when he came to record the similar terrain of Suffolk.

DST

73 Jan Weenix

AMSTERDAM 1642–1719 AMSTERDAM

Landscape with Shepherd Boy, 1664

Oil on canvas
32⅛ × 39¼ in. (81.6 × 99.6 cm)
Signed and dated, bottom left: *J.Weenix/*
1664
DPG 47; Bourgeois bequest, 1811

REFERENCE: I. Gaskell in *Collection for a King*, Washington, D.C., National Gallery of Art, and Los Angeles County Museum of Art, 1985–86, no. 34

This is one of the best surviving examples of the early painting of Jan Weenix, when he was working in the style of his father and teacher, Jan Baptist Weenix (1621–1660). Indeed, the attribution hangs upon the date on the picture, 1664, four years after Jan Baptist's death.

Even more than Berchem's fountain landscape (cat. 62), this image suggests the sentiment contained in the familiar Latin tag *sic transit gloria mundi* (Thus passes away the glory of the world). A once noble Corinthian temple has undergone so comprehensive a transit that it is buried to within a few feet of its capitals, while trees overgrow its cornices. The stone terraces and perhaps even the city that presumably once surrounded it are swallowed into oblivion and reclaimed by the landscape.

Modern life hardly measures up to the ancient standard – a shepherd boy sprawls on the floor clipping his dog's nails, while his sheep huddle and bleat nearby. The image of the boy leaning against a sarcophagus-like fragment, overturned by an earthquake, adds a further shade of meaning: he is as careless of his own mortality as he is unaware of the grandeur of the past.

Weenix here paints with a brilliance of touch and a freedom that gives the scene an animated, transitory quality.

DST

74 Willem van de Velde the Younger

LEIDEN 1633–1707 LONDON

A Calm, 1663

Oil on canvas on panel
13⅜ × 14¾ in. (34 × 37.5 cm)
Signed and dated, bottom right: *w.v.v. 1663*
DPG 197; Bourgeois bequest, 1811

REFERENCES: C. Hofstede de Groote, *A Catalogue Raisonné of the Works of the Most Eminent Dutch Painters of the Seventeenth Century*, 10 vols., London, Stuttgart, and Paris, 1908–27, no. 201 and probably 340a; M.S. Robinson, *The Paintings of the Willem van de Veldes*, 2 vols., London, 1990, I, p. 493, no. 102

Willem van de Velde the Younger was trained by his father, Willem van de Velde the Elder (1611–1693), the most technically precise marine draftsman of the age. He also studied briefly with Simon de Vlieger (1600–1653), from whom he may have developed his interest in the atmospheric effects of the sea in its different moods. This is a fine example of a painting of the sea rather than of boats. The extraordinary quality of the work's atmosphere depends on the artist disregarding the surfaces which he knows are there. Definition of where the sea meets the shore and of where the horizon meets the sky is altogether absent. Instead, wet sand and the lapping tide run imperceptibly into one another, with an effect that Turner was to reproduce countless times; a glassy sheen of light, created by the mist hovering over the sea, similarly obscures the horizon. Apart from the ships themselves, the strongest line in the landscape is given to an insubstantial element – the crest of the central cloud bank.

De Vlieger was an exponent of what is called the tonal style of Dutch landscape, where atmospheric effects are achieved by thinly applied, sketchy, and almost monochrome paint. However impressed he may have been by these effects, Willem van de Velde employed different means and clearly belongs to another, later stage of Dutch landscape (which unfortunately lacks a name). He uses not only bright color, but also subtle transitions of colors – from white through grey to blue – as a fundamental means of suggesting space. He also employs a smooth, polished, and finished paint surface.

DST

75 Willem van de Velde the Younger

LEIDEN 1633–1707 LONDON

A Brisk Breeze, ca. 1665

Oil on canvas
20½ × 25⅝ in. (52.1 × 65 cm)
Signed on floating plank, lower left:
W V V.
DPG 103; Bourgeois bequest, 1811

REFERENCES: C. Hofstede de Groote, *A Catalogue Raisonné of the Works of the Most Eminent Dutch Painters of the Seventeenth Century*, 10 vols., London, Stuttgart, and Paris, 1908–27, no. 493; D. Cordingly in *Collection for a King*, Washington, D.C., National Gallery of Art, and Los Angeles County Museum of Art, 1985–86, no. 32; D. Cordingly in *Kolekcja dla Króla*, exhib. cat., Warsaw, Royal Palace, 1992, no. 26; M.S. Robinson, *The Paintings of the Willem van de Veldes*, 2 vols., London, 1990, II, pp. 810–11, no. 103

The title is a traditional one, probably dating from the eighteenth century. Willem van de Velde here depicts a range of Dutch ships reacting to strong, but not threatening, winds. The *kaag* to the left (a general cargo ship) seen also in *A Calm* (cat. 74), and a *smalschip* (a small cargo boat) in the center are both lowering some foresail. In the background to the left a common type of fishing vessel, a *hoeker*, is cruising, while to the right some warships are heeling in the wind. It is obvious that no view of the sea, even immediately off the coast of Holland, could have included so many ships in such a small compass. Their presence enlivens the painting, and would have conveyed to a Dutch audience the thrill of contemplating their teeming maritime activity and economic enterprise.

This painting of about 1665 is contemporary with the mature landscapes of Jacob van Ruisdael and employs the same device of highly palpable cloudbanks, clearly laid out in a spatial recession and with their dramatic shadows cast across the surface of the sea.

DST

76 Ludolf Bakhuizen

EMDEN(?) 1630/31–1708 AMSTERDAM

Boats in a Storm, 1696

Oil on canvas
24¾ × 31⅛ in. (63 × 79 cm)
Signed, on side of boat, lower left:
L.BAKHUZYN; dated, on floating plank,
bottom left: *1696*
DPG 327; Bourgeois bequest, 1811

REFERENCES: C. Hofstede de Groote,
*A Catalogue Raisonné of the Works of the
Most Eminent Dutch Painters of the
Seventeenth Century*, 10 vols., London,
Stuttgart, and Paris, 1908–27, no. 235;
D. Cordingly in *Collection for a King*,
Washington, D.C., National Gallery of
Art, and Los Angeles County Museum
of Art, 1985–86, no. 1; D. Cordingly in
Kolekcja dla Króla, exhib. cat., Warsaw,
Royal Castle, 1992 no. 1

In this painting the *wijdschip*, a large sailing vessel, has been sailing into an estuary in order to gain the harbor, the presence of which is signaled by the masts to the extreme right. The strong wind has driven her against the line of stakes, called a groin; men on shore are pulling on a rope to steady her stern; and other boats are coming to the assistance of the distressed passengers. The church and the burst of blue sky to the right suggest that the scene may have an allegorical meaning concerning man's (or perhaps a nation's) struggle toward salvation.

Ludolf Bakhuizen evolved his manner of marine painting by observing the work of the Van de Veldes, whose departure for England in 1672 allowed him to exploit the lucrative Amsterdam market. This painting belongs to the last and most polished phase of the Golden Age of Dutch painting. Viewers today tend to be disturbed by the artfulness of the scene. We expect instantaneous actions and the turbulence of nature to be rendered with a raw, direct, bold, and sketchy touch – more like Ruisdael's *Waterfall* (cat. 66) or the storm scenes of Turner. In reality, however, all representational paintings depict an instant, whether it be a moment of calm or of catastrophe.

Bakhuizen allowed his original audience the opportunity to contemplate an event that was impossible to take in when it was actually happening. To do so he subjected chaos to the organizing power of art. Every form has a clear outline and shape that could almost be rendered in sculpture. The patterns of the sails, clouds, and waves are wild, but also contrived, elegant, and rhythmical. Where detail is withheld, as in the distant figures, a clear and simplified block of color takes its place. The surface of the painting is given an even matt polish. The color is minutely calibrated, with the most astonishing effect achieved through a narrow range of greys.

This type of artifice can succeed only if the scene seems probable. In this case the quality of the observation is extraordinary – especially in the translucency of the waves and the fine distinction between the depths of grey cloudbank to the top left.

DST

VI The English School

As Giles Waterfield has observed in "A History of Dulwich Picture Gallery" (see especially page 26 above), the Bourgeois collection contained very few English works. Apart from portraits of the collectors and friends, and twenty-one of Bourgeois's own paintings, the 1811 bequest contained only a single landscape by Richard Wilson, a single portrait by Thomas Gainsborough, and a small group of works by Joshua Reynolds, dominated by his portrait of Sarah Siddons (fig. 18, p. 26), a second autograph version of the original in the Huntington Art Gallery, San Marino, commissioned in 1789 by Desenfans. There was no love lost between Desenfans and Reynolds, but Desenfans obviously felt that a Polish National Gallery would be incomplete without a historical portrait in the grandest manner by Reynolds, president of the Royal Academy and author of the *Discourses*, the most widely read contribution to artistic theory written in English. This is a somewhat token representation of the English school, to which must be added those Van Dycks that happened to be painted in England (cat. 77 and 78).

The entire Dulwich Picture Gallery collection, on the other hand, contains some 650 paintings, of which one third are by British artists. It is bequests other than Bourgeois's that have allowed Dulwich to show English art of the seventeenth and eighteenth century in its European context in such an effective way. The crucial contribution in this respect was made by William Linley, who, in 1831, bequeathed a small but distinguished group of portraits of his parents and siblings, including four important Gainsboroughs and three Lawrences (cat. 87, 88, and 90). In 1911, presumably to mark the gallery's centenary, the Pre-Raphaelite painter Charles Fairfax Murray donated a collection of forty paintings (three more following a few years later), the vast majority of them portraits produced in England (cat. 79–84 and 86). Although entirely absent from this selection, there were also two important bequests which preceded the founding of the gallery in 1811. Edward Alleyn, the Elizabethan actor-manager and first mover of all the Dulwich Foundations, left his college a group of some forty paintings, which were supplemented by another eighty from the bequest in 1686 of another theatrical manager, William Cartwright. These two rare and important seventeenth-century collections, predominantly of British art, must have been a significant factor in persuading Fairfax Murray that his collection, with its strong representation of the early years of British portraiture (from the period 1650–1750), would make a welcome addition at Dulwich. The result is an opportunity to examine British artists of the seventeenth and eighteenth centuries alongside their Continental contemporaries, rather than tacking Reynolds and Gainsborough on to the end of the period as Bourgeois had planned.

How does art produced in Britain compare with that produced on the Continent? This depends on the period to which the question refers. Early on, when Alleyn bequeathed his collection in 1626, it does not compare at all. A sociologist seeking to explain cultural activity without the enigma of individual creativity could do well to contemplate Alleyn's paintings. Few of them would have made it on to the walls of a moderately successful Dutch tavern. Yet London should have suited painters as well as Amsterdam: there was great wealth, thriving industry and sea trade, and a similarly expanding middle class of Protestant faith and constitutional aspiration. Nor was London without culture: Alleyn, like his contemporary William Shakespeare, made his fortune in the theater. Admittedly bear-pits and brothels contributed to his profits, but so did plays: he was, after all,

Christopher Marlowe's leading actor, the man who created the roles of Tamberlaine and Doctor Faustus. How could he have acted in such good plays and bought such bad pictures?

If we examine the other end of the timescale and ask what was the state of British painting at the time of the gallery's foundation in 1811, things look very different. The works of Turner and Constable in landscape, of Lawrence in portraiture, and of David Wilkie in genre painting were admired across Europe. It might even be said that, though clearly inferior in absolute quality, nineteenth-century painting in Britain was similar in patronage and patterns of artistic activity to that in seventeenth-century Holland.

Various factors have been suggested in order to explain the slow emergence of British art and its peculiar character. Hogarth blamed foreign imports. It is certainly true that British art was dominated by several highly successful Continental artists working in London: Hans Holbein, Anthony van Dyck (cat. 77 and 78), Peter Lely (cat. 79 and 80), and Sir Godfrey Kneller. Other Continentals exploited the English market, among them Antonio Bellucci (cat. 9), Sebastiano Ricci (cat. 10 and 11), Canaletto (cat. 12), Zuccarelli (cat. 17), Willem van de Velde (cat. 74 and 75), Soldi (cat. 84), Roubiliac, and De Loutherbourg. Whatever Hogarth thought, these appear from today's perspective to have brought the best of European art across the Channel; however, such imports do not necessarily create a culture of home-grown talent.

It was not just the living foreigner who challenged English artists' livelihood; there were also the old masters to consider. From the collection Charles I was already forming in the 1620s until the gallery's foundation in 1811 and beyond, major European old masters played an important part in the development of British art and patronage, sometimes inspiring, sometimes paralyzing. On the positive side, one need look no further than the examples of Turner, Constable, Wilkie, and many other British artists who were inspired by the Bourgeois paintings, just as the previous generation of Reynolds and Gainsborough had been by other fine collections throughout the country.

On the negative side, however, one can examine a pattern of collecting which seemed for many years to work against the living native artist. Throughout the eighteenth century the British nobility covered the walls of their houses with "dismal dark subjects" (as Hogarth called them) by dead painters, and, while they acquired a reputation for taste, it was achieved without giving work to anyone except, perhaps, an unscrupulous restorer. These collections may have inspired artists, but in the main they failed to inspire patrons. One explanation for this is a phenomenon that might be called the "superfluous subject." It was a peculiarity of auction-room patronage that the subject matter of painting was incidental: it is unlikely that Desenfans rejoiced at having a *Saint John the Baptist* (cat. 4); what he wanted was a Guido Reni. The average Protestant British collector probably agreed with Hogarth that the subjects of religious paintings were sacrilegious and those of mythologies absurd. It is perhaps this separation of painting-as-commodity from painting-as-subject matter that explains the astonishing lack of imagination shown by the British when it came to commissioning works for themselves. It is as if nobody could think of a subject that they actively wanted. They fell back on a record of themselves and their immediate surroundings far more narrowly conceived than by the Dutch. Dr. Johnson declared, "I had rather see the portrait of a dog I know than all the allegories you can show me!" (quoted in N. Pevsner, *The Englishness of English Art*, p. 22). Most English patrons agreed with him, though they expanded this winning formula to include their horse, their house, and their park, as well as their wife, their children, and themselves. Lely's friend Richard Lovelace summed up this taste with one devastating phrase: "Let them their own dull counterfeits adore" (see cat. 79). For Lovelace, the English had substituted the idolatry of the self for that of the saints. Certainly for the majority of English patrons, at least until 1750, painting and portraiture were the same thing.

Painting seems to have been an accessory to ownership – an inventory of property, a record of the lineage by which it had been acquired, a celebration of the couple in present possession, and a glimpse of the healthy progeny by whom its future would be assured. But if the notion of private property was the curse of painting, it also turned out to be its liberation. One of the most important events in the history of English literature as well as art was the invention of the principle of what we now call "intellectual property," marked by the Copyright Acts of 1709 (covering text) and 1734 (covering images). It was through prints, thus protected from piracy, that artists could profit from the ideas in their paintings. Just as Alexander Pope became rich through his translations of Homer, so Hogarth did through his famous series of narrative prints – his *Progresses, Marriage à la Mode*, and so on.

In spite of the flourishing middle class (similar to that in Holland), the English collector of paintings (as opposed to prints) tended to be an aristocrat. As we have seen, his patronage was broadly similar, especially in its dynastic portraits, to that of a European prince, except that his palace was a country house and his "collection" (rather self-consciously conceived as such) was bought *entirely* from Christie's. It was through prints that a broader middle-class and even mass audience contributed at last to the world of painting. The invention of the public exhibition (in 1759) and of the public gallery (in 1811) were extensions of the creation of the public marketplace for art through prints. The stimulus was transforming, not just for narratives such as Hogarth's but also for portraits. Unlike a painted portrait, a print must be enjoyed by others apart from the sitter's family. The public liked to see prints of subjects they did not know, provided that they were interestingly conceived. Through the participation of the public, the imaginative side of painting was allowed to flourish – ideas, variety of compositions, and the development of human interest. It is through this means more than any other that English artists on the one hand created interesting portraits and on the other found a market for art other than portraiture.

Most of the portraits in this section include a hint of narrative or some idea about character to enliven what would otherwise be a "dull counterfeit." There is a clear transition from Van Dyck's portrait of Lady Digby (cat. 77), in which the narrative is of a private kind, to the later examples, in which it is more public. While enlivening the conventions of portraiture artists tended to express ideas about people in general rather than just the individuals portrayed: Soldi uses the sculptor Roubiliac as a means to explore the idea of "creative fury" (cat. 84); Hogarth turns a portrait commission into a genre painting of a family in the park (cat. 82); and Gainsborough uses the Linley sisters to create a general evocation of the idea of feminine sensiblity and sisterly affection (cat. 88).

DST

77 Anthony van Dyck

ANTWERP 1599–1641 LONDON

Venetia Stanley, Lady Digby, on Her Deathbed, 1633

Oil on canvas
29¼ × 32¼ in. (74.3 × 81.8 cm)
DPG 194; Bourgeois bequest, 1811

REFERENCES: G.A. Waterfield in *Collection for a King*, Washington, D.C., National Gallery of Art, and Los Angeles County Museum of Art, 1985–86, no. 7; E. Larsen, *The Paintings of Anthony van Dyck*, 2 vols., Freren, 1988, no. 845; A. Sumner in *Death, Passion and Politics*, exhibit. cat., London, Dulwich Picture Gallery, 1995–96, no. 31

With the possible exception of Holbein, Anthony van Dyck was the greatest Continental artist ever lured to England. As a young man Van Dyck worked in Rubens's studio, where he learned a technique of handling paint to which he subsequently added a certain refinement perfectly suited to aristocratic portraits. When he arrived in London in 1632 as principal painter to King Charles I, Van Dyck brought with him a style of portraiture that was sought after in all the major artistic centers of Europe.

This touching and surprising painting belongs completely outside the mainstream of Van Dyck's own career. It is part of a northern European – particularly English – tradition of posthumous commemorative portraits. The beautiful Venetia Stanley (1600–1633) was notorious for the sexual license of her youth, something not usually encountered or tolerated in English seventeenth-century high society. Sir Kenelm Digby (1603–1665), a soldier, poet, and scientist of some distinction, fell so completely in love with Venetia that in 1625 he married her, in secret and against the wishes of his family, following his advanced principle that "a wise man, and lusty, could make an honest woman out of a Brothell-house" (John Aubrey, *Brief Lives*, 1692, pp. 100–01). When Lady Digby died unexpectedly in her sleep during the night of April 30, 1633, Sir Kenelm was so distraught that he summoned Van Dyck to record the transitory beauty of her corpse. Sir Kenelm's own description of the painting is worth quoting at length:

It is the Master peece of all the excellent ones that ever Sir Anthony Vandike made, who drew her the second day after she was dead; and hath expressed with admirable art every circumstance about her, as well as the exact manner of her lying, as for the likeness of her face; and hath altered or added nothing about it, excepting onely a rose lying upon the hemme of the sheete, whose leaves being pulled from the stalke in the full beauty of it, and seeming to wither apace, even whiles you looke upon it, is a fitt Embleme to express the state her bodie then was in When wee came in wee found her almost cold and stiffe; yet her blood was not so settled but that our rubbing of her face brought a litle seeming color into her pale cheekes, which continued there till she was folded up in her last sheete, and Sir Anthony Van Dike hath expressed excellently well in his picture.

The symbolism Sir Kenelm fails to mention is the comforting likeness of death and sleep, a commonplace of poetry also invoked in an elegy written upon the death of Venetia Digby by the young poet William Habington:

> *She past away*
> *So sweetly from this world, as if her clay*
> *Laid only down to slumber. Then forbeare*
> *To let on her blest ashes fall a teare.*
> *But if th'art too much woman, softly weepe,*
> *Lest griefe disturbe the silence of her sleepe.*

("To Castana: Upon the Death of a Lady")

This image is unusual in Van Dyck's work because its effect of tender close-up – as if the viewer is leaning over to kiss the corpse – means that there is almost no perspective. This helps us to see the figure in a different, less physical way: a face within an undulating mass of white, surrounded by blue, clearly suggests to us the image of a soul resting in the clouds.

DST

78 Anthony van Dyck

ANTWERP 1599–1641 LONDON

George, Lord Digby, Later 2nd Earl of Bristol, ca. 1638–39

Oil on canvas
40⅝ × 32¾ in. (103.2 × 83.2 cm)
DPG 170; Bourgeois bequest, 1811

REFERENCES: E. Larsen, *The Paintings of Anthony van Dyck*, 2 vols., Freren, 1988, no. 945; M. Rogers in *Kolekcja dla Króla*, exhib. cat., Warsaw, Royal Castle, 1992, no. 9; A. Sumner in *Death, Passion and Politics*, exhib. cat., London, Dulwich Picture Gallery, 1995–96, no. 7

George Digby (1612–1677) was the cousin of Sir Kenelm, who commissioned the portrait of Lady Digby (cat. 77). Like his cousin, George was a soldier, poet, ardent Royalist, and eventually a Catholic.

This portrait shows the influence of sculpture on Van Dyck's work. In 1635 Van Dyck was commissioned to paint three views on the same canvas of the head of King Charles I for Gianlorenzo Bernini, in order to give the Italian sculptor as clear an idea as possible of the king's appearance. Bernini's completed bust of the king arrived in England in 1637 (it was destroyed by fire in 1698). Both the bust and Van Dyck's triple portrait employ the device of a silk drape partly covering the king's modern clothes and disguising the truncation of the bust at the sitter's waist. In the same way Van Dyck throws a silk drape over Lord Digby's shoulder, concealing the obviously modern elements of the costume (like a lace collar) and giving his dress a generalized and timeless character. The drape also helps to puff out the chest and shoulders with appropriate bulk and dignity. In this way Van Dyck makes a strong three-dimensional unit of the chest, arms, and head, just like a mass of carved marble. The diagonal view and dramatic contrasts of candlelight create a particularly swashbuckling effect, appropriate for a cavalier.

DST

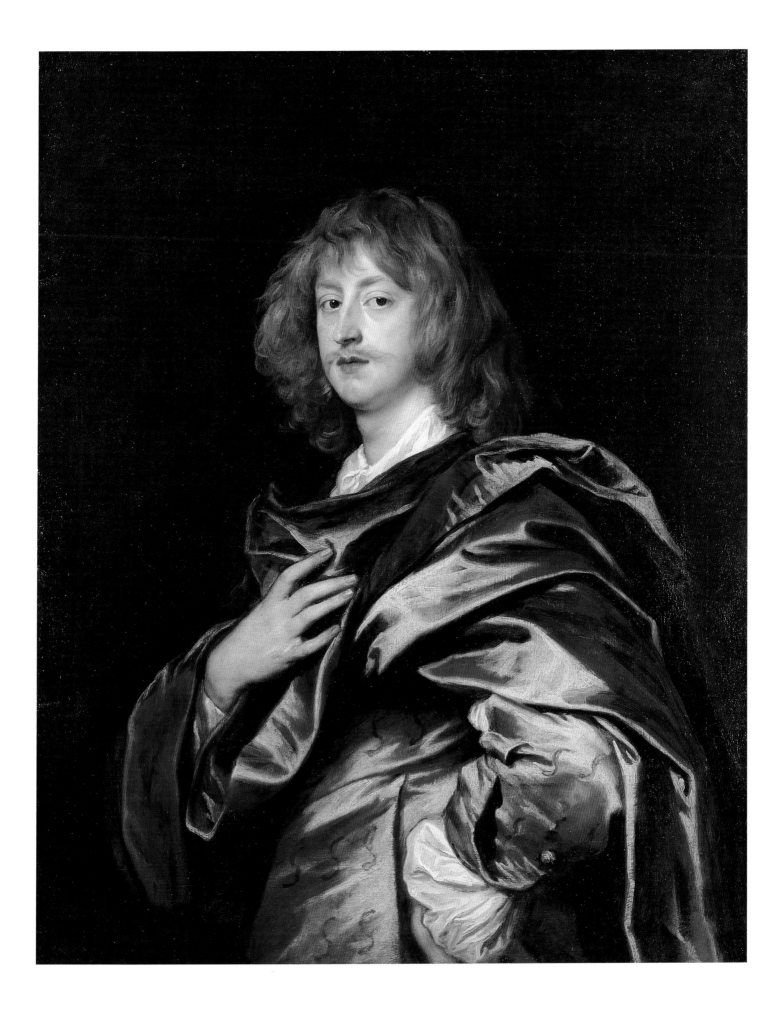

79 Peter Lely

SOEST (WESTPHALIA) 1618–1680 LONDON

Nymphs by a Fountain, ca. 1650

Oil on canvas
50¾ × 57 in. (128.9 × 144.8 cm)
DPG 555; Fairfax Murray gift, 1911

REFERENCES: R.B. Beckett, *Lely*, London,
1951, no. 594; O. Millar, *Sir Peter Lely,
1618–80*, exhib. cat., London, National
Portrait Gallery, 1978, no. 25; M. Rogers
in *Collection for a King*, Washington, D.C.,
National Gallery of Art, and Los Angeles
County Museum of Art, no. 20;
O. Millar, "Peter Lely," in J. Turner (ed.),
The Dictionary of Art, 34 vols., London,
1996, XIX, p. 120

Born in what is now Germany, Peter Lely studied painting in Haarlem with Frans Pietersz de Grebber before moving to London in 1641–43, where he remained for the rest of his life. Lely's career in England was in every respect a success. Naturalized in 1662 and knighted in 1680, he managed a hugely productive studio and amassed a considerable fortune, which in turn allowed him to become one of the most distinguished art collectors of his age.

Lely regretted one thing about his adopted country: that he was given so little opportunity to paint Arcadian scenes like this one. The reason is given by his friend the poet Richard Lovelace:

Now my best Lilly let's walk hand in hand,
And smile at this un-understanding land;
Let them their own dull counterfeits adore,
Their Rainbow-cloaths admire, and no more;
Within one shade of thine more substance is
Than all their varnish'd Idol-Mistresses:

("Peincture: A Panegyrick to the Best Picture of Friendship Mr. Peter Lilly")

It is the familiar problem: the English only like portraits. In the same poem Lovelace writes of painting (or peincture as he rather pretentiously calls it), that it "dost fairly draw/ What but in Mists deep inward *Poets* saw." The implication here is that the highest form of painting depicts the historical, religious, or mythological stories told by poets. It would seem that this painting satisfies this criterion and shows Lely working in the same tradition of European history painting that produced, for example, Poussin's *Nurture of Jupiter* (cat. 27) and Rubens's *Ceres (?) and Two Nymphs* (cat. 38). The fountain, the woodland setting, and the warm evening sunlight, surrounded by deep shadows, are all certainly characteristic of mythological painting at this time, but there are some

serious problems. For one thing, the subject of Lely's painting is either obscure or non-existent. There are mythological episodes that provide an excuse to paint naked sleeping women, but Lely evidently felt that no such excuse was necessary.

Moreover, there is something about the treatment of the figures that is disconcertingly immediate for a type of painting that is supposed to evoke the remote past of the poetic imagination. These nymphs wear a somewhat disheveled version of the hairstyles of 1650; they seem to be lying on discarded silk dresses and linen shifts, rather than abstracted pieces of drapery. The mythological nude is generally an edited version of the human body, the anatomy and even the surface of the skin idealized in order to resemble antique sculpture. Even the flesh-and-blood nudes of Rubens have a pattern and painterliness about them that sets art at one remove from life. By contrast, Lely's nudes do not seem to be refracted through some aesthetic medium; they are seen in the raw. Their form is discreetly imperfect: the lower left nymph has a plump stomach; the one lying on her back has breasts flattening with their own weight; the lower right nymph has dirty feet. A grazing light accentuates every slight convexity on the surface of the anatomy. More generally, the smooth paint surface has a tactile quality that has no suggestion of marble about it.

These nymphs are part of an alternative tradition – seen in the work of Caravaggio, in Velázquez's Rokeby *Venus* (National Gallery, London) and in Manet's *Olympia* (Musée d'Orsay, Paris) – that seeks to remove the idealizing conventions that can, as it were, clothe the nude and deliver the shock of real nakedness. This makes Lely's nymphs less uplifting and more erotic.

DST

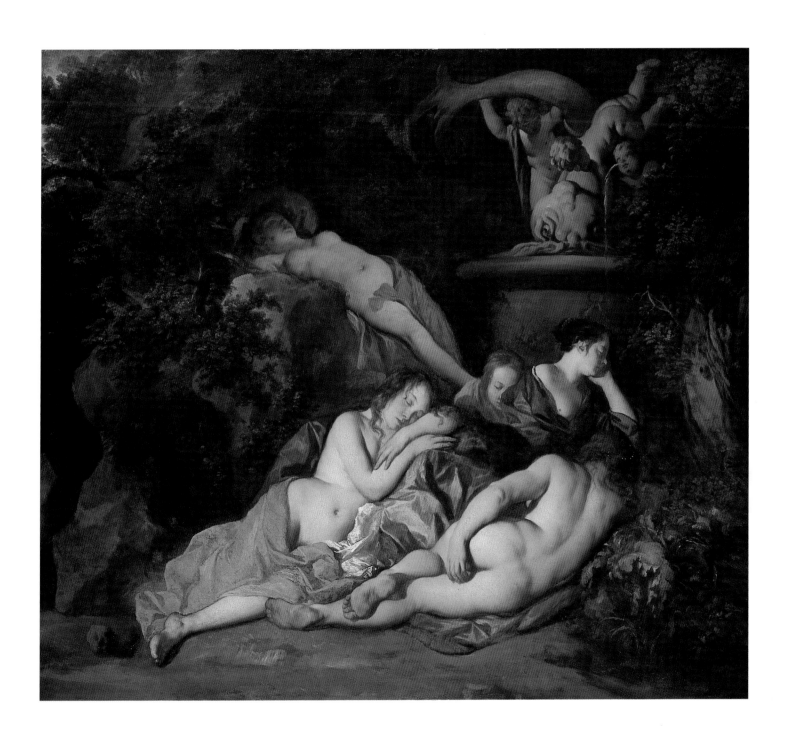

80 Peter Lely

SOEST (WESTPHALIA) 1618–1680 LONDON

Young Man as a Shepherd, ca. 1658–65

Oil on canvas
36 × 29¾ in (91.4 × 75.6 cm)
Signed, lower right: PL (in monogram)
DPG 563; Fairfax Murray gift, 1911

REFERENCES: R.B. Beckett, *Lely*, London, 1951, no. 129; O. Millar, *Sir Peter Lely, 1618–80*, exhib. cat., London, National Portrait Gallery, 1978, no. 28; M. Rogers in *Collection for a King*, Washington, D.C., National Gallery of Art, and Los Angeles County Museum of Art, no. 21; M. Rogers in *Kolekcja dla Króla*, exhib. cat., Warsaw, Royal Castle, 1992, no. 15

This dreaming boy was thought for many years to be the poet and child prodigy Abraham Cowley (1618–1667), a fanciful identification especially favored by a former owner of the portrait, the antiquarian author Horace Walpole. Unfortunately, the painting was probably executed between 1658 and 1665, when Cowley was forty. More recently, Malcolm Rogers has suggested that the portrait may depict Bartholomew Beale (1656–1709), the eldest son of Lely's pupil Mary Beale. This identification is plausible, though still a guess.

What is certain is that this is a portrait of a boy play-acting. Though presumably of gentle birth, he prefers to see himself as a dreamy shepherd boy with staff and pipe, singing a ditty in a forest. His clothes are covered by a loose wrap so that we cannot recognize any particular fashion. He could be a rustic from any time or place, even from Arcadia, the legendary pastoral paradise of ancient Greece. More immediately, Lely may have been thinking of the exiled duke in Shakespeare's *As You Like It* (Act I, Scene 1), who lives in the forest of Arden where "many young gentlemen flock to him every day, and fleet the time carelessly, as they did in the golden world."

When people refer to "old master brown," this is what they mean. A basically drab color, appropriate for shepherds, covers the entire surface, yet it is so subtly varied, the different shades resonating with each other, that the final effect has the richness of the finest mahogany. In this way Lely conveys an impression of effortless or natural luxury – of fine silk, lustrous golden hair, and perfect skin. He takes the romantic and melancholy world of the Elizabethan pastoral and adds one crucial ingredient of his own – glamour.

DST

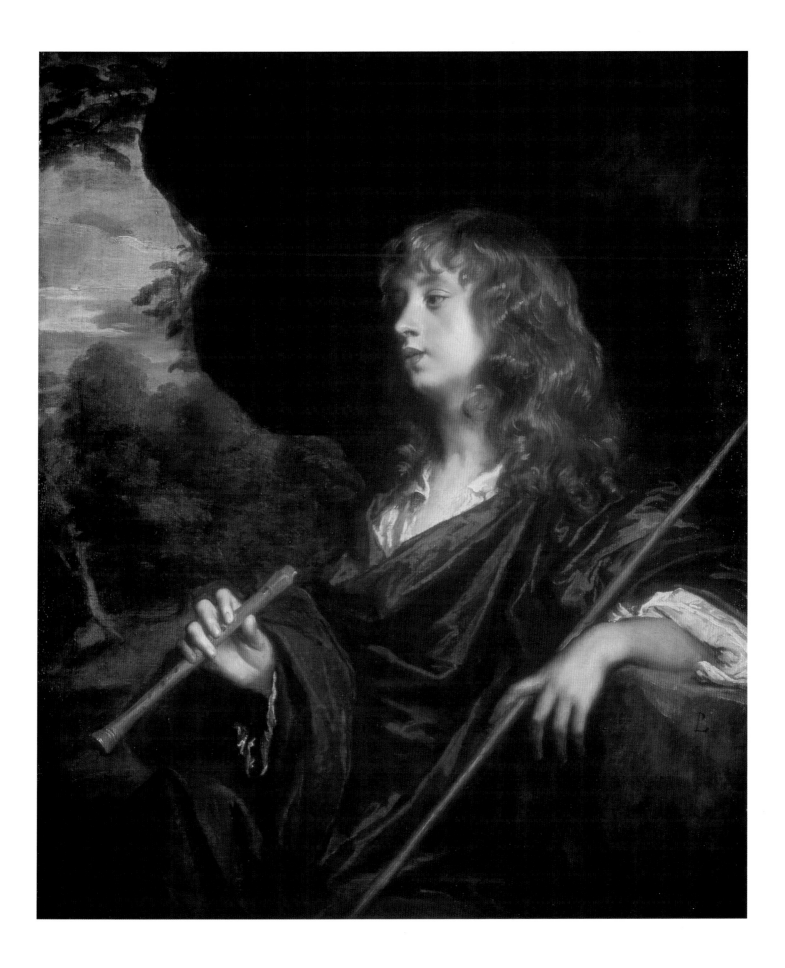

81 William Hogarth

LONDON 1697–1764 LONDON

A Fishing Party ("The Fair Angler"), ca. 1730

Oil on canvas
21⅝ × 19 (54.9 × 48.1 cm)
DPG 562; Fairfax Murray gift, 1911

REFERENCES: R.B. Beckett, *Hogarth*, London, 1949, p. 42 and fig. 29; G.A. Waterfield in *Collection for a King*, Washington, D.C., National Gallery of Art, and Los Angeles County Museum of Art, 1985–86, no. 13; R. Paulson, *Hogarth*, 3 vols., New Brunswick and Cambridge, 1991–93, I, p. 212

William Hogarth was a pugnacious outsider, enjoying spats with picture dealers, collectors, theorists, and politicians; as an artist he was a comedian, a popularizer, and a maverick. He originally trained as a silver engraver and for his entire career he made his living through sales of his copper engravings. He came to painting relatively late in life; this small canvas, of about 1730, is one of his earliest essays.

This is a fine example of what is called a "conversation piece," a form brought over from France a few years earlier by a follower of Watteau, Philippe Mercier (1689–1760). It derived from the high-life genre paintings of the Dutch and French traditions, seen, for example, in Dou's *Woman Playing a Clavichord* (cat. 51), Watteau's *Plaisirs du bal* (*Pleasures of the Dance*; cat. 33), and to a lesser extent in Wouwermans's *Halt of a Hunting Party* (cat. 70). The idea is that anonymous characters can be replaced by portraits, while preserving the "business" of genre painting – the interest in landscape or interior settings and the hints of anecdotal narrative. In this case an image that could have been merely a small-scale portrait of a nobleman showing off his wife and property has been turned into an intimate snapshot of family life. The child (probably a boy) is being taught to fish by his nurse and mother, while the father watches and a couple go punting in the background.

Perhaps the most interesting thing about this image is that the child is the center of attention. The solicitude of the nurse and mother even create a certain awkwardness – they are not looking their glamorous best. As the eighteenth century proceeded, this "child-centered" idea of informal learning became increasingly popular, usually happening out of doors. In literature one thinks of Tom Jones's early poaching escapades (Henry Fielding, *Tom Jones*, 1749, Book III, chapter 2), and in painting of the charming high spirits and mischief of the children in the conversation pieces of Johann Zoffany (1733–1810).

DST

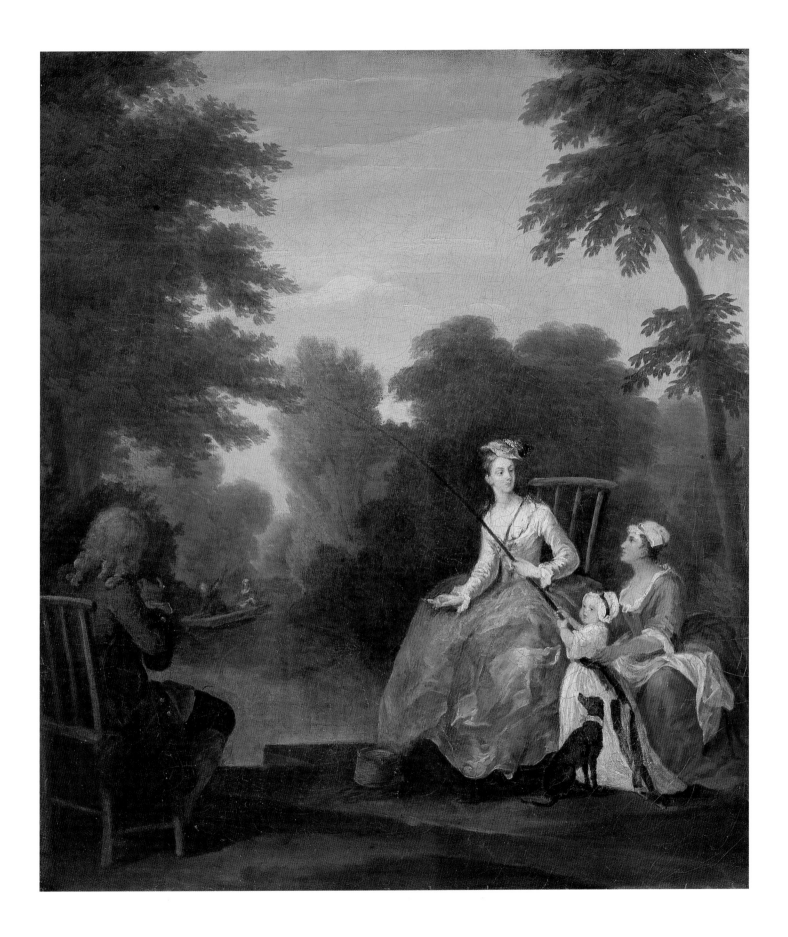

82 William Hogarth

LONDON 1697–1764 LONDON

Portrait of a Man, 1741

Oil on canvas
30 × 25⅛ in. (76.2 × 63.8 cm)
Signed and dated, bottom left: *W Hogarth Anglus pinxt 1741*
DPG 580; Fairfax Murray gift, 1911

REFERENCES: R.B. Beckett, *Hogarth*, London, 1949, p. 51 and fig. 132; R. Paulson, *Hogarth*, 3 vols., New Brunswick and Cambridge, 1991–93, II, p. 173

William Hogarth was always suspicious of portrait painters, or "phiz-mongers" as he called them, who toadied to the rich and made indecent sums of money. He was especially riled when foreigners muscled in on this lucrative trade, as J.B. Vanloo (1684–1745) did on moving to London in 1737. In 1740 Hogarth quite consciously set out to challenge mainstream life-size portrait painters in England at their own game. The signature on this portrait, *W Hogarth Anglus pinxt* (W Hogarth, Englishman, painted this), is clearly intended as self-promotion through nationalism.

Hogarth's contemporaries might have guessed that he was an Englishman without his needing to tell them, as he paints in a self-consciously matter-of-fact English style – hence the careless lean of the figure and the direct way in which he communicates with the viewer. Everything about the figure, down to the slightest detail, has simplicity and weight, built upon a reassuringly thick surface of paint. On the other hand, it is not difficult to see why Hogarth never became a fashionable portrait painter. Especially if we compare this man with Gainsborough's later portraits (see cat. 87 and 89), we can see that the features are too pronounced, too strongly delineated, too heavy and coarse for the fashionable ideal of elegance and male beauty at the time. This unknown man looks like a capable professional in an age when everybody wanted to look like an aristocrat.

DST

83 George Knapton

LONDON 1698–1778 LONDON

Lucy Ebberton, ca. 1745

Oil on canvas
30⅛ × 25¼ in. (76.5 × 64.1 cm)
DPG 606; Fairfax Murray gift, 1917–18

REFERENCES: A. Staring, "De Van der Mijns in England II," *Nederlands Kunsthistorisch Jaarboek*, XIX, 1968, pp. 200–02 (as Frans van der Mijn); G.A. Waterfield in *Collection for a King*, Washington, D.C., National Gallery of Art, and Los Angeles County Museum of Art, 1985–86, no. 17

George Knapton made his most significant contribution to British portrait painting during the 1740s and 1750s, especially through a set of portraits of members of the Society of Dilettanti, depicted in classical costume or "fancy dress" and with laddish raillery.

This portrait, of the late 1740s, was engraved by J. McArdell between 1746 and 1765 as the work of Knapton. We have a name for the sitter only because Horace Walpole wrote it on his copy of the McArdell engraving, but no further information about her background or character is known.

During the 1740s, portraits began to show ladies wearing the same "fancy dress" that they wore to masquerades. The issue of whether fancy or plain dress was most suitable for portraiture concerned artists until the end of the century. Knapton's solution is a clever one. This is not fancy dress, for Lucy Ebberton wears an "informal" costume appropriate for visiting and receiving before "dressing" for dinner at three in the afternoon. She wears a dress of silk made in Spitalfields, straw hat over a linen bonnet, and a paste necklace. However, with the floral pattern of her white dress and her Bo-Peep hat, her look is so pastoral that she could pass for a shepherdess, one of the most popular disguises at masquerades. To complete the characterization, Knapton has set her in a soft-focus woodland and put a wicker basket of flowers in her hand. Her costume and setting proclaim Lucy Ebberton's simplicity and purity of heart, as does the shy smile on her lips and the modest blush on her cheeks.

DST

84 Andrea Soldi

FLORENCE 1703–1771 LONDON

Louis François Roubiliac, 1751

Oil on canvas
38⅜ × 32¾ in. (97.5 × 83.2 cm)
Signed and dated, center left:
A.a Soldi | Pin.ˣ A.⁰ 1751
DPG 603; Fairfax Murray gift, 1917–18

REFERENCES: *Rococo: Art and Design in Hogarth's England*, exhib. cat., London, Victoria and Albert Museum, 1984, S17

Louis François Roubiliac (1702–1762) shared honors with John Michael Rysbrack (1694–1770) as the most important and successful sculptors of their generation in London. Both were immigrants, Rysbrack from Antwerp in Flanders and Roubiliac from Lyons in France. Between them they developed a theatrical style of tomb sculpture, importing the lessons of the Roman Baroque to England, and an informal type of bust portraiture in marble and terracotta. Roubiliac is here seen holding a spatula and working on a clay model for the monument to the Duke of Montagu in Warkton Church, Northamptonshire, showing an allegory of Charity explaining the virtues of the deceased to her accompanying child.

Soldi's image of Roubiliac belongs in a milieu shared by artist and sitter, a community of foreign artists bringing the liveliness of the Continental Rococo style to the otherwise rather stodgy London artistic scene. Soldi wishes to express the idea of genius, a characteristic of which he believes to be an informality that expresses an impatient spirit and a creative carelessness. Every button on Roubiliac's jacket is undone; even his shirt cuffs are open. He sports, at a rakish angle, the type of velvet cap that gentlemen wore when, in the strict privacy of their studies, they felt able to remove their wigs. His posture is similarly casual, slumped against his stone work surface, unaware that he is being observed, utterly absorbed in his task. This informality is stylish as well as careless; it was the aim of fashion (as of art) not to seem to be trying too hard. Alexander Pope refers to a similarly informal portrait of himself as making him look "like a modern modish author" (quoted in Desmond Shawe-Taylor, *Genial*

Company, Nottingham, 1987, p. 33). This shows Roubiliac as a modern modish artist.

Another attribute of genius is poetic fury – a sort of creative wildness, not, curiously, incompatible with elegance. Roubiliac has a furrowed brow, arched eyebrows, wide lids, and prominent staring eyes, catching the light like marbles. This facial distortion (not unlike the way in which shock is sometimes expressed in art) conveys a state of heightened emotional excitement. This expression, and the way in which Roubiliac seems to see beyond the physical clay to his vision of Charity, reminds us of Shakespeare's description of inspiration:

The poet's eye, in a fine frenzy rolling,
Doth glance from heaven to earth, from earth to
 heaven;
And, as imagination bodies forth
The forms of things unknown, the poet's pen
Turns them to shapes, and gives to airy nothing
A local habitation and a name.

(*A Midsummer Night's Dream*, Act V, Scene 1)

DST

85 Richard Wilson

PENEGOES 1713/14–1782 COLOMENDY

Tivoli, the Cascatelle, and the "Villa of Maecenas," ca. 1750–57

Oil on canvas
28⅞ × 38¼ in. (73.3 × 97.2 cm)
DPG 171; Bourgeois bequest, 1811

REFERENCES: W.G. Constable, *Richard Wilson*, London, 1953, p. 225, pl. 117a; G.A. Waterfield in *Collection for a King*, Washington, D.C., National Gallery of Art, and Los Angeles County Museum of Art, 1985–86, no. 36; C. Powell, *Italy in the Age of Turner*, exhib. cat., London, Dulwich Picture Gallery, 1998, p. 63, fig. 23

Richard Wilson was Welsh by birth, the son of a clergyman. Coming to London in 1729, he trained as a portrait painter. In 1750 he set out for Italy, stopping first at Venice, but soon moving on to Rome (by 1752), where he remained until 1756–57. It was in Rome that he embarked on a career as a serious landscapist, basing his style on the example of Claude and Dughet. He met with some success in his new field when he returned to Britain, but it did not last. The Royal Academy of Arts, of which he was a founding member, eventually appointed him librarian in 1776, to save him from penury.

This painting, by comparison with another version, dated 1752, in the National Gallery of Ireland, must have been produced during Wilson's Italian period. Exploring the Roman campagna, he has clearly brought his knowledge of Claude and Dughet to bear on his composition. His subject is a famous scenic spot – the view of Tivoli, with its celebrated waterfall, the Cascatelle, and the ruins of what was then assumed to be the Villa of Maecenas, but which is now known to be the Sanctuary of Hercules Victor. The rather rugged, earthy handling of the land is far heavier than that of Claude, although the sky is clearly indebted to his example. Wilson's approach is more generalized, depending for its effect of distance on a carefully modulated use of receding planes contrasting with the brightness of the sky. He has included an artist in the foreground, whom his pupil Joseph Farington, in his diary for May 3, 1809, identifies as Wilson himself, although this does not mean that the finished painting would have been executed out of doors. Details such as the spray from the falling water have been carefully observed and recorded, lending credence to the story of Wilson's exclamation on seeing Tivoli: "Well done, water, by God!"

The poverty of Wilson's final years bears witness to the falling off of his reputation in his own lifetime, in favor of the more decorative style of such artists as Francesco Zuccarelli, who was also a founding member of the Royal Academy (see cat. 17). After his death, however, he rapidly found favor again, and a younger generation of artists, including Turner and Constable, admired Wilson's *gravitas* and power. According to Farington, this painting previously belonged to one "Dr Monro," presumably Dr. Thomas Monro, the early patron of the young Turner. This painting may well have been one of the roots of Turner's fascination with Italy, and with this view in particular.

IACD

86 Thomas Gainsborough

SUDBURY 1727–1788 LONDON

An Unknown Couple in a Landscape, mid-1750s

Oil on canvas
30 × 26⅜ in. (76.2 × 67 cm)
DPG 588; Fairfax Murray gift, 1911

REFERENCES: E. Waterhouse,
Gainsborough, London, 1958, no. 753;
L. Stainton in *Collection for a King*,
Washington, D.C., National Gallery of
Art, and Los Angeles County Museum of
Art, 1985–86, no. 10

Thomas Gainsborough had two careers; one, up until 1759, as a small-scale Dutch-style painter in provincial East Anglia; and the other, after 1759, as a painter of life-size portraits and more ambitious landscapes in fashionable Bath and London.

This small portrait belongs to the first career, and shows him developing the ideas seen in Hogarth's *Fishing Party* (cat. 81) of a quarter of a century earlier. The unifying activity of the conversation piece has become less important, though the wife here holds a *porte-crayon* and a newly completed landscape drawing in her hand as a "talking-point" for the viewer. More important, however, is the integration of the figures within the landscape. The husband leans on a fence with the informality of ownership, his corn behind him, his wife and perhaps even his constituency (if he is a Member of Parliament) in front of him. It is entirely typical of Gainsborough's work that the man stands out from the landscape, his clothes contrasting in tone and color, while his wife seems to sink into it, her stiff, orange silk dress picking up the browns and golds of the earth and the corn. This expresses the prevailing notion of the time that there was a special affinity between women and landscape, partly deriving from their common fertility. Men command landscape; women feel for it.

The style of background is based on the highly colored and decorative landscapes of Wijnants and can be directly compared to cat. 71 and 72, which have the same sense of precise atmospheric conditions caught in a small compass.

This double portrait has been identified as a companion to the *Girl Seated in a Park* in the Fitzwilliam Museum, Cambridge. An X-ray has revealed an underlying half-length female portrait. Gainsborough turned the canvas upside down before repainting it with the present composition.

DST

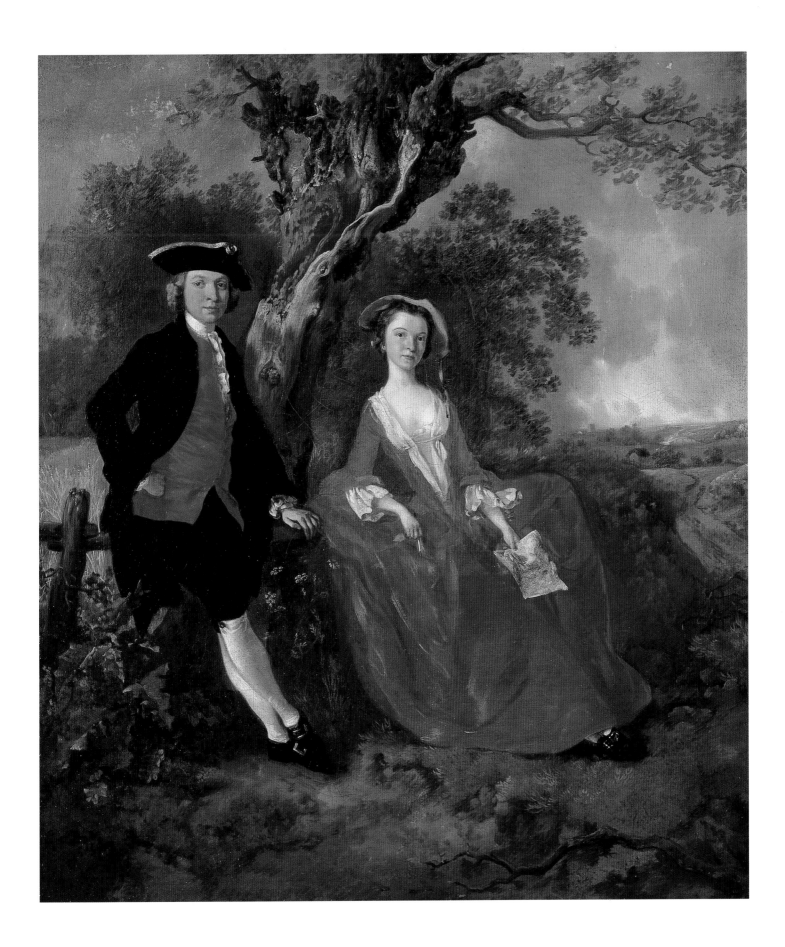

87 Thomas Gainsborough

SUDBURY 1727–1788 LONDON

Thomas Linley the Younger, ca. 1771

Oil on canvas
29⅞ × 25 in. (75.9 × 63.5 cm)
DPG 331; Linley bequest, 1835

REFERENCES: E. Waterhouse,
Gainsborough, London, 1958, no. 447;
S. Wallington in *A Nest of Nightingales*,
exhib. cat., London, Dulwich Picture
Gallery, 1988, no. 5:1

Thomas (Tom) Linley (1756–1778) was the most distinguished member of a famous family of composers and performers, who dominated musical life in Bath and London for generations. As an enthusiastic amateur musician himself, Thomas Gainsborough was naturally drawn into the Linley circle at Bath and became a close family friend. Tom, the eldest son of the elder Thomas (1732–1795), performed as a singer and violinist and was also a composer. He studied the violin in Florence, where in 1770 at the age of twelve he met, played duets, and formed a brief friendship with his contemporary Wolfgang Amadeus Mozart.

Linley composed violin sonatas and concertos as well as choral works and provided most of the music for Sheridan's opera *The Duenna* (1775). He drowned in a boating accident at the age of twenty-two. This portrait was probably painted soon after Tom's return to England in 1771.

DST

88 Thomas Gainsborough

SUDBURY 1727–1788 LONDON

The Linley Sisters (Mrs. Sheridan and Mrs. Tickell), ca. 1772

Oil on canvas
78⅜ × 60¼ in. (199 × 153.1 cm)
DPG 320; Gift of W. Linley, 1831

REFERENCES: E. Waterhouse, *Gainsborough*, London, 1958, no. 450; N. Kalinsky in *A Nest of Nightingales*, exhib. cat., London, Dulwich Picture Gallery, 1988, no. 3.3

Elizabeth Anne (1754–1792) and Mary (1758–1787) were the elder daughters of the elder Thomas Linley (1732–1795; see cat. 87); both were talented singers, performing in Bath and London. In 1773 Elizabeth eloped with the playwright Richard Brinsley Sheridan, whose play *The Rivals* (1775) provides a thinly disguised version of the romantic circumstances of their courtship. Mary married a more obscure playwright, Richard Tickell, in 1780. The portrait, probably painted in 1772, was retouched by the artist in 1785.

Both sisters were at the pinnacle of their fame when this portrait was painted. Mary had joined her sister as a professional singer in 1771 at the Three Choirs Festival. Both hold symbols of their profession. The music held by Mary (seated) is said to be "A Song of Spring" by Tickell, set to music by the sisters' father Thomas Linley. Elizabeth holds a guitar. Yet in many ways the portrait is a curious image of two prima-donnas. Where is the glamour, the stage presence, the extroversion? More about the character of the sisters than their careers, this is an image intended to suggest the paramount female virtue of the period – sensibility. An eighteenth-century viewer would instantly recognize that Elizabeth and Mary have sought out this secluded woody bank not in order to practice, but because of their instinctive love of wild places. For these sisters, to love nature was regarded as a virtue as important as loving each other (which their tender proximity suggests they do). The same instinct for the undergrowth, with the same association with "natural" fine feelings, is demonstrated by Marianne, the embodiment of sensibility in Jane Austen's *Sense and Sensibility* (1811).

Though wearing silk gowns of the latest fashion, the sisters seem to blend with their woodland setting. Gainsborough echoes the colors of the landscape and even its rough texture in the painting of the costumes. Coarse grasses grow over Mary's dress almost as if they were being stitched into its design. Gainsborough's handling of paint lends the image a remarkable organic unity. He was famous for using long-handled brushes and for working up every part of the painting together. The brushstrokes are long, loose, and capricious, more like the free shading of a rapid pen sketch than a finished painting.

DST

89 Thomas Gainsborough

SUDBURY 1727–1788 LONDON

Philippe Jacques de Loutherbourg, 1778

Oil on canvas
30⅛ × 24⅞ in. (76.5 × 63.2 cm)
DPG 66; Bourgeois bequest, 1811

REFERENCES: E. Waterhouse,
Gainsborough, London, 1958, no. 456;
L. Stainton in *Collection for a King*,
Washington, D.C., National Gallery of
Art, and Los Angeles County Museum of
Art, 1985–86, no. 8; G.A. Waterfield in
A Nest of Nightingales, exhib. cat., London,
Dulwich Picture Gallery, 1998, no. 14:6;
L. Stainton in *Kolekcja dla Króla*, exhib.
cat., Warsaw, Royal Castle, 1992, no. 10

Philippe Jacques de Loutherbourg (1740–1812) was a landscape painter and stage designer who was first brought to London in 1772 from his native France by the actor David Garrick. Gainsborough became a close friend of De Loutherbourg after his own move to London from Bath in 1774. In 1778 the two artists painted each other. De Loutherbough's portrait of Gainsborough is in the Paul Mellon Collection at Yale; this portrait, which was exhibited at the Royal Academy in 1778 and came to the Dulwich Collection through De Loutherbourg's pupil Francis Bourgeois, is the only Gainsborough and one of the very few English works in the original 1811 bequest.

In many ways the portrait is a later equivalent of Soldi's *Roubiliac* (cat. 84): the product of an international artistic community, a record of friendship, and a tribute to genius. De Loutherbourg's "fine frenzy" is more urbane and gentlemanly than Roubiliac's; yet he leans forward with energy, intentness, and a sparkling eye, seeming to look beyond his immediate surroundings. All these characteristics betray De Loutherbourg's creative temperament, the "hot head and strong mind" referred to by the diarist Joseph Farington. The other striking difference between this portrait and that of Roubiliac is that the artist's hands, so prominent and so capable in the image of the sculptor, are here hidden by his hunched-up pose. Things are rarely accidental in portraiture: by hiding the hands Gainsborough may be intending to express the old academic conceit that the noble artist is distinguished by the ideas in his head rather than the labor of his hand.

DST

90 Thomas Lawrence

BRISTOL 1769–1830 LONDON

William Linley, 1789

Oil on canvas
30 × 25 in. (76.2 × 63.5 cm)
DPG 178; Linley bequest, 1835

REFERENCES: K. Garlick in *Collection for a King*, Washington, D.C., National Gallery of Art, and Los Angeles County Museum of Art, 1985–86, no. 18; K. Garlick in *A Nest of Nightingales*, exhib. cat., London, Dulwich Picture Gallery, 1988, no. 10:1; K. Garlick, *Sir Thomas Lawrence, A Complete Catalogue of the Oil Paintings*, Oxford, 1989, no. 496

Thomas Lawrence received no formal training, but his portrait drawings in pastel produced as a child in his father's inn at Devizes revealed a precocious talent. In 1780 his family moved to Bath where he produced portraits in pastel and began painting in oils. By 1787 he had moved with his father to London and in that year exhibited a pastel at the Royal Academy. Despite his youth, he was soon seen as a successor to Joshua Reynolds, whom he succeeded in 1792 as Painter-in-Ordinary to the king. Knighted in 1815, he became president of the Royal Academy in 1820. He assembled one of the greatest collections of old master drawings in Europe.

One of his earliest oils, this painting played a key role in the establishment of Lawrence in London. S.P. Denning, keeper of Dulwich Picture Gallery from 1821 to 1864 and a friend of the sitter, tells the following anecdote about it in his manuscript catalogue of the collection:

Mr William Linley used to tell the story of the origin of this picture. Some patron of the young Lawrence offered to present to the notice of the king, George III, some Specimen of his Stile. Lawrence chose the young Linley for his subject, & painted this picture. It was duly presented to His Majesty. After looking at it some time, all he said was "Ah! Ah! Why doesn't the blockhead have his hair cut?"

The long hair, a style with perhaps too much of a whiff of proto-Romantic artistic pretension for the tastes of George III, was to last almost another decade – not until October 1798 does the family correspondence record William's "wonderful metamorphose … a Crop … at last" (Jane Linley to her future husband, October 6, 1798.)

The Lawrences had known the Linleys since they were nextdoor neighbors in Bath. William, youngest son of the elder Thomas Linley, and brother to Tom, Elizabeth Sheridan, and Maria Tickell (see Gainsborough's portraits, cat. 87 and 88), had been sent to Saint Paul's School in London in 1785. Ill health interrupted two periods of work for the East India Company, 1790–95 and 1800–05, and on retiring from the company in 1810 he devoted himself to singing (Samuel Taylor Coleridge's sonnet "While my young cheek retains its youthful hues" was written on hearing William sing Henry Purcell), a little composing, but mainly to being the convivial and sociable personality he was.

Astonishingly accomplished for the work of a twenty-year-old, this portrait signalled the arrival on the scene of a true virtuoso of the paintbrush, effortlessly able equally to suggest the softness of the hair and the crispness of the neckerchief. The portrait's mood also seems new, a romantic vision of youth, with none of the extreme stylization that was later to attract criticism from some quarters. Lawrence brought a quality of glamour to his handling of paint that ensured his popularity with sitters, who could reasonably expect that some of it would rub off on them. This portrait is particularly interesting, therefore, in that its subject was apparently chosen by the artist, and was, furthermore, a friend, so that the agenda can reasonably be assumed to be all the artist's.

IACD

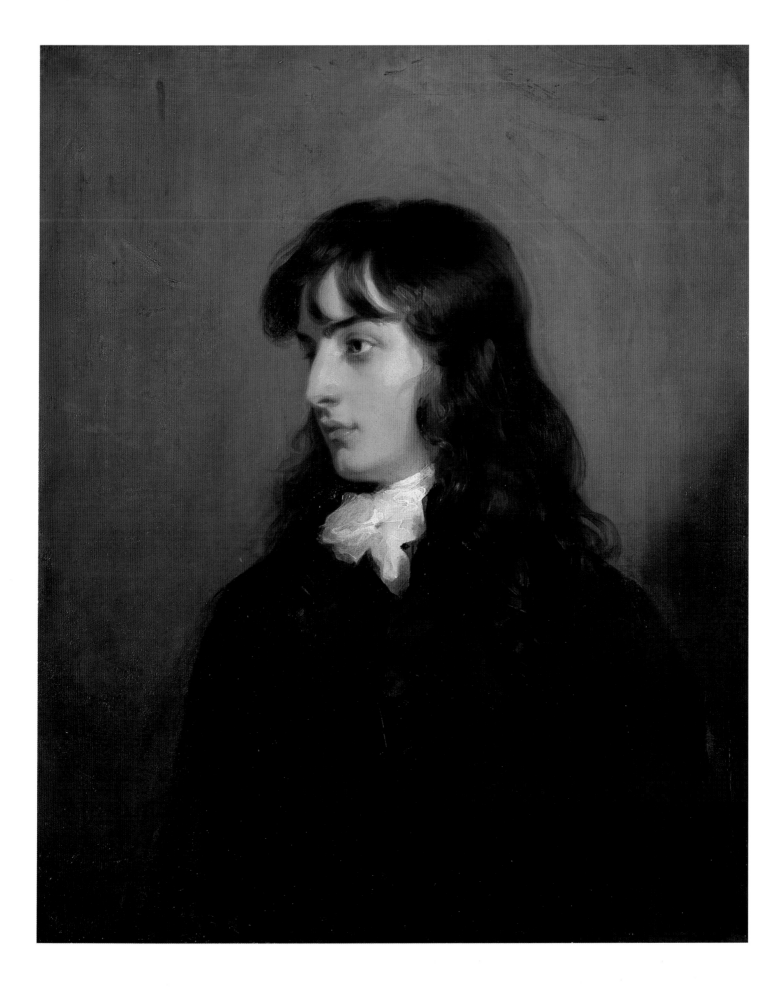

Bibliography

Alpers, S., *Rembrandt's Enterprise, The Studio and the Market*, London, 1988

Angulo Iñiguez, D., *Murillo: Su vida, su arte, su ombra*, 3 vols., Madrid, 1981

Asturia, M.A., and P.M. Bardi, *L'opera completa di Velázquez*, Milan, 1969

Baer, R., *The Paintings of Gerrit Dou (1613– 1675)*, diss., New York University, 1990

Bagatin, L., P. Pizzamano, and B. Rigobello, *Lendinara, notizie e immagini per una storia dei beni artistici e librari*, Treviso, 1992

Baldassari, F., *Carlo Dolci*, Turin, 1995

Barrell, J. (ed.), *Painting and the Politics of Culture: New Essays in British Art 1700– 1850*, Oxford and New York, 1992

von Bartsch, J.A.B., *Le peintre graveur*, 21 vols., Vienna, 1803–21; *The Illustrated Bartsch*, ed. W.L. Strauss, New York, 1978

Bazin, G., *Baroque and Rococo*, London, 1964

Beckett, R.B., *Hogarth*, London, 1949

Beckett, R.B., *Lely*, London, 1951

Beresford, R., *Dulwich Picture Gallery: Complete Illustrated Catalogue*, London, 1998

Beruete, A. de, *Velásquez*, Paris, 1898

Blunt, A., *Artistic Theory in Italy, 1450–1660*, Oxford, 1940

Blunt, A., *Art and Architecture in France, 1500 to 1700*, London (Penguin Books), 1953

Blunt, A., *The Paintings of Nicolas Poussin: A Critical Catalogue*, London, 1966

Blunt, A. (ed.), *Nicolas Poussin, Lettres et Propos sur l'art*, Paris, 1989

Bodmer, H., *Lodovico Carracci*, Burg bei Magdeburg, 1939

Boisclair, M.N., *Gaspard Dughet, 1615–1675*, Paris, 1986

Braham, A., *El Greco to Goya: The Taste for Spanish Paintings in Britain and Ireland*, exhib. cat., London, National Gallery, 1981

Bredius, A., revised by H. Gerson, *Rembrandt: The Complete Edition of the Paintings*, London, 1971

Brewer, J., *The Pleasures of the Imagination: English Culture in the Eighteenth Century*, London, 1997

Briganti, G., L. Trezzani, and L. Lauranti, *I Bambioccanti: pittore della vita quotidiana a Roma nel Seicento*, English ed. transl. by R.E. Wolf, Rome, 1983

Britton, J., *A Brief Catalogue of Pictures Late the Property of Sir Francis Bourgeois, R.A., with the sizes and proportions of the Pictures* (Ms. Dulwich College Archive)

Broulhiet, G., *Meindert Hobbema (1638– 1709)*, Paris, 1938

Brown, B.L., *Giambattista Tiepolo: Master of the Oil Sketch*, exhib. cat., Fort Worth, Kimbell Art Museum, 1993

Brown, J., *Murillo and His Drawings*, Princeton, 1976

Brown, J., *Velázquez: Painter and Courtier*, New Haven and London, 1986

Brown, J., *The Golden Age of Painting in Spain*, New Haven and London, 1991

Brown, S.F., *Sir Joshua Reynolds' Collection of Paintings*, London, 1986

Brugnoli, M.V., "Note alla Mostra dei Carracci," *Bolletino d'Arte*, XLI, 1956, pp. 356–60

Bruyn, J. et al., *A Corpus of Rembrandt Paintings*, II, Dordrecht, Boston, and Lancaster, 1986

Bryson, N., *Word and Image: French Painting of the Ancien Régime*, Cambridge, 1981

Burke, J.D., *Jan Both (ca. 1618–1652), Paintings, Drawings and Prints*, New York and London, 1976

Canaletto, exhib. cat., New York, Metropolitan Museum of Art, 1989

Mr. Cartwright's Pictures, exhib. cat., London, Dulwich Picture Gallery, 1987–88

Cézanne and Poussin. The Classical Vision of Landscsape, exhib. cat., Edinburgh, National Gallery of Scotland, 1990

Chong, A., *Aelbert Cuyp and the Meaning of Landscape*, diss., New York University, 1992

Clark, K., *Landscape into Art*, Boston, 1961

Clark, K., *Ruskin Today*, Harmondsworth, 1964

Collection for a King: Old Master Paintings from the Dulwich Picture Gallery, exhib. cat., Washington, D.C., National Gallery of Art, and Los Angeles County Museum of Art, 1985–86

Conisbee, P., *Painting in Eighteenth-Century France*, London, 1981

Conserving Old Masters, exhib. cat., London, Dulwich Picture Gallery, 1995

Constable, W.G., *Canaletto*, 2nd ed. revised by J.G. Links, Oxford, 1976

Cook, E., *Catalogue of the Pictures in the Gallery of Alley's College of God's Gift at Dulwich, revised and further revised and completed by the Governors*, London, 1926

Coonley, P., and G. Malafarina, *L'opera completa di Annibale Carracci*, Milan, 1976

Courage and Cruelty, Le Brun's Horatius Cocles and The Massacre of the Innocents (Paintings and Their Context, III), exhib. cat., London, Dulwich Picture Gallery, 1990–91

Craske, M., *Art in Europe 1700–1830*, Oxford, 1997

Cropper, E., and C. Dempsey, *Nicolas Poussin, Friendship and the Love of Painting*, Princeton, 1996

Crow, T., *Painters and Public Life in Eighteenth Century Paris*, New Haven and London, 1985

Cuzin, J.-P., *Fragonard, Life and Work, Complete Catalogue of the Oil Paintings*, New York, 1988

Daniels, J., *Sebastiano Ricci*, Hove, 1976

Demus, K., *Verzeichnis der Gemälde. Kunsthistorisches Museum*, Vienna, 1973

Desenfans, N., *A Descriptive Catalogue (with remarks and anecdotes never before published in English) of some Pictures of the Different Schools purchased for His Majesty the Late King of Poland*, 2 vols., London, 1802

D'Hulst, R.A., and M. Vandenven, *Corpus Rubenianum, III, The Old Teatament*, London and New York, 1989

Downes, K., *Rubens*, London, 1980

Dussler, L., *Raffael. Kritisches Verzeichnis …*, Munich, 1966; English ed. London, 1971

Foss, M., *The Age of Patronage: The Arts in England, 1660–1750*, London, 1974

Friedlaender, W., *Caravaggio Studies*, Princeton, 1955

Gaehtgens, B., *Adriaen van der Werff, 1659–1722*, Berlin, 1987

Garboli, C., and E. Baccheschi, *L'opera completa di Guido Reni*, Milan, 1971

Garlick, K., *Sir Thomas Lawrence, A Complete Catalogue of the Oil Paintings*, Oxford, 1989

Gasseau, M., *Charles Le Brun. First Painter to King Louis XIV*, New York, 1992

Gaya Nuño, J.A., *L'opera completa di Murillo*, Milan, 1978

Gerson, E., and H.E. Ter Kuile, *Art and Architecture in Belgium, 1600–1800*, Harmondsworth, 1960

Gemin, M., and F. Pedrocco, *Giambattista Tiepolo: I dipinti. Opera completa*, Venice, 1993

Grant, M.H., *Jan van Huysum, 1682–1749*, Leigh-on-Sea, 1954

Gregory, C., and S. Lyon, *The French Classical Tradition*, New York, 1985

Harwood, L.B., *Adam Pynacker*, Doornspijk, 1988

Harwood, L.B., *A Golden Harvest, Paintings by Adam Pynacker*, exhib. cat., Sterling and Francine Clark Art Institute, Williamstown, and John and Mable Ringling Museum of Art, Sarasota, 1994–95

Haskell, F., *Patrons and Painters, Art and Society: Baroque Italy*, New Haven and London, 1980

Haskell, F., *Rediscoveries in Art*, London, 1976

Hecht, P., in *De Hollandse fijnschilders: Van Gerrit Dou tot Adriaen van der Werff*, exhib. cat., Amsterdam, Rijksmuseum, 1989

Held, J.S., *The Oil Sketches of Peter Paul Rubens: A Critical Catalogue*, Princeton, 1980

Hofstede de Groot, C., *A Catalogue Raisonné of the Works of the Most Eminent Dutch Painters of the Seventeenth Century*, 10 vols. (vols. IX and X in German), London, Stuttgart, and Paris, 1907–26

Huemer, F., *Corpus Rubenianum*, XIX, *Portraits*, 2 vols., Brussels, London, and New York, 1977

L'ideale classico del Seicento in Italia e la pittura di paesaggio, exhib. cat., Bologna, Palazzo del Archiginnario, 1962

Ingersoll-Smouse, F., *Vernet*, 2 vols., Paris, 1926

Jaffé, M., "Some Drawings by Annibale and by Agostino Carracci," *Paragone*, LXXXIII, 1956, pp. 12–16

Jaffé, M., *Rubens: Catalogo completo*, Milan, 1989

Kalnein, W.G., and M. Levey, *Art and Architecture of the Eighteenth Century in France*, Harmondsworth, 1972

Kitson, M., *Salvator Rosa*, London, 1973

Kitson, M., *The Age of Baroque*, London, 1976

Klinge, M., *David Teniers the Younger: Paintings, Drawings*, exhib. cat., Antwerp, Koninklijk Museum voor Schone Kunsten, 1991

Kolekcja dla Króla, exhib. cat., Royal Castle, Warsaw, 1992

Larsen, E., *The Paintings of Anthony van Dyck*, 2 vols., Freren, 1988

Levey, M., *Rococo to Revolution*, London, 1966

López-Rey, J., *Velázquez: A Catalogue Raisonné of His Œuvre*, London, 1963

López-Rey, J., *Velázquez' Work and World*, London, 1968

Magani, F., *Antonio Bellucci, catalogo ragionato*, Rimini, 1995

Mahon, D., *Studies: Seicento Art and Theory*, London, 1947

Mahon, D., *Nicolas Poussin, Works from His First Years in Rome*, Jerusalem, 1999

Mâle, É., *L'Art réligieux après le Concile de Trente*, Paris, 1932

Mallory, N.A., *Bartolomé Esteban Murillo*, Madrid, 1983

Mallory, N.A., *El Greco to Murillo, Spanish Painting in the Golden Age, 1556–1700*, New York, 1990

Martin, J.R., *Baroque*, London, 1977

Masterpieces of Reality, exhib. cat., Leicester Museum and Art Gallery, 1985–86

Mérot, A., *Poussin*, Paris, 1990

Millar, O., *The Age of Charles I, Painting in England 1620–1649*, exhib. cat., London, Tate Gallery, 1972

Montagu, J., *The Expression of the Passions*, New Haven and London, 1994

Morassi, A., *Complete Catalogue of Giovanni Battista Tiepolo*, London, 1962

Murillo, exhib. cat., Madrid, Museo del Prado, and London, Royal Academy of Arts, 1982–83

Murray, P., *The Dulwich Picture Gallery. A Catalogue*, London, 1980

Negro, E., and M. Pirondini (eds.), *La scuola di Guido Reni*, Modena, 1992

A Nest of Nightingales, Thomas Gainsborough The Linley Sisters (Paintings and Their Context, II), exhib. cat., London, Dulwich Picture Gallery, 1988

Pace, C., *Félibien's Life of Poussin*, London, 1981

Panofsky, E. (trans. J.J.S. Peake), *Idea: A Concept in Art Theory*, New York, 1968

Paulson, R., *Emblem and Expression: Meaning in English Art of the Eighteenth Century*, Cambridge MA, 1975

Paulson, R., *Hogarth*, 3 vols., New Brunswick and Cambridge, 1991–93

Pepper, D. S., *Guido Reni*, Oxford, 1984

Pepper, D. S., *Guido Reni: L'opera completa*, Novara, 1988

Pignatti, T., *Veronese*, Venice, 1976

de Piles, R., *Conversations sur la Connoissance de la Peinture*, Paris, 1677

de Piles, R., *Cours de Peinture par principes*, Paris, 1708

Piovene, G., and A. Palluchini, *L'opera completa di Giovanni Battista Tiepolo*, Milan, 1968

Piovene, G., and R. Marini, *L'opera completa di Veronese*, Milan, 1968

Posner, D., *Annibale Carracci*, 2 vols., London, 1971

Powell, C., *Italy in the Age of Turner*, exhib. cat., London, Dulwich Picture Gallery, 1998

Pupil, F., *Le Style Troubadour ou la nostalgie du bon vieux temps*, Nancy, 1985

Puttfarben, T., *Roger de Piles' Theory of Art*, New Haven and London 1985

Reiss, E., *Aelbert Cuyp*, London, 1975

Rembrandt's Girl at a Window (Paintings and Their Context, IV), exhib. cat. London, Dulwich Picture Gallery, 1993

Guido Reni (1575–1642), exhib. cat., Bologna, Pinacoteca Nazionale; Los Angeles County Museum of Art; Fort Worth, Kimbell Art Museum; 1988–89

Richter, J.P., and J.C.L.Sparkes, *Catalogue of the Pictures in the Dulwich College Gallery with Biographical Notices of the Painters*, London, 1880 (entries on the British school by Sparkes and on foreign schools by Richter)

Sebastiano Ricci, exhib. cat., Villa Manin, Udine, 1989

Robinson, M.S., *The Paintings of the Willem van de Veldes*, 2 vols., London, 1990

Rococo: Art and Design in Hogarth's England, exhib. cat., London, Victoria and Albert Museum, 1984

Roethlisberger, M., *Claude Lorrain: The Paintings*, New Haven, 1961

Roethlisberger, M., *Bartholomeus Breenbergh, The Paintings*, Berlin and New York, 1981

Roethlisberger, M., and D. Cecchi, *L'opera completa di Claude Lorrain*, Milan, 1975

Roland-Michel, M., *Tout Watteau*, Paris, 1982

Rooses, M., *L'Œuvre de Rubens*, 5 vols., Antwerp, 1886–92

Rosenberg, J., *Jacob van Ruisdael*, Berlin, 1928

Rosenberg, J., S. Slive, and E.H.Ter Kuile, *Dutch Art and Architecture, 1600 to 1800*, Harmondsworth, 1966

Rosenberg, P., *Fragonard*, exhib. cat., Paris, Grand Palais, and New York, Metropolitan Museum of Art, 1987–88

Rosenberg, P., *Tout l'oeuvre peint de Fragonard*, Paris, 1989

Rosenberg, P., and I. Compin, "Quatre nouveaux Fragonard," *Revue du Louvre*, III, 1974, pp. 183–92

Rosenberg, P., M. Grasselli, *et al.*, *Watteau*, exhib. cat., Washington, D.C., National Gallery of Art; Paris, Grand Palais; and Berlin, Schloss Charlottenburg, 1984–85

Rosenberg, P., and L.A. Prat, *Nicolas Poussin, 1594–1665*, exhib. cat., Paris, Grand Palais, 1994–95

Ruskin, J., *Modern Painters*, vols. I–V, London, 1843

Ruskin, J., *The Stones of Venice*, 3 vols., London, 1853

Ruskin, J., *Aratra Pentelici*, London, 1872

Salerno, L., *L'opera completa di Salvator Rosa*, Milan, 1975

Salerno, L., *I dipinti del Guercino*, Rome, 1988

Schama, S., *The Embarrassment of Riches, An Interpretation of Dutch Culture in the Golden Age*, London, 1987

Schulz, W., *Herman Saftleven, 1609–1685: Leben und Werke*, Berlin and New York, 1982

Schwartz, G., *Rembrandt: His Life, His Paintings*, Harmondsworth, 1985

Shawe-Taylor, D., *The Georgians: Eighteenth Century Portraiture and Society*, London, 1990

Shearman, J., *Andrea del Sarto*, Oxford, 1965

Shearman, J., *The Early Italian Pictures in the Collection of Her Majesty the Queen*, Cambridge, 1983

Simon, K.E., *Jacob van Ruisdael, Eine Darstellung seiner Entwicklung*, Berlin, 1927 (reprinted with errata and addenda, 1930)

Sluijter-Seiffert, N., *Cornelis van Poelenburch (ca. 1593–1667)*, diss., University of Leiden, 1984

Smith, J., *A Catalogue Raisonné of the Works of the Most Eminent Dutch, Flemish and French Painters*, 8 vols., London, 1829–37

Sparkes, J.C.L., *A Descriptive Catalogue of the Pictures in the Dulwich College Gallery with Biographical Notices of the Painters*, London, 1876

Sparkes, J.C.L., and A.J. Carver, *Catalogue of the Cartwright Collection and other Pictures and Portraits at Dulwich College*, London, 1890

Sumowski, W., *Die Gemälde der Rembrandt-Schüler*, 6 vols., Landau in der Pfalz, 1983

Sutherland, J., and E. Camesasca, *The Complete Paintings of Watteau*, London, 1971

Sutton, P., *Masters of Seventeenth-Century Dutch Genre Painting*, Philadelphia, 1984

Taylor, P., *Dutch Flower Painting, 1600–1750*, exhib. cat., London, Dulwich Picture Gallery, 1996

Thieme and Becker, *Allgemeines Lexikon der bildenden Künstler*, 37 vols., Leipzig, 1907–50

I Tiepolo e il Settecento vicentino, exhib. cat., Vicenza, 1990

Thuillier, J., and A. Chatelet, *French Painting: From Le Nain to Fragonard*, Geneva, 1964

Thuillier, J., *L'opera completa di Poussin*, Milan, 1974

Tümpel, C., *Rembrandt, All Paintings in Colour*, Antwerp, 1993

Valentiner, W.R., *Rembrandt: wiedergefundene Gemälde*, Berlin and Leipzig, 1921

Les Vanités. Dans la Peinture au XVIIe siècle, exhib. cat., Caen, Musée des Beaux-Arts, 1990

Verdi, R., K. Scott, and H. Glanville, *Nicolas Poussin, Venus and Mercury (Paintings and Their Context, I)*, exhib. cat., London, Dulwich Picture Gallery, 1986–87

Verdi, R., *Nicolas Poussin. Tancred and Erminia*, exhib. cat., Birmingham Museum and Art Gallery, 1992–93

Verdi, R., *Nicolas Poussin, 1594–1665*, London, Royal Academy of Arts, 1995

Die Verführung der Europa, exhib. cat., Berlin, Staatliche Museen, Preußischer Kulturbesitz, Kunstgewerbemuseum, 1988

Wallace, R.W., *The Etchings of Salvator Rosa*, Princeton, 1979

Waterhouse, E., *Gainsborough*, London, 1958

Wittkower, R., *Art and Architecture: Italy, 1600–1750*, Harmondsworth, 1973

Wright, C., *Poussin Paintings: A Catalogue raisonné*, London, 1985

Wright, C., *The French Painters of the Seventeenth Century*, London, 1985

Young, E., "Antonio Bellucci in England and Elsewhere," *Apollo*, XCVII, 1973, pp. 492–99

The American Federation of Arts

Artist Index

Numbers indicate catalogue numbers.